ANGLESEY
an English corruption of the Norse, Ongulsey

MÔN
in Welsh

MONA
in Latin

In contrast to the mainland,
only in six places
does the land rise to above 500ft

●Amlwch

Parys
Mine

Moelfre ●

annerchymedd

Puffin Island

□ Trescawen

Penmon ●

□Rhiwlas
● Pentraeth

Brynhyfryd□

Llansadwrn ●
Treffos □ Beaumaris ●

● Llangefni

Llandegfan ●

Craig-y-don □
Menai Bridge ●

● Bangor

Llanfairpwllgwyngyll ●

Afon Menai

CAERNARVONSHIRE
DISCARDED
WINNIPEG
LIBRARY
Portage Avenue
Winnipeg, Manitoba R3B 2E9
D1161618

● Caernarfon

| 0 miles | | | | 5 |
| 0 kms | | | | 8 |

ND
497
.W66A2

Across the Straits

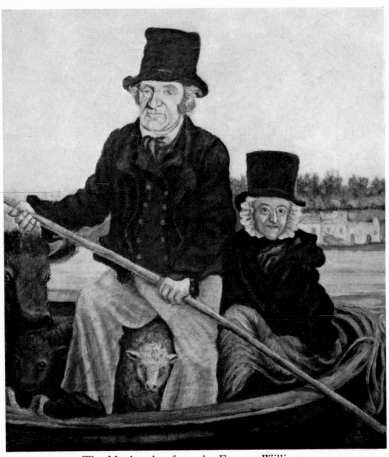
The Moel-y-don ferry, by Frances Williams

ND
497
.W66A2

Across the Straits

an autobiography

Kyffin Williams

Duckworth

First published in 1973 by
Gerald Duckworth & Company Limited
The Old Piano Factory
43 Gloucester Crescent, London NW1

© 1973 Kyffin Williams

All rights reserved. No part of this publication
may be reproduced, stored in a retrieval system, or transmitted,
in any form or by any means, electronic,
mechanical, photocopying, recording or otherwise, without
the prior permission of the copyright owner.

Printed in Great Britain by
Ebenezer Baylis & Son Limited
The Trinity Press
Worcester, and London

ISBN 0 7156 0730 8

For Anna

Preface

Six years ago Professor Idris Foster, the Editor of the Honourable Society of Cymmodorion, suggested that I should write a brief history of my family. He thought it might be of interest as a record of Anglesey social life during the eighteenth and nineteenth centuries, but imperceptibly it grew into an auto-biography, an outcome that neither he nor I had intended. I have included a few photographs from the family albums, and some of my own paintings, and have added some decorations that appear throughout the text.

I have received much kind advice for which I am most grateful, and among those who have helped me I would like to mention in particular Hilda Vaughan, and Anna Haycraft to whom this book is dedicated. I would like to thank Princess Woroniecki for giving me so much information about the Craig-y-don family and for allowing me to reproduce some of the caricatures drawn by her great-aunt Blanche Williams.

Finally I must thank Mr David Collins for the care and professional skill he has shown in designing this book.

Family Album

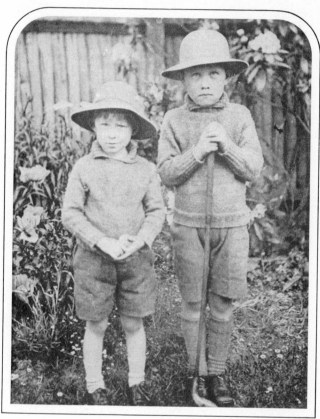

1922: myself aged four, with Dick two years older

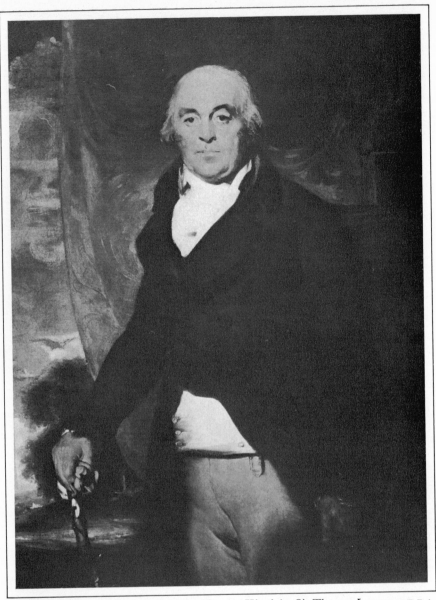

Thomas Williams MP, 1737–1801, the 'Copper King', by Sir Thomas Lawrence P.R.A.

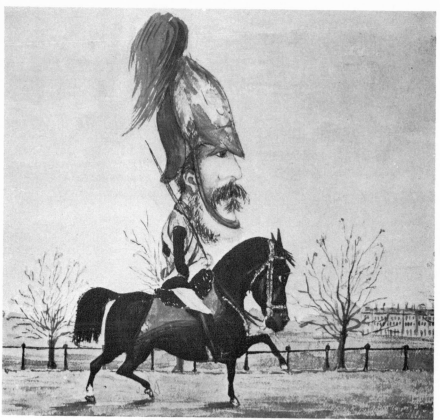

Lt General Owen Williams MP, Royal Horse Guards,
a caricature by Blanche Williams

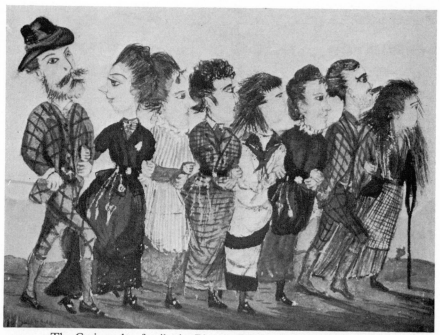

The Craig-y-don family, by Blanche Williams. From left to right,
Owen, Margaret, Edith, Emily, Blanche, Nina, Hwfa, Evelyn

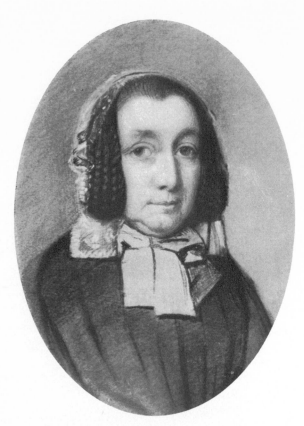

My great-grandmother, Frances Williams

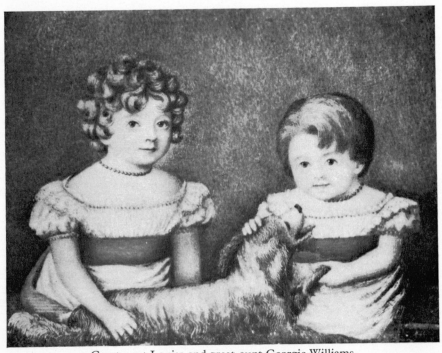

Great-aunt Louisa and great-aunt Georgie Williams

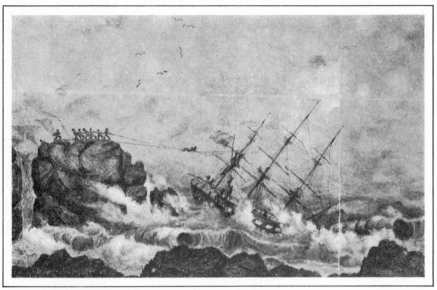

My great-grandfather, the Rev James Williams, rescuing the crew
of the *Active*. From a lithograph by Frances Williams

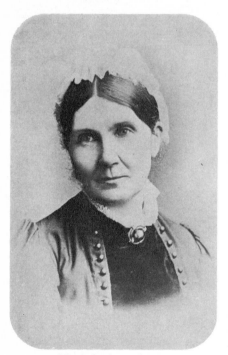

My father's mother,
Margaret Williams (Nain)

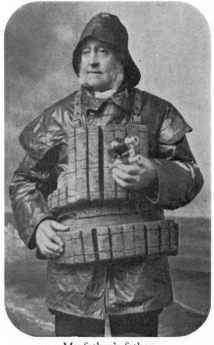

My father's father,
Canon Owen Lloyd Williams (Taid)

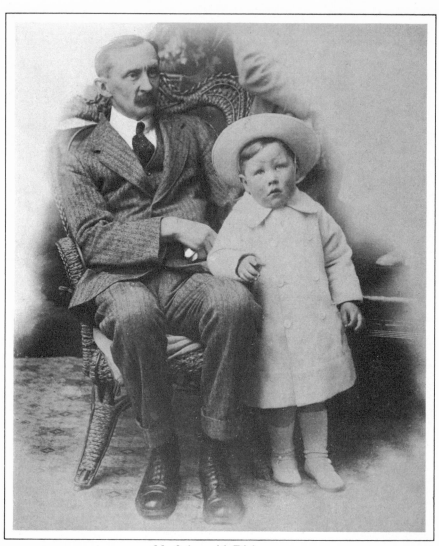

My father with Dick 1920

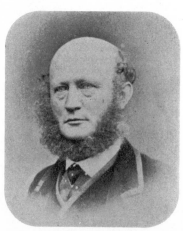

Ben Ellis (the ghost)

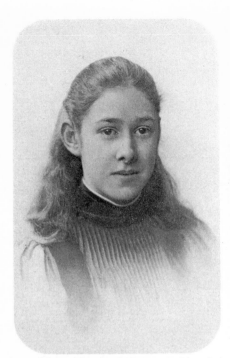

My mother aged sixteen and her father, the Rev Richard Hughes Williams

Aunt Mamie

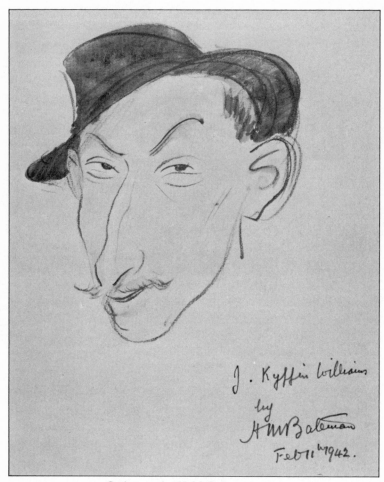

Caricature by H.M.Bateman 1942

Bonzo

Family trees

It is unwise to state categorically that one's pedigree is correct, for often in the past the compilers of such documents have been forced by threats or bribes, to legitimise certain irregularities in order that a family might be able to show to the outside world a line of continual respectability.

Both the Treffos and Craig-y-don families shown overleaf are descended from Wmffre the blacksmith, but whereas it is reasonably safe to assume the Treffos line to be correct, such confidence might be misplaced in the case of Craig-y-don.

the Treffos family

William ap John ap Rhys
of Llandegfan

Wmffre 1661-1752
who took the name of Humphrey Williams
=
Elizabeth
d. of Rev William Prytherch
Rector of Llanfechell

Owen Williams 1698-1786
of Treffos and Tregarnedd
=
Jane Lloyd
of Hendre Howel

Thomas Williams MP
the 'Copper King'
see Craig-y-don family

Rev John Williams 1740-1826
of Treffos
Chaplain to Princess Augusta of Wales
Rector of Llanfairynghornwy
=
Eleanor
d. of Rev James Vincent
Vicar of Bangor

John Williams 1784-1876
of Treffos
Receiver General for North Wales
=
Elizabeth Jane
d. of Captain William Goddard RN

Rev James Williams 1790-1872
Chancellor of Bangor
Rector of Llanfairynghornwy
=
Frances
d. of Thomas Lloyd
of Glangwna, Caernarfon
and Whitehall, Shrewsbury

Rev Thomas Norris Williams
of Treffos
=
Mary Elizabeth
d. of Rev Richard Coetmor Howard DD
Canon of Bangor

John Robert Williams
of Treffos

Sir Ralph Williams
'The Boomer'
Governor of Newfoundland

Colonel Richard Williams

Allured Williams
sold Treffos in 1903

Geoffrey Williams

General Sir Guy Williams

Louisa
=
Sir Andrew Ramsay
'The Geologist'

Georgina
=
Nicholas Spargo

Rev Owen Lloyd Williams 1828-1919 ('Taid)
Chancellor of Bangor
Rector of Llanrhuddlad
=
Margaret (Nain)
d. of Rev John Kyffin
Rector of Llanystumdwy

Captain James Williams
of the Chilean Navy

Ann Frances Williams

Rev Owen Kyffin Williams
Rector of Coedana

Mary Dorothea Williams
(Aunt Mamie)

John Bethune Williams
(Uncle Bob)

Rev John Williams
Rector of Rhoscolyn
=
Elizabeth Ann
d. of Rev Richard Hughes
of Hendre Gwalchmai

Rev Richard Hughes Williams
Rector of Llansadwrn
=
Martha
d. of Rev John Roberts
of Rhiwlas
Rector of Llansadwrn

Inglis

Henry Inglis Wynne Williams 1870-1942
=
Essyllt Mary

Owen Richard Inglis Williams
(Dick)

John Kyffin Williams
(the author)

the Craig-y-don family

William ap John ap Rhys
of Llandegfan
=
Wmffre
the blacksmith
=
Owen Williams
of Treffos

Thomas Williams MP 1737-1801
the 'Copper King'
=
Catherine Lloyd
of Llanfihangel-tre'r-beirdd

Rev John Williams
of Treffos
see Treffos family

Owen Williams MP 1764-1832
of Craig-y-don
=
Margaret Hughes
of Kinmel

Jane
=
Major General Wheatley

Emma
=
1st. Lt Colonel Thomas Knox
2nd. Lt General Sir Henry Campbell

Lt Colonel Thomas Peers Williams MP 1795-1875
=
Emily Bacon
of Benham Park, Berks

Lt General Owen Lewis Williams MP
=
1st. Florence
d. of St George F. Caulfield
of Donamon Castle, Roscommon
2nd. Nina
d. of Sir John Tollemache Sinclair, Bart

Margaret
=
Sir Richard Williams-Bulkeley, Bart

Edith
=
Heneage Finch
7th Earl of Aylesford
'Sporting Joe'

Emily Gwendolen
=
William
2nd Earl of Cowley

Blanche
=
Lord Charles Innes-Kerr

Nina
=
Seton Montgomerie
2nd son of the 17th Earl of Eglinton

Hwfa
=
Florence Farquharson
of St Leonards, Blandford

Evelyn
=
1st. Colonel Henry Wellesley
3rd Duke of Wellington
2nd. Colonel the Hon Frederick Arthur Wellesley

Captain Owen Gwynedd Williams
killed in Matabeleland 1903

I

Like every other man in North Wales, I can trace my descent back to Lludd ap Beli Mawr. The English perversely insist on calling him 'Lud'; they invest him with kingship and say he built London around 120 B.C. If I include the female line, I go back to him on my father's side by way of fifty-nine generations, and on my mother's by sixty-two. This, I believe, makes me her fifty-ninth cousin three times removed.

Genealogical games of this sort can easily be played in Wales, where nobody could own any property unless he was able to recite his ancestors back twenty generations. Pedigrees were of the utmost importance and were carefully preserved.

In the direct male line I can't reach further back than one Wmffre ap William John ap Rhys, who was born in 1666. He was the blacksmith

13

in the parish of Llansadwrn in Anglesey, but I believe he came of yeoman stock settled in the neighbouring parish of Pentraeth, where the family had their own pew in the church.

Wmffre was a lucky man, for outside the smithy on the brow of the hill, where the road starts to wander down to Beaumaris, he found a pot of gold. One day he was having difficulty shoeing a fresh young horse, so he tethered it to the stump of a dead tree. The horse pulled and lunged until finally the whole stump came out of the ground, and there in the hole Wmffre saw a golden bowl.

It is possible that it was buried Celtic treasure, since the field nearby shows undulations that could be the remains of an old burial ground. One day I visited John Owen who lives alone in a cottage built near the site of the old smithy. 'Seen any gold round here lately?' I asked. 'No,' he replied, 'and if I had I wouldn't be telling you: you've had quite enough.'

As some of Wmffre's descendants became immensely successful and wealthy, it has become fashionable to regard the story as made up to show how remarkable was their rise from rags to riches; but in the village the old people believe it, and one old friend of eighty tells me her mother was told of it by her grandmother who was born in the parish at the end of the eighteenth century. Had the story been fabricated it might have been believed across the straits, but not in the parish.

Anyway, Wmffre was rich. He sold the pot, and with the money he bought Cefn Coch, the neighbouring farm across the fields from the smithy. It is a good farm and he did well there. He saved money to build the local almshouses, and instituted charities in the parishes of Llansadwrn and Llandegfan, from which money was distributed every St. Thomas' day to the local poor. Today the rectors are hard put to it to find recipients.

By this time Wmffre was a man of substance and, as was the habit of those days, he was able to dispense with his string of *ap*s and assume a surname. 'Wmffre' became anglicised to 'Humphrey', and he had the choice of following this up with the name of his property or the Christian name of his father. As 'Humphrey Cefncoch' would have been unusual he chose to become 'Humphrey Williams'. He married twice, died at the age of ninety-three and was buried in the churchyard at Llansadwrn, close to the church, in which an inscription records his generosity. Carved in the wood of the lychgate are his initials, H.W.

Humphrey Williams was the first known member of my family to be buried in Llansadwrn churchyard, though since then we have been laid there in such profusion that but for our bones the east end of the

church would probably collapse. It is an ancient churchyard, and evidently superseded a stone circle of past times, which was possibly the source of the huge stones that make up the wall on the roadside near Tynllan.

Humphrey was succeeded by his son Owen, who consolidated his father's success by buying Treffos, the '*plas*' of the parish, and there the family was to live and prosper until the early years of the twentieth century. Treffos is an ancient site and means 'the place with a ditch', so at one time it was probably fortified. It was certainly the property of the old Welsh princes, and on the death of the last Llywelyn, the conquering Edward Plantagenet gave it to the Bishops of Bangor. Nearby in the Bryn Eryr fields there are the marks of an old British fort, while lower down by the river Braint are the square foundations of a Roman camp.

The house is small, and like all Welsh houses of its period it has no view. It was built in the seventeenth century and is surrounded by great rook-infested trees, and everything grows well there. Even the daffodils seem to be bigger than anywhere else.

Owen had two sons, John and Thomas, and with these two very different personalities the family divided. There were the solidly prosperous descendants of John who lived at Treffos, and the wildly wealthy descendants of Thomas who lived at nearby Craig-y-don on the straits, and who, by bursting into the decadent entourage of Edward VII, married into the English aristocracy and spent themselves on the turf.

John, who was my great-great-grandfather, became chaplain to Princess Augusta of Wales at Windsor and afterwards, because of his royal associations, received the Anglesey livings of Llangaffo, Llanddeusant and Llanfairynghornwy. He was successful, but was easily outshone by Thomas, who, with an unusual aptitude for business, cornered the whole of the British copper industry and died an M.P. and a millionaire.

The history of Thomas's side of the family, from their rise in the eighteenth century to their extinction at the beginning of the twentieth, is romantic if somewhat sordid; for from shrewd and solid beginnings they ended a spendthrift lot who worshipped fun and money. Their progenitor, Thomas, would hardly have approved.

Thomas Williams was born in Cefn Coch on 31 May 1737. His father by that time was well-connected and owned several important properties, so when Thomas became a solicitor it was natural for him to have dealings with the wealthy of the island. It was not long before the Rev. Edward Hughes of Llysdulas, whose wife was a relative of Thomas, asked him to act for him in a dispute with Sir

Nicholas Bayley of Plas Newydd, the ancestor of the first Marquess of Anglesey.

Overlooking what was then the village of Amlwch stood the hump-like hill known as Mynydd Parys, and there since Roman times copper had been mined. Part of it was owned by Edward Hughes and part by Sir Nicholas; and the apathy of the former and the greed of the latter caused a quarrel that was to last for many years. Edward Hughes claimed that Sir Nicholas was mining where he had no right to mine and called on the legal assistance of Thomas Williams. Sir Nicholas, unaware of this, also turned to the shrewd young attorney. Thomas was in a difficult position, but he used it with such diplomacy that by 1785 he virtually controlled the Anglesey mines, and Bayley and Hughes had become sleeping partners. He went on to take over the copper mines of Cornwall, and controlled the price of British copper from 1787 to 1792. He built copper warehouses in London, Birmingham and Liverpool, and started smelting works in South Wales, Lancashire, Holywell and Marlow. Later he became M.P. for Marlow and, a mile up the Thames, built a large and elegant mansion known as Temple House. Four generations of the family represented Marlow in the House of Commons.

Thomas provided the copper sheaths for the ships of the British Navy; and after the naval reverses in the American war had been put down to the rotting of the iron bolts that held these sheaths, he initiated the use of copper ones instead. Soon he was sending agents over to the continent and supplying the navies of France, Spain and Holland. One of his most interesting ventures was the production of a token coinage for use in Anglesey, which was so well designed that he hoped to gain the contract for the legal coinage. In this he failed, but Anglesey pennies and half-pennies remain the best-designed coinage of the eighteenth century.

In 1800 Thomas Williams was accused by Pitt of ruthlessly keeping the price of copper at an artificial level. He demanded an enquiry to clear his name, and since he was a member of Parliament this could not easily be turned down. He appeared before his fellow members and acquitted himself with such ability that prices remained as they were. Soon after, his health declined, and he died in Bath on 29 November 1802. He was buried there, but later his body was removed and reburied, first in Llanidan church and later in Llandegfan.

Those, briefly, are the facts of Thomas's successful life, but we know little of his personality. Practically the only human knowledge we have of him is that he suffered from gout. That he was shrewd and able is obvious, and even if the powers in London knew him to be a tough man of business, his honesty was seldom in question. In

Anglesey he was known as 'Twm Chwarae teg', which means 'fair play Tom', and he kept a fatherly eye on his workmen.

He was largely responsible for building the new church in Amlwch, in spite of a continual battle with the Bishop of Bangor. He left a vast industrial empire which years later was to form the nucleus of I.C.I. Soon after his death his son Owen sold his share of the Anglesey mines, but retained control of the Williams Chester and North Wales Bank, which had been started by his father.

Owen married the daughter of Edward Hughes. He was a founder member of the Royal Yacht Squadron, and lived a life of comparative ease. He seems to have been a worthy and genial character: when Telford supervised the joining of the chains of the new Suspension Bridge over the straits in 1820, Owen gave a party for the workmen at his house, provided them with free beer and fired a salvo from his cannon on the terrace.

Owen was followed as M.P. for Marlow by his son Thomas, who commanded a body of men known as the Royal Anglesey Light Infantry. Thomas was a swarthy, good-looking, bad-tempered man who sired a brood of children destined by the extravagance of their living to shock not only the people of Anglesey but London society as well. In his later years he became eccentric and insisted on telling the time by the sun. This caused him to miss many trains at Menai Bridge Station, and his uncontrollable temper often exploded on the unfortunate station master.

Thomas's two sons and six beautiful daughters suffered accordingly, and this may have accounted for their extraordinary behaviour in later life. From family house to family house they moved, in luxury no doubt, but also in continual fear of the wrath of their father. From Temple House, Marlow, they moved to a palatial residence in Berkeley Square, and on to Craig-y-don. Backwards and forwards they went, cowed but amazingly good-looking. The two boys were Owen and Hwfa, pronounced 'Hoover', and the lovely girls who were to break so many aristocratic hearts were Margaret, Edith, Emily, Blanche, Nina, and lastly Evelyn, who was born with one leg considerably shorter than the other, and yet possessed the greatest charm.

Owen was commissioned into and later commanded the Royal Horse Guards. He swiftly pushed his way into the Marlborough House set, and was mixed up in the notorious Tranby Croft scandal; but he found aristocratic husbands for his beautiful sisters, of whom the most wayward was Edith, who drove a four-in-hand of ostriches. She became shamefully involved with the Prince of Wales and the Marquess of Blandford, as a result of which the Prince challenged Lord Randolph Churchill to a duel with pistols on the coast of

France. Her brother Hwfa then challenged Blandford, but no shots were fired in either case, the final word being said by Queen Victoria, who sternly admonished her son: 'What a disgraceful business! The Williamses are a bad family.' I am afraid she was right.

Hwfa built Sandown Park Racecourse on his brother's property, and initiated the Eclipse Stakes. He was a director of the Savoy, Simpson's, Claridge's and the Berkeley. And yet he was too stupid to see that one Florence Farquarson would be a matrimonial menace. He married her and settled down to a life of social extravagance.

One day as he was walking down the Mall he stumbled, put a hand to his left knee and announced, 'I have been shot.' Indeed he had, and on the other side of the road the police found a demented Post Office clerk seated in the gutter, waving a revolver in his direction and mumbling that the man had moved and so he had shot him. The clerk was led away, the victim of overwork in the telegraphic department. Florence was thrilled when four hundred people came to call the next day.

With the aid of the Royal Physician, Hwfa survived to pour yet more money into his wife's eager grasp. The social whirl continued until, worn out with keeping up with her, Hwfa departed this life. Florence wrote a book called 'It Was Such Fun' and continued to live wildly and spend freely. When nearly all the Williams' wealth had gone, she moved to Paris, and died just as the last penny had been frittered away. I suppose one can at least say she made the most of it. Thus the Craig-y-don side of the family disintegrated in a whirl of extravagance, while we, the descendants of the Rev. John Williams, continued to live sober lives on our native island.

2

On the walls of Llansadwrn church is a white marble tablet commemorating the life of my great-great-grandfather and his wife. I always enjoy the phrasing:

> To the memory of the Rev. John Williams of Treffos, for fifty-three years Rector of Llanddeusant. He blended the active discharge of every social duty with a liberality of sentiment, a piety, and cheerfulness rarely united. He died on 5 September 1826 aged 88.
>
> also
>
> of Eleanor Williams, daughter of the Rev. James Vincent and wife of the above John Williams for upwards of 50 years, possessing like him a pious and highly cultivated mind and beloved for every domestic virtue. She died on 30 July 1828 aged 78.

Eleanor was really a Corbet of Ynysmaengwyn, a family descended from the hereditary standard-bearers of the Normans. These big-nosed men were mighty warriors, who for their services to the conqueror were given land in Shropshire. Later some of them moved to Wales. One of my ancestors, Sir Vincent Corbet, disinherited his eldest son and forced him to change his name to Corbet Vincent. The newly-named Vincent moved to Bangor, where he founded a line of clerics who served the church and cathedral faithfully for two hundred years. The last of the Vincent family was Sir William, who was permanent head of the Indian Civil Service in the 1920s. He was tall and like all his family had a monstrous beak. We called him 'Bill Bluenose'.

With John Williams began our association with the far north-west

corner of Anglesey, and there is hardly a parish in the square of Amlwch, Llangefni, Holyhead and Llanfairynghornwy in which we have not held the living at some time in the last two hundred years.

When George IV landed at Holyhead in 1821, old John was among the welcoming throng on the quayside. Recognising him from his days at Windsor, Prinny greeted him warmly and asked whether there was anything he could do for him. John said that he would die happy if his son could succeed him at Llanfairynghornwy. The King agreed, and ordered the Bishop of Bangor to see that his wishes were obeyed. That son (my great-grandfather James Williams) was a clever, good-looking man and a devout Christian. He was made a fellow of Jesus College, Oxford, in 1813 and took his B.D. in 1820.

James Williams had very wide interests. He was chaplain of the Anglesey Hunt and also secretary of the Druidical Society of Anglesey, and he was well known for his broad religious views. The *Dictionary of Welsh Biography* says he was a 'clerigwr bonheddig, da iawn ei fyd, o'r hen stamp oedd James Williams, ustus heddwch, a gwr hynod fawr ei barch', which means roughly that he was a good sound fellow.

James married Frances, daughter of Thomas Lloyd of Glangwna Caernarvon and Whitehall Shrewsbury, a highly intelligent girl who brought some culture into the family. She was born in 1798. She painted well, studied astronomy and had a passionate interest in shipping—she is said to have charted the Menai Straits before she was twenty-one.

As a bride, Frances began her long association with the sea when she came to her husband's rectory at Llanfairynghornwy, where the waves race and roar, and jagged reefs, such as the Harry Furlongs, wait to rip open the bottoms of the ships that pass between the Skerries and the mainland. There were continual disasters, the first of which occurred as soon as the couple arrived back from their honeymoon. A packet boat, the *Alert*, struck the West Mouse rock and, buffeted by the racing tide, gradually broke up. It was a calm clear day, and James and Frances watched with horror as the boat disappeared with 140 people on board. There were only seven survivors.

Whether the thought came to them simultaneously I do not know, but from that moment onwards they were determined that there should always be boats ready to prevent such disasters. James exhorted the local gentry; Frances started a fund to buy lifeboats and reward those who saved lives, and made lithographs to raise money. The Anglesey Lifeboat Association was founded just as Sir William Hillary began to think about the National Lifeboat Service, and James was made the organising secretary. The first boat was presented by the Association and stationed below the rectory in the sheltered

bay of Cemlyn. This was close to the Skerries, the West Mouse, and the Harry Furlongs; and James became its coxswain, while the farmers of the parish provided the power.

Many times must James have leapt on his cob and cantered down to the lifeboat house, to sweep out into the wild Irish sea, while his parishioners heaved on the oars and drove their boat into the dreaded North wind which sent so many ships on to that rocky coast.

Sometimes he went alone, as when the *Active* of Belfast grounded on the rocks at the entrance to Cemaes Bay. It was a rough day and no boat could be launched, but my great-grandfather was obviously a resourceful character, for it is said that he managed, with the assistance of his horse, to throw a grapnel into the bowsprit shrouds, and, with this firmly secured, a boat was pulled over to the breaking ship. It sounds very unlikely, and it is difficult to imagine what part the horse played, but the crew was saved and James was awarded the Gold Medal of the National Institution.

James was obsessed with his life-saving. He designed and built lifeboats at Holyhead, and also made lifebuoys and rocket equipment. When the *Sarah* went aground near Aberffraw the same year as the wreck of the *Active*, James happened to be there to get a line to the masthead. Frances made a drawing of the rescue, lithographed it, and sold the copies. Sometimes she took a more active part in rescues. When the men of the Skerries Light were sick, she accompanied her husband through the heavy seas to nurse them and bring them back to the mainland for medical attention.

By the time the Anglesey Association was taken over by the Royal National Lifeboat Institution in 1856, something like four hundred lives had been saved.

In that remote parish James and Francis reared two sons and two daughters—Owen, my grandfather, and Inglis, and Louisa and Georgina. Their nurse and their mother's constant companion was Frances Louisa Brown, a vague figure who became one of the family, and who shared my great-grandmother's interests. While Frances has a drawing in the National Library of Wales, Frances Louisa has a flower study in the National Museum in Cardiff. The rectory must have been a strange cultural cell in that bleak countryside; all the latest books from London came to fill the library, and the children were taught to paint and play the harp.

Their visit to London in 1840 was filled with lessons, musical and artistic, and Louisa, who, I feel, was a bit of a blue stocking, made professional notes after a visit to the shipping in the docks. While Frances lithographed and learned to model in wax, Louisa and Georgie had harp lessons and, judging from their diary, seemed to

spend a great deal of their time purchasing envelopes. They visited the Zoo at Kennington, where Georgie saw some monkeys, which she wrote were 'tolerably ugly (pretty I mean), but the greater number were very ugly indeed'.

There were several visits to the Royal Academy to see George Jones, the Academician, and to watch him at work. As Frances Louisa Brown wrote, 'Georgie went to Willie's rooms to dance and Louisa and I visited Soho bazaar and thence to the Royal Academy and called upon Mr. Jones and sat half an hour watching him painting. Immediately afterwards we set off to Exeter Hall to a concert of ancient music and returned before midnight highly delighted. There were upwards of 500 performers and more than 2,000 listeners.' The family worked hard; but their visit had to last them a long time, and it must have been an exciting change from their quiet windswept home in far-off Anglesey.

Louisa married well. Andrew Ramsay, a geologist, who later became the Director of the Geological Survey of Britain, was prospecting in North Wales and had an introduction to the family at Llanfairynghornwy. He was an intelligent and industrious Scot from Dundee who, with his director, De la Beche, did much to unravel the intricate pattern of British geology. Anglesey, with its varied rocks, was a natural place for him to go, and while at Capel Curig in October 1849 he wrote to a colleague '. . . we had a short rap at Anglesey at very old rocks—older than Cambrian'. It was an historic entry, for it was the first record of the existence of pre-cambrian rock.

Andrew and Louisa led a full life, travelling widely in Europe on geological expeditions. After Andrew received his knighthood, they returned to Beaumaris, and when they died they were buried with the family at the east end of Llansadwrn church, under an immense rough-hewn boulder of Welsh granite. They had four daughters and one son, and I was to see a lot of them when I was a boy.

For Georgie, there was romance, misery and an early grave. One winter in 1848, a Cornish mining adventurer called Nicholas Spargo arrived in Anglesey to make his fortune out of the dying copper mines. We were always told he was tall, sallow and unscrupulous, that he rode a black stallion, and already had a wife and family in Cornwall. He met Georgie, who was captivated by his dark Latin features. Her father said that if she had anything to do with him he would never speak to her again: I am sure Great Uncle Nick must have been pretty awful to inspire such feelings in the mind of the gentle Rector.

But Georgie was madly in love, and one dark night when the satanic Spargo, mounted on his stallion and carrying a ladder strapped across his back, arrived below her bedroom window, she was quite ready to

fly with him. They eloped, but only to a rough cottage nearby. There, ignored by her father and beaten by her drunken husband, she must have lived a terrible life. Soon she too took to drink, and two years after leaving her father's home she was dead. Her father had carried out his threat and had never spoken to her.

Nicholas Spargo is still remembered in Llanfairynghornwy, where he lived until his death with his third wife, who is reputed to have been his grand-daughter. As small boys my brother and I were led to the small and infamous cottage to be shown some hideous stains on the floor. These, we were told, were made by the effusion that seeped from Great Uncle Nick's coffin as it lay on trestles awaiting burial. He was certainly sinister to the end.

Georgie's brother Owen, my father's father, was, like his father before him, Chancellor of Bangor Cathedral. He was an incorrigible leg-puller, and years after his death, when I was calling at a farm in the parish and explained that I was a member of the Rectory family, the old farmer said: 'Dduw no, not the old Chancellor's grandson?' Then in his slow Anglesey voice he told me how, long ago, my grand-father had told him an unforgettable story.

'Well, well, well,' he said. 'I remember him on the road above the rectory, telling me of the time when he was hit in the eye by a ball at school. How they was take him to hospital, take his eye out and put it on a plate in front of him and how he was see as well with his eye on the plate as he could with it in his head.'

He followed his father and grandfather to Jesus College, Oxford, and, when he had graduated, naturally went into the Church. It was when he was curate of Portmadoc that he met and married Margaret Kyffin, whose father, the Rev. John Kyffin, was the rector of Ynyscynhaiarn.

Margaret came of an old Montgomeryshire family, whose name derives from the Latin 'confinium', meaning a 'boundary' or 'border'. In the fifteenth century it was to a farm of this name that one Madoc ap Madoc goch ap Evan ap Cuhelyn went as a child to be nursed. He took its name as a surname, and became the progenitor of wild, passionate men and women. Morys Kyffin, the bard, was one, and Roger Kyffin, a pirate, another, while from Maenan in the Conway Valley Sir Griffith Kyffin terrorised the neighbourhood until he was dealt with finally by the Court of Star Chamber. The name has been spelt in many ways, sometimes Cyffin, or even Cyffyn, but in old Welsh the K was used, so the family has reverted to the original spelling. The name of Edward Cyffyn is carved in the Beauchamp Tower of the Tower of London. He was on the jury which was instructed by Bloody Mary to bring in a verdict of guilty on a

certain prisoner. The jury refused to a man and were consequently incarcerated in the Tower.

We always referred to our paternal grandparents in the Welsh form of 'Taid' and 'Nain'. Nain was the gentlest of all the Kyffins. Like her mother-in-law, she had to suffer the continual absence of her husband, for Owen, like his father, was dedicated to saving lives. He had gone out as a boy in the old Cemlyn lifeboat, so he knew how to master the rough seas. He had suffered as the oarsmen suffered in those days, when on reaching shore the ice had to be broken away from the hands that held the oars.

Taid's first parish was Boduan in West Caernarvonshire. Boduan is in the middle of the Lleyn Peninsula, a parish of woodland and bog dominated by Garn Boduan, a rocky lump, wooded on one side and with a group of old British stone dwellings near the top. From there you can look north to Anglesey, east to the Snowdon range and south to Cardigan bay; while to the west the peninsula stretches like a hoary finger to Aberdaron, pointing seawards to the distant Wicklow Mountains.

The parish was well suited to my grandfather, for he could look after the Porthdinllaen lifeboat on the north coast and the Abersoch lifeboat on Cardigan Bay. And once in the middle of a sermon a man ran down the aisle to tell of a ship in distress off Nefyn. Taid followed him out to his waiting cob and cantered away into the night. Sometimes he would return to one lifeboat house only to be summoned to the other, for a parson at the helm meant a lot to the superstitious crews.

When he first came to Boduan in 1862, a great storm drove fourteen ships ashore at Porthinllaen. The locals stood on the cliffs and watched and waited to make their gruesome pickings, as one by one the sailors were swept from the rigging and drowned in the boiling sea. Taid railed at them and cursed them, exhorting them to help him save the sailors. They, surly and listless, wished him in hell and continued their greedy watch. Two men only joined him and with their help he saved twenty-four lives.

One January night in 1870, after trying to launch the lifeboat for four weary hours, he eventually left the bay at Abersoch and rowed out into the gale and the darkness to the help of the *Kenilworth* of New York, hard aground on St. Patrick's Causeway. This was a shallow bank off Llanbedr that was a constant danger to shipping off the Merioneth coast. The *Kenilworth*'s main mizzen masts had gone and only a part of the foremast was standing when the lifeboat reached her. The captain and thirteen of the crew were rescued, but three weeks later the captain died, it is said, of a broken heart.

It was nine miles from Boduan to Abersoch, and it took many hours for the lifeboat to reach the Causeway; sometimes it would be out and standing by a vessel for twenty-four hours.

Four boys and two girls were born in the vicarage. James, the eldest, went to the *Conway* training ship, and Kyffin became a parson and died young. John Bethune, or 'Bob' as he was known, also went to sea, and spent most of his life as a captain of boats sailing to South America, where he and Uncle James, true to their rebellious nature, fought for the revolutionaries in Chile. My father Harry was the youngest. Annie and Mamie were the two cheerful girls. Annie, like Kyffin, died young, but my Aunt Mamie, naughty, improvident, brave, and lovable, was one of the great characters of my youth.

In 1878 the family moved back to Anglesey, to Llanrhuddlad, the next parish to Llanfairyghornwy. The contents of Boduan rectory were loaded on to a sloop at Porthdinllaen and landed at Cemlyn, to be transported by farm-carts over the Garn to the new home.

An elderly relative once told me that Taid met her one summer at Valley station and drove her at a smart pace to the foot of the hill below the rectory where the pony stopped outside a cottage and refused to move. Taid seemed to accept this as normal and casually shouted from his driving seat: 'Maggie Jones, Maggie Jones, send out the pig!' The cottage door opened slightly and out shot a small pig. At great speed it bolted up the hill, followed furiously by the pony. The race continued until they arrived safely at the rectory door.

Taid had a huge telescope fixed in the window of his study, and there he sat and searched the Irish sea for shipping, and maybe at times observed the behaviour of his parishioners too. He was well placed, for across the bay, tight under the crouching mountain, was Holyhead harbour, and a constant flow of boats of all kinds went to and from Dublin.

He must have been a clever man, although we were never brought up to believe so. The present rector has some of his sermons and tells me that they are far too erudite for any congregation today. However, it is mainly as a benevolent and respected character that he is remembered. He dispensed advice to church and Nonconformists alike. The old people in the parish say that he would never pray for rain until the wind had veered to a favourable quarter.

He solved problems in the simplest way. When Lizzie Jones arrived in tears at the rectory, complaining of the continual abuse of her neighbour, 'Cock her a snook' suggested my grandfather. A few days later Lizzie returned. 'I did, Chancellor,' she wailed, 'and she still calls me dirty names!' 'Then cock her two snooks and waggle your little finger!' replied Taid. There was no more trouble after that.

In church he was a law unto himself; he leaned against the window so that he could watch the ships sailing by. 'I gristnogion o bob enw,' he would always start his sermons, implying that it was immaterial to what denomination he addressed himself. Christians were all alike to Taid, and he was a great friend of John Williams, Brynsiencyn, the famous Nonconformist preacher. He altered the Prayer Book whenever he wished. 'May the Lord have mercy upon you, you miserable sinners,' he would intone. He never included himself.

Everything at the rectory was easy-going. Taid sold what was left of his property, but even so there was little money for luxuries. He refused to dress as befitted a clergyman in those days, and instead of the white dog-collar, he wore a white paper bow-tie that had to be made each morning by one of his children. He was tall, bewhiskered and untidy, and the blind eye added to his unusual appearance. But in the rectory, under the gentle and efficient supervision of Nain, all was well-organised and tidy.

Taid made his last heroic gesture at the age of eighty-five. Hearing that the Royal National Lifeboat Institution was determined to move from Cemlyn what he considered to be the family lifeboat, he decided on action. He, more than anyone, knew how easy it was for ships to be lured and broken on the Harry Furlong reefs, and how vital it was to have assistance near at hand. So, armed with a marlinspike, he boarded the train at Valley, and in London, at the headquarters of the R.N.L.I., he brandished this fearful weapon before the astonished eyes of clerks and officials. The militant cleric must have been an awesome sight as he roared that only over his dead body would the Cemlyn boat be moved. Evidently he made his point, for it was not until a week after his death, five years later, that the lifeboat was moved to Cemaes.

Harry, my father, had been delicate ever since his nurse allowed him to fall out of his pram as a baby. He broke his leg, and the nurse, fearing the wrath of my grandparents, said nothing, so that the break mended itself and he grew up with one leg shorter than the other. This didn't prevent him driving wildly down the lanes of Anglesey in dog-cart, brake or tandem. The harness was probably done up with string, but this mattered little, and, swaying and bumping, the four brothers careered through the neighbouring parishes.

Aunt Annie conceived the unusual idea of going in for domestic science. This was considered socially degrading at the time, but that didn't worry Annie, who went up to London and thoroughly enjoyed herself, cooking and organising banquets, until she died in her early thirties. Aunt Mamie was frail, but equally irrepressible. She was born with a crooked spine, but ignored the advice of her doctors to

take life easily. She had a lovely soprano voice and was trained as a singer in Brussels, though her incorrigible gaiety prevented her from taking it up seriously.

As my father was so delicate, it was many years before he took a job. In the meantime, he stayed at home, and in a small cottage on the slopes of the Garn learnt how to master the hammer and chisel. In this cottage he did some beautiful carving, and he continued his craft wherever he went in later life. In his early thirties his health improved, and he decided he should earn some money. Our wealthy Craig-y-don relations had recently sold their Chester and North Wales Bank, but nevertheless it was assumed that banking was in the blood, and my father joined the North and South Wales Bank.

Nobody could have been less suitable for such a job, but the governors, evidently working on the theory of make-or-break, gave him a revolver and a small terrier and told him to open a branch in Penydarren in the Rhondda.

My father succeeded amazingly. The locals, unused to such an open and generous person, took to him immediately. He liked them and to show his appreciation carved an altarpiece for the local church. When he moved to Portmadoc he left a sad community behind him.

My father's greatest asset was his ability to get on with people. Completely and naively oblivious of class, he enjoyed speaking Welsh whenever he could and was as at home in the cottage as in the *plas*. He couldn't believe that anybody was capable of a dishonest or injurious act, and so was continually disillusioned. But always the unworthy would be forgotten, and my father would take up once again his blissfully open attitude to life. Maybe this helped him in the bank, as his honesty was obvious to everyone.

He was tall, moustached, and very good-looking, and as he had such a lovable nature it is surprising that he didn't marry until comparatively late in life. When he finally got round to it, he chose the little girl from the next parish, Essyllt Mary, the daughter of the Rev, Richard Hughes Williams.

As my father's father was known to us as 'Taid', my mother's father, the Rev. Richard Hughes Williams, was known as 'Grandfather'. His father, the Rev. John Williams of Rhoscolyn, had been born in Llanddewibrefi in Cardiganshire, and had come to the north to be vicar of Llanrhychwen above the Conway Valley. His mother was a Hughes of Hendre Gwalchmai, in Anglesey.

To my grandfather life was a struggle, and this he recorded in his diaries from 1861 to his death in 1902. They are gloomy, monumentally boring and filled with continual references to the state of his health. The words 'poorly', 'seedy' and 'bilious' recur monotonously,

and from as early as 1865 he seems to have suffered from a bad throat. There is very little cheer to be found in the voluminous pages, and he hardly ever offered an opinion. Nevertheless, he was obviously a most dutiful parson, continually visiting, reading to the sick, attending wakes and comforting the dying in his parishes at Llandrygarn, Llansadwrn and Llanfaethlu.

In 1870 the initials M. and M.R. begin to appear, and it is clear that while at Llansadwrn he fell in love with Martha Roberts of Rhiwlas. On 4 February 1879 occurred the most delirious entry of the whole forty years. 'Went to Rhiwlas. Took M.R. to Vrongoch (won her, thank God). The happiest day hitherto of my existence.' But on 15 September of the same year there is the simple unemotional reference: 'My wedding day.' There are several mentions of my grandmother, invariably as 'poor Mattie', and pitiable indeed she was, as she suffered continual attacks of migraine, confined to a dark room with her head swathed in brown paper.

On 1 July 1883, the arrival of my mother into the world takes second place to the weather with: 'Showery. Little girl born at 12.30 p.m.' And he showed more joy when one of his cows called Blackan calved ten days later. On 7 November 1878 he 'rode roan filly to meet of hounds at Fourcrosses—came to grief'; and twenty years later 'Robert Roberts mowed hay in Cae Laundry and Cae Jericho', both entries being underlined with unusual ecstasy.

At the end of each year he settled down to a heavy session of gloom. On Sunday, 31 December 1865: 'No sermon, owing to my throat. So ends a sorrowful year for me. My poor mother's death; Jack's, Harry's, Annie's, Mary's illness—and my own bad luck.' On 31 December 1891 he is unusually forthcoming and mysterious: 'The year 1891 has been, as far as weather is concerned, wet, dull and dismal: and for myself personally, my heart is sore and weary—much annoyed with the unjust aspersions of an unscrupulous calumniator, and yet I have much to be thankful for. Life is short and may I be ready when the end arrives. At present it is somewhat dark. Lead kindly light and guide me in the way I should go for my great Master's sake, amen.'

Nobody has been able to find out who his enemy might have been, and no further mention was made of any such trouble. In 1899 there are further worries: 'This ends 1899 with a very gloomy prospect owing to the Transvaal war. This ends the year and century not unattended with many sad events in family, parish and kingdom. God grant us more peace and prosperity in the future.' Remarkably, his final entry in 1902 was in comparison lighthearted: 'Memorable year, begun in war—saw King's illness and restoration to health;

peace and prosperity, coronation: passing of Education Act. Death of Archibishop Temple and the Bishop of St. Albans.'

Just as I later found that Taid was a man of greater depth than I had previously supposed, so I have also heard that my grandfather could be 'such fun'—something that hardly comes through in his diaries.

As he had a son and a daughter to educate, my grandfather felt he had to accept the better living of Llanfaethlu, knowing that to move his wife from her home would kill her. They moved and she died. He was a lonely man in his last parish; he failed to understand my happy-go-lucky Taid, in the adjoining parish, and often accused him of poaching his parishioners. I have a feeling that the cheerful, eccentric character of Taid naturally attracted the good people of Llanfaethlu to his church at Llanrhuddlad.

His son Owen won a scholarship to Westminster, but did no more than marry a local barmaid and spend his life in a brewery in Manchester. My mother, the product of this melancholy hypochrondriac father and a neurotic mother, was small, vital, insecure and apprehensive. She lived alone with her ailing father in the old rectory above the sea. She worshipped him unnaturally, and when the time came for her to go to bed, she would creep upstairs, terrified of being alone. Instead of going to sleep, she knelt on the landing, her small frightened face peering through the railings at the beloved figure of her father, who sat, neat in a smoking jacket, in the hall below, unaware of his daughter's sensitivity.

He decided to send her to school in London, so she entered Camden School and boarded at the hostel, where the only other girls went to the superior North London Collegiate. It was cruel and insensitive of him, and not surprisingly she ran away; after that her only education came from governesses. As a girl, she had to play the part of hostess for the rector, and at a parish tea one day a farmer told some particularly earthy story. It wounded her sensitive mind, and after that she believed all Welshmen to be vulgar. Fifty years later, I had to warn my visiting friends that this was the first thing my mother would impress upon them when they entered the house.

Her father's death when she was eighteen must have shattered her. She went to live in Bangor with an old aunt, Agnes Roberts, who imposed a rigid discipline. Some of her vitality was spent playing golf and hockey, but most of it was forced inwards to gnaw and fester so that she lived in a world of unreality and fear.

She was related to several of the old Anglesey families, and from her Trescawen relations she inherited a family diary of 1682 containing estate accounts, deeds, improbable cures for unmentionable

diseases and, in beautiful brown ink, instructions for the catching of a witch. It runs as follows:

Of a horse that is witched.

Take the heart of a horse that is by a witch killed; take it hot out of him and strike a nail through it; then broil on the coals or on a spit rost it; and the heart of the witch shall be so tormented with heat and pain, that she will come in all haste to the fire and use all means to take away the heart.

Whereupon, I suppose, you threw a sack over her head and despatched her.

Essyllt Williams, by reason of her awareness of her isolation, was a figure apart. Her uncle's family at Rhiwlas had never been allowed to visit the rectory at Llansadwrn, as Mrs Rice Roberts considered a parson's to be a lowly profession, and later my mother was never allowed to stay with them when dances were held in the old house. She had to stay in a small cottage near the shore.

She was related to the Pritchards of Trescawen, and through them to the Hampton Lewis family of Henllys, but those strong, hard-hunting girls and my mother had little in common. Their maternal uncle, George Pritchard, had won the Grand Military Gold Cup on one of his own horses and was probably the most notable shot of Edwardian times. His most remarkable feat was accomplished on one of the Trescawen bogs, when he shot 365 snipe in 365 consecutive shots for a wager of 365 pounds.

By the time my mother married at the age of thirty-four, she had assembled a strange mass of inhibiting ideas. Desperately concerned with doing the right thing, and always conscious of what people might think of her, she only succeeded in doing nothing. My father must have given her the stability she needed. I never in the whole of their time together heard an angry word pass between them, but I doubt if there was any real love. Her past had closed the door on her emotions and only apprehension and occasional anger would creep through the cracks. She was a brilliant housekeeper and wonderful cook, and my brother and I were preserved like porcelain figures. Were we to do this, we would die of pneumonia, and were we to do that, assuredly we would break our necks. She slaved for us interminably, but never do I remember a cuddle or a kiss. Such things were not done, or perhaps she was incapable of doing them. For affection I would climb on to my father's knee, but to hazard such a thing with my mother would have been unthinkable.

The Williams family continued to live at Treffos, even though the

younger sons were away ministering to the parishes of Anglesey. My great-great-grandfather, who had so many parishes to look after, always lived there, and James, my great-grandfather, was born in the old house. John, his brother, was a notable figure in the county and Receiver General for North Wales; like my great-grandfather, he was educated at Eton. This gave him particular prestige in the island, and once a letter addressed to 'John Williams, Wales' was delivered safely. He was one of the few founder members of the Anglesey Hunt Club and later became Father of the Hunt: indeed the Anglesey Harriers were at one time kennelled at Treffos.

John's grandson, Ralph Williams, was one of the more adventurous members of the family. Son of the rector of Aber, he so embarrassed his father by his undisciplined behaviour that he was packed off to Australia with £100 and told never to return. He returned, and was given another £100 and dismissed to South America with the same instructions. There, in Patagonia, he flourished, lived with the Indians of Punta Arenas on the Straits of Magellan and hunted with the bolo on the Pampas. Money ran out; once again he returned to North Wales and once again the rector got rid of his embarrassing son.

This time Ralph went to South Africa, and having arrived at the age of discretion got married and settled there. He became friendly with such varied people as Cecil Rhodes, Selous and Lobengula, King of the Matabeles, and prospered to such an extent that he ended up as Commissioner of the Bechuanaland Protectorate. Governorship of the Windward Islands and Newfoundland followed, until he returned to his triumphant retirement in Beaumaris, with a knighthood and a woman other than his wife. I remember him as a menacing figure in broad checks, a sombrero and a heavy drooping moustache. We always knew him as the Boomer.

His son, Geoffrey, seemed to be mentally unbalanced. This was understandable, as his domineering father had dragged him at the age of six with his mother to the Victoria Falls. No white woman or child had been there before, and the journey was made in a sixteen-ox wagon with the family crest emblazoned on the side. Ralph nearly died of fever; they ran out of water and were finally captured by a Matabele impi with the blood-lust fresh upon them. They had just performed some particularly revolting and memorable massacre, and seemed inclined to carry out yet another. But Ralph knew Lobengula, and Lobengula had given them his pass. The bloody warriors lowered their assegais and the Williams wagon rolled safely into Kimberley.

Geoffrey was also a snob. He arrived in Anglesey from his farm in Kenya, obsessed with the idea of buying Treffos, which had been sold twenty years earlier, so that our family might appear as suitably as

possible in *Burke's Landed Gentry*. With great energy he canvassed the male members of the family, impressing on them the desirability of such a distinction. I am happy to say we proved both apathetic and unco-operative. Geoffrey was outraged. He failed to persuade the owner to part with Treffos; she almost had to call on the local police to remove him; so he bought Brynhyfryd from my mother, and under that name he finally achieved his ambition. As the Williamses of Brynhyfryd we resided briefly between the red-bound covers of *Burke's*.

Geoffrey's campaign was over. He had won a small victory over the natives who had proved to be so unfriendly. Disillusioned, he returned to Africa and changed his name to Howard.

It was his cousin Alured who had sold Treffos. He had become a barrister in London and lost his money because, I am told, he only accepted briefs to defend beautiful and impecunious women. No money was forthcoming to keep the old house in good repair, so in 1904 the family left Treffos after a hundred and fifty years.

3

I often wonder whether my mother really wanted a second child, for in my elder brother she had, by sheer will-power, produced a replica of her beloved father. She even had him named after him, although my father, joking, insisted he had called him Dick in memory of his favourite horse.

In later years it gratified my mother to see how Dick grew yearly to look more and more like her father, whereas I, fair and skinny, seemed to be a youthful member of the other side of the family of whom her disapproval was rabid. My father must have realised that he was always second best, and that the presence of his father-in-law haunted our home, guiding my mother's every action.

I was born on Ascension Day, 1918, in Tanygraig, a small and pleasant house on the outskirts of Llangefni. Perhaps the initial shock of my arrival was too much for my mother, for I was immediately despatched to a nearby farmer's wife to be fostered. After a while my mother demanded my return, and I was brought back to Tanygraig for my christening. Relations from Rhiwlas and Tregayan arrived in their carriages drawn by grey horses, and in this splendid cavalcade I was swept through the streets of Llangefni to the church. Taid took the service, at the age of eighty-nine; he remarked that I seemed a nice, clean little boy and died soon after. It was only the second time he had conducted a christening service in English, the first time being two years earlier when he performed the same ceremony for my brother.

Back at Tanygraig, a professional nurse called Nannie Regan now ruled the nursery, and her calm efficiency eased the constant apprehension of my mother. But even in the best-run houses accidents are apt to occur, and one morning Dick, in an unusually violent moment, threw his nurse's knitting out of the first-floor nursery window. At the early age of two he had a well-developed sense of what was right and

what was wrong, and recognising the enormity of his crime he was determined to make amends.

He struggled, heaved, pushed, and eventually squeezed his fat little body between the bars covering the window. Seeing the knitting far below on the gravel path, he launched himself from the windowsill. His descent was broken by the roof of the porch, from which he bounced downwards to land, unharmed, on the gravel, between the knitting and an iron foot-scraper.

My mother's anxiety for our safety must have increased after this episode. Luckily for her, the incident curbed my brother's pioneering spirit. Over forty years later, when I suggested that he should go abroad for a holiday, she reprimanded me ferociously for even thinking that he could go abroad alone.

Early in 1919 my father was made manager of the newly opened branch of the Midland Bank in Chirk, close to the English border. Chirk was a pleasant village in those days, still complacent for having bred Billy Meredith, the famous Welsh footballer, and comfortably placed beneath the ancient castle of the Myddleton family, then tenanted by the unusual Lord Howard de Walden. We moved, first to lodge in a farm, and then to take up residence in the Old Rectory, a house of considerable charm within walking distance of the bank and the beginning of the gentle Ceiriog Valley.

It was in the Old Rectory that I first knew fear. We had been given a book of English fairy stories illustrated only too effectively by Arthur Rackham. Page after page of horror met me. On one page the giant Cormoran towered over a village, a clutch of screaming peasants tied to his great belt by their necks. On another they hung by their hair from hooks in his larder, with eyes protruding from their contorted and emaciated faces. The giant had come into our house, and round every corner I expected to meet him, to be grabbed and swept away to that fearful larder. The top storey of the house was the most terrifying to me, for I felt certain that he lived up there, and I would clutch our nurse's hand and huddle against her whenever we went there. I never told her why.

When I was about four years old I did my first drawing. It was an unskilful rendering of my brother sitting on his pot; but feeling rather pleased with it I took it to my mother. The result was terrifying. In a second she changed into a mad thing, her eyes shone with ferocity, and picking up a tortoiseshell hairbrush she threw herself at me. 'Ah you nasty little thing,' she screamed, 'ah, you dirty little boy; ah, ah, ah, take that, take that and that!' and the blows seemed to hit me everywhere. The physical pain I forgot soon enough. But I never forgot the demented figure who was my mother, changed so swiftly, so

unaccountably, into another being. Nobody could tell me why. Evidently I had sinned most terribly.

If Dick or I wanted to go to the lavatory, our request always had to be camouflaged in such a way as to avoid embarrassment. We were told to refer to it as the Poogeally. It was quite a nice name, so we used it readily enough, and it was only many years later that I discovered it was really the French 'Puis j'y aller?' which my mother had introduced in order to bring decorum to so humble an act.

Always conscious as she was of the vulgarity of the Welsh nation, and haunted by the thought that we might pick up a Welsh accent, our mother may have been pleased by the move to Denbighshire; for Chirk was Anglo-Welsh. Nannie Regan had gone, to be followed by a series of Welsh nurses, none of whom was allowed to speak a word of Welsh in the presence of my brother and myself. Annie and Janet from Penrhyndeudraeth, and my dearly beloved Susan from Chirk, all received my mother's firm instructions, and the only Welsh we ever heard was when we went to my grandfather's old parish of Llanrhuddlad for our summer holidays.

Llanrhuddlad and Llanfairynghornwy were a fairyland to a small boy, and everywhere I felt the presence of my dead forebears. Taid seemed to be everywhere and the faces of everyone, Church and Nonconformist alike, lit up at the mention of his name. Ten years, twenty years after his death, he was still the old Chancellor, and his memory was worshipped in the parish. Old men and old women would tell endless stories of Taid and Nain.

We used to visit farms for crempog teas and I used to eye the huge pot of melted butter, in which lurked the small round pancakes, with apprehension. I knew I could never eat enough to satisfy the farmer's wife, and always when I had consumed about six I could take no more. Unfortunately one's manhood was judged by one's capacity to down a vast number of crempogs, and I always failed abysmally in the eyes of the parish.

'Well, well you are no good,' complained one old body. 'Your father could do twelve, Master Johnny could do twenty and your grandfather twenty-four.'

I was humiliated and hardly a member of the rector's family anymore.

'Dduw, Master John, only six? Well, well you're hopeless.'

There would be laughter and cheerful goodbyes, but I crept away, a six-crempog boy.

It was a glorious place for a summer holiday. Gentle farms, and steep cliffs covered with gorse and heather; and in the spring the grassy slopes above the sea were coated with sea pinks and a pale blue smoke of

delicate scilla. Narrow lanes dived between high grass-topped banks that hid the gentle munching Welsh blacks. The noise as they invisibly tore the sweet grass conjured up images of strange beasts. Sometimes they were elephants or buffaloes, bison or prehistoric animals.

The farm we liked best was Swtan. Everything was thatched there, the outbuildings, the pigsties and the squat little farmhouse with its mighty tower-like chimney at one end. 'Swtan' is a strange name, and long ago it used to be called 'Swittan', which reinforces the legend that Suetonius Paulinus landed there, for the 'W' is pronounced more forcibly in Welsh than it is in English.

When we stayed at Llanrhuddlad, old Hugh Jones lived there, as he had when my father was a boy. He was in his eighties when I knew him, a tall dignified figure with an iron-grey beard that emerged from beneath a black trilby hat. He farmed the few acres and fished in the bay below.

I remember one evening he took Dick and me out into the bay in his boat, and there, gazing towards the shore, he gave what amounted to a running commentary on the landing of Suetonius from his galleys. Under the spell of Hugh Jones' vivid and dramatic description I could see it all happening. Bearded, bronze-clad figures leaped from their galleys, centurions, infantrymen and finally the mighty Suetonius himself. There was a savage battle as my ancestors hurled spears and stones from the cliff-tops until, inevitably, a terrible massacre took place on the slopes of the Garn. My excitement was damped by the feeling that Hugh Jones seemed to favour the Romans.

Swtan has long been deserted, and its ruins lie like the decomposing body of a rabbit, the thatch and rafters like a jumble of hair and bones.

Down at Porth Swtan there was sand and many-coloured cliffs, and deep rock pools with glorious starfish and sea anemones, while out at sea the grey shapes of the liners slipped by towards the Skerries, from where they would turn eastwards to Liverpool. Their great engines throbbed, and we waited for the wash to break on the sandy shore. There were days when a heavy sea-mist drenched and clung to the land, blotting out the comforting bulk of Holyhead mountain across the bay. The ships wailed and crept anxiously by while an air of mystery cloaked the land.

Both parishes were dominated by the Garn, a rocky hill that was almost the highest point in Anglesey. There were Welsh mountain ponies, hares, ravens and even peregrines up there, and from the top one clear summer day my great-grandmother had drawn not only the outlines of the Mountains of Mourne and the Isle of Man, but also the Cumberland Fells.

While my mother ruled the household at home, in this wild Welsh

countryside my father came into his own, laughing and joking with the locals and bursting with pride over the family that he had brought from the borders of England to meet them. My mother quietly melted into the background and seemed content to allow my father the luxury of his happiness.

One wet day, when the rain beat across the bay from Holyhead, my father drove us over the mountain road in a dog-cart to visit Miss Owen of Caerau in my great-grandfather's parish of Llanfairyng-hornwy. There is a local story that it was in Caerau that Bonnie Prince Charlie stayed on his flight from Scotland after the '45. We heaved up the hill with the wind at our backs and then slipped gently down to the old stone house with its avenue of beeches. Wet harness, steaming pony, soaking boys, but Caerau was worth it, and we were fascinated by the eccentric character of the lady of the house. She was the daughter of the old squire and his housekeeper and had once explained her mother to my aunt Mamie, at a parish tea, with 'You must excuse my mother, Miss Williams, but she is very vulgar'.

If Llanrhuddlad seemed a mysterious land, Llanfairynghornwy was more so. Anglesey is full of stories of hidden gold and the little people, but nowhere are they easier to believe than in Llanfairynghornwy. There are many Neolithic standing stones, and old Sarah Richards of Clegir once told me of a farm in the parish where they had never ceased to worship the sun and the moon, even though they attended chapel regularly.

On the shores of this wild parish, a ship was wrecked in the eighteenth century. There was only one survivor and he was a small boy who spoke in a foreign tongue. A farmer took him in and cared for him and eventually he became one of the family. One day the farmer found him putting a crude splint on the broken leg of a chicken. To please the boy, he let him look after the bird, and to his astonishment found that the leg healed completely. He worked naturally and con-fidently, and soon anyone in the parish with bone trouble would come to the farm to be manipulated and healed by the foreign boy, who by this time had been adopted by the farmer and his wife. Nearly all his descendants inherited his gift, and the bone-setters of Anglesey be-came well known not only in Wales but also in England.

Many years later, when I was studying land agency in Pwllheli, I would go and sit during my lunch break with old Richard Evans in his small bone-setter's shop in Gaol Street. He would always greet me by encasing my hand in his, and then for what seemed an age his fingers wandered unconsciously over every bone, feeling, pressing, easing, stroking, until finally he seemed satisfied that all was well. He too was from Anglesey.

When our nurses left, we had a governess called Daisy Jenkins, who came over every day from Gobowen and occasionally as a great treat took us back to her little 'Ruabon red' brick house to have tea with her mother. We were joined at our lessons by Pat Salt, the lively and enterprising son of a local doctor. My mother did not really approve of his unbridled energies, and when one day he fell off the roof of his father's house and fractured his skull, she was able to set him up as a terrifying example of waywardness.

My mother had us very well disciplined, and Chirk became used to the sight of two small boys taking their caps off to everyone from Archdeacon Lloyd, the rector, to Mr Edwards, the grocer. Manners were what she valued most, and manners were to be distributed indiscriminately. Continually thinking of others, as a well brought up parson's daughter should do, she was nevertheless fully conscious of her position and very concerned as to whom we played with. To my father such things didn't matter, and he must have longed to be back in Anglesey talking Welsh to the locals.

Sometimes we went for walks up the lovely wooded Ceiriog valley that forced its way into the heart of Welsh-speaking Wales and was clothed in honeysuckle, dog-roses and bluebells. Llanarmon-dyffryn-Ceiriog seemed to be real Wales in a way that Chirk was not. The English end of the valley was spanned by the noble viaduct and aqueduct of Thomas Telford, and it seemed to a small boy like a barrier dividing Wales from England, condescendingly allowing the gentle Ceiriog to flow beneath its mighty arches.

The railway viaduct was exciting, but it was nothing compared with the aqueduct, and the sight of straining horses towing the silent barges across that water span was far better than the London-Birkenhead express, and the tunnel at the Chirk end was better than the railway tunnel. Silently the barges slipped into the darkness as rats dropped into the water from the ramshackle path, and far away a semicircle of light showed where it ended.

We were not supposed to go into that eerie place, but Pat took us there, and to many other wonderful places like Offa's Dyke, a great earth ditch that in spring-time was covered with a yellow coat of primroses.

Anything exciting was always forbidden. We did not realise how much our mother worried over us, although her continual apprehension transmitted itself to us. I am sure Dick, who was unusually sensitive, suffered more than I did and must have realised her passion for him and her anxiety on his behalf. This inhibited his actions, and he was never able to wander away on his own as I could do, for he always

UNIVERSITY OF WINNIPEG
LIBRARY
515 Portage Avenue
Winnipeg... R3B 2E9

felt that whatever he did would upset his mother. I didn't realise then how lucky I was.

Inevitably we found relations nearby. Indeed, as we were still in Wales, it would have been remarkable had we not. Of all these relations the most memorable was cousin Aggie.

Agnes Hunt was born in the old house of Boreatton near Baschurch in 1867 and was the daughter of Rowland Hunt, the local squire, whose mother was a Lloyd of Glangwna. Her mother was a large eccentric woman who, according to cousin Aggie, disliked children intensely. She disliked them when they were coming, during their arrival and, most intensely, after they had arrived. Unfortunately for her, between the ages of twenty-one and forty she was doomed to produce eleven.

Handed over to a series of governesses, the children conceived a puritanical code of honour in which it was not done to complain of any sickness whatever. Cousin Aggie was undoubtedly a sick child, but so strong was the code that only when somebody touched her where one of her sores was hidden by her dress and she screamed in agony did her mother reluctantly realise that something was wrong. But she was never allowed to think she was in any way different from the rest of the children; perhaps her mother's attitude enabled her later to help her fellow-cripples adjust themselves to a life of reasonable normality.

When her husband died Mrs Hunt decided to buy an island off the coast of Queensland and settle there with her large family, with the strange idea of breeding Angora goats. They sailed in 1884. Everything went wrong, and worst of all, Aggie's health, which her mother still ignored, deteriorated rapidly, and signs of approaching osteomyelitis became evident. The sicker she became the more intense was her desire to be a nurse, and in 1887 she returned to England and tried to find a hospital that would take her as a student nurse. Finally the Royal Alexandra Hospital, Rhyl, took her in as a lady pupil. In 1900 she opened, in a ramshackle house in her native Baschurch, the first open-air orthopaedic hospital in the world. Her mother, surprisingly, did everything she could to help her, and the many Shropshire relations banded together to form a committee to organise the home. The Royal Salop Infirmary sent patients, and soon they found there was never a spare bed.

Cousin Aggie was in constant pain all this time, and in 1903 had to go to Liverpool for an operation. Liverpool had for a long time been the mecca of aspiring Welsh doctors, and some of the famous Anglesey bone-setting family had become qualified there. Thomas of Thomas's Splint had been one, and Robert Jones was another. It was to him that

Agnes went for her operation. It was a meeting of great importance, for they were greatly impressed with each other. So much so that afterwards Robert Jones paid monthly visits to Baschurch.

In 1919, Park Hall Military Hospital, Oswestry, was bought, and the cripples were moved from Baschurch to a place where there was room for three-hundred patients. In 1924 Cousin Aggie contracted lupus and had to give up active work, but in 1927 she returned to open the Derwen Cripples' Training College.

It was there we used to visit her. By this time her suffering had begun to show and she could only walk on crutches. I remember her as being at first sight somewhat formidable. Her hair was cut short and her face was strong and almost masculine. But her eyes were the kindest I have ever seen, made the more so perhaps by the severe head in which they were set. She always wore a pale blue whip-cord uniform with a nurse's cap to match, and I remember walking beside her through the wards, her deep voice booming, and laughing as she lifted up a crutch and playfully clobbered a cripple with it.

In 1933 Sir Robert Jones died and the name of the home was changed to 'The Robert Jones and Agnes Hunt Orthopaedic Hospital'. In 1937 Cousin Aggie had the pleasure of reading her glowing obituary in *The Times*. This obviously appealed to her sense of humour, and prompted an appropriate letter in reply. The final obituary came a few years later.

My father worshipped her, partly I suppose because he too was crippled, and knew how much she had suffered, and that hers was a far greater suffering than his own.

Our other relations were the redoubtable Lloyd-Williamses of Moreton Hall. There, in an old red-brick house, Cousin Lil and her high-powered, educationally-minded daughters had started a girls' school that was later, under her daughter Bronwen, to become one of the best known in the country. In 1924, when Dick had been sent to school at Tre-Arddur Bay in Anglesey, Daisy Jenkins was dismissed and I became a day boy at Moreton Hall, the only other male being a small French boy who could speak no English. I was collected every morning by a party of day-girls in a governess cart. I used to scramble through the little door at the back and, as all the seats were already full, was forced to sit on the floor. The pony clip-clopped the three miles to the school and the girls gave me occasional kicks as the governess cart bumped on its way.

I don't think I learnt very much, but I acquired a certain feeling of superiority, since I found girls did an inordinate amount of crying. 'John is a very good little boy' was Cousin Lil's report. I suppose I was; I always took my cap off to everyone except the girls.

In Chirk our Doctor was a genial squire-like character by the name of Lloyd. He took us under his wing, as did his daughter Blanche Adele who, failing to catch a personable young curate, had turned her attention and affection towards my mother. She was hardly ever out of the house and Dick and I came to know her as Aunt Dolly. Her face shone like a polished pippin and her eyes were large and demented. 'Poor Dolly,' my mother used to explain. 'She had meningitis as a girl. She should really have been allowed to die.'

Aunt Dolly showered us with presents. My mother accepted them and her adoration with a stoic indifference and impeccable good manners, as she could never have been consciously cruel. So Dolly Lloyd came to be accepted as one of the family, and wherever we went she was to follow. Kind, unbalanced, moody, she caused my poor father continual trouble, and she was the only person I can remember who ever really upset him. In and out of the house she went, beaming, organising, giving us presents, bursting into tears, quickly taking offence and creating atmospheres black as night. All this my father bore with, not through weakness but because he realised that Dolly Lloyd was basically a good but sick woman.

Another trial for my mother was her brother Owen, who was continually begging for money. Her father had spent all his money on educating his son and had done little for his daughter; yet my mother managed to send off something every now and then to support a brother who had, in her eyes, wasted a promising life.

Then in 1926 my father fell on his way to a local hospital meeting and broke his good leg. This evened things up a bit and he walked better afterwards, but his health gave way and he had to give up his job. The blow was eased by the death of a cousin of my mother's in Anglesey. Ellen Pritchard, a daughter of the well-known family of Trescawen, and a famous horse-woman of her day, had decided to leave her house, Brynhyfryd, near Beaumaris, with the grounds and gardens and a fair sum of money, to my mother and not to one of her reasonably wealthy nieces, as 'she is my only relative without a large house'. After my mother she willed it to me, but a few years later cut me out and left it to my brother instead. To her nieces she left little. Gwen Dwyer-Hampton got the farm, since it adjoined her Henllys property; Sisli Vivian received £500 and instructions to buy two hunters, while Mary Pritchard-Rayner received nothing at all. Mary was furious and declared war.

Under the threat of hostilities we returned to the island. At Brynhyfryd we found an inebriated butler and empty linen cupboards. The maids had departed with the contents.

We never cared for the house, which was large, and together with the grounds and nursery gardens would need a lot of money to keep it in good repair. It was created by the union of two large and dull Edwardian villas. United, they achieved a charmless monotony of tasteless rooms, which were filled with lace antimacassars, beaded Victorian fire screens and bad Venetian glass. The pictures were for the most part Victorian sporting prints or insensitive local water-colours. Conspicuous were some good bits of furniture and porcelain, and these were the objects that prompted our distant relative to bring her action against my mother.

Finally, after interminable legal wrangling, the case was brought before the court. The claim was dismissed, and the judge in his un-fathomable wisdom decided that both parties should pay their own costs. The judgment meant that the wealthy Mary Pritchard-Rayner retired almost unscathed, but my mother, even if she retained the furniture, was so wounded financially that we had no alternative but to sell the house.

In the middle of the three-day sale, a large pink predatory woman burst into our sitting room and imperiously demanded a small sofa table. Dick and I knew without being told that this was our formid-able relative Mary Pritchard-Rayner, and we watched fascinated as my father tactfully asked her to remove herself. My mother simmered softly in the background.

Although the house was a disappointment to us, the gardens, care-fully tended by Haley the gardener, were a continual joy. Huge blue and green grapes hung in the vinery, and every morning I pestered the good-natured Haley to let me have some for breakfast. Haley and his son Arthur were great allies and allowed us the freedom of the green-houses, where vast prize begonias and cinerarias grew to incredible sizes and exotic rubber trees fascinated us.

The stables, deserted—since Miss Pritchard had sold her hunters before she died—were a sad yet wonderful playground, with the stalls and loose-boxes still smelling of their previous occupants. I lay in the straw in the loft, breathed in the sweet smell and imagined the glorious horses that had lived there—stunning chestnuts and bays. I heard their hooves dancing on the flags and swore that one day I would join the cavalry. For a short time, we borrowed from an old friend an energetic pony called Spark, and he took up residence in the deserted stables. We made hazardous expeditions to Llangoed or Penmon, and my mother suffered agonies of suspense as we belted out of the stable yard; but my father, bred in the hard school of tandem driving, had everything under control and enjoyed it all as much as we did.

We often went across the fields to the edge of the straits where Girling, a fisherman and lifeboat-man, lived in a small cottage and kept a weir of stakes driven into the sand. Here, when the tide went out, we saw the shining stranded fish, and helped Girling catch them and put them into large wicker baskets. From his cottage, five miles of sea and sand stretched to the foot of the Caernarvonshire mountains, and we watched knowledgeable sailors weaving their way between the treacherous sandbanks against the ever-changing backcloth of cloud and mountain. To the east, Puffin Island squatted like a rocky stop to the main island, and far away on the horizon the Great Orme plunged into the sea. The straits narrowed like a funnel towards Bangor, and then meandered between wooded banks and under the great bridges to Caernarvon and the open sea. The reaction of a Caernarvonshire farmer to the boasting of an Anglesey stockbreeder can easily be understood: 'Fatter they are, you say? Well damn, look what a view they've got!'

From Beaumaris pier we caught the ferry boats on their way to Bangor—the beautiful and elegant *La Marguerite* with her trim red funnels and thrashing paddles, and the common little *Cynfal* that chuffed and belched its way to the other side.

We saw little of our Anglesey relations, but occasionally we went over to see our cousins at Rhiwlas, an old house perched on a hill above the beautiful square of Red Wharf Bay. My mother's first cousin, Winnie Rice Roberts, had inherited it from her father. She had married Colonel Frank Mills, one of the Lancastrian invaders of the previous century, and had produced two round phlegmatic children. Inhabited by the hard-riding Winnie and the sharp-shooting Frank, Rhiwlas was distinctly county. Trophies of the chase were everywhere. Military relics threatened from the hall and in the gun room, carefully placed above the fireplace, rested a pair of well-polished knuckle-dusters.

One lovely Anglesey Sunday, we went over to lunch at Rhiwlas. From my seat at the heavy polished dining table I could see an herbaceous border rich with peonies and delphiniums. Frank carved, my father and mother and cousin Winnie made polite, strained conversation, while Dick and I, John and his sister Doris maintained a stolid silence.

Over my roast beef I suddenly saw a magnificent tabby tom-cat walking proudly along the border, occasionally stopping to sniff the flowers. My pleasure at seeing this superb specimen overcame my social diffidence. 'Look at that lovely cat!' I burst out.

The Colonel leapt to his feet. 'Where is it?' he shouted.

I pointed to the edge of the border. Angry and red-faced, Frank

43

Mills stamped out of the room; the conversation stuttered on as I watched my beautiful tom.

Suddenly from a room above came a violent explosion. The cat leapt in the air, fell on to its back and after a few frantic twitches lay still and dead. I felt sick and shocked: sick that such a lovely animal had been slaughtered in such a ruthless manner in the middle of our lunch; and shocked, strangely enough, because the execution had taken place on the Sabbath.

The Colonel returned to his roast beef, and the conversation continued as if nothing had happened; but the meat on my plate remained untouched.

Frank Mills could also be kind; for when, mounted on the ferocious black pony from the smithy in Beaumaris, I arrived at a meet of the Anglesey Harriers, it was he alone who showed any concern for my safety.

Cousin Winnie was a fearless rider and an incurable optimist, and when in later life she became very deaf she replied to every conversational gambit with a smile and an inevitable 'What fun, eh?' The announcement of the decease of her nearest and dearest would have received the same response. My mother eventually created her own instinctive verbal reaction, and it is interesting and revealing that it was an invariable 'Oh dear!'

The social life of Anglesey, centred as it was on the pursuit of the hare, left us severely alone. Mary Pritchard-Rayner was a notable member of the Hunt, which, with heavy horses and overgrown harriers, chased its quarry in ever-decreasing wire-enclosed circles until, with no further room to manœuvre, and rent by feuds, it gave up at the outbreak of the Second World War.

The Hunt Ball remained, and each year an eligible young man was made Controller and an eligible girl Lady Patroness. Ancient men in pink coats delivered passionate exhortations to preserve traditions; but the only tradition now observed is the unique retention of a Hunt Ball without a Hunt.

Sensing a certain social ostracism, my mother sold Brynhyfryd to our eccentric cousin Geoffrey and rented an ugly castellated house between Criccieth and Portmadoc. We moved in 1928 to the more hospitable countryside of south Caernarvonshire and there, near the north-east shores of Cardigan Bay, surrounded by some of the most glorious landscape in Britain, I began to assemble unknowingly a vast library of feelings, sensations and knowledge that were to form the foundations of my future life as a landscape painter.

4

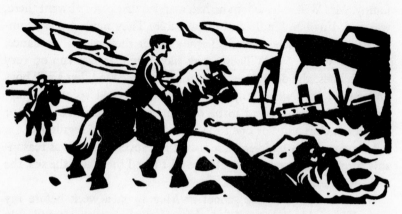

Tre-Arddur House School was perched on a rocky gorse-covered hill above the largest and sandiest bay on Holy Island. An ungainly conglomeration of huts nestled behind it, as if for protection from the south-west gales that swept over that treeless land. Below the hill and alongside the coast road were the playing-fields, where, winter and summer, small boys in red, white and blue wrestled and squealed and learned the fundamentals of sportsmanship.

Holy Island is very much a land of its own, a wandering, contorted eruption of an island, joined to Anglesey at the north end by a causeway and at the south by a bridge. Between these two lies the inland sea that at the village of Tre-Arddur Bay almost breaks through to the Irish sea. On the island itself there is always rock trying to force its way upwards through the poor thin soil, and there is always sand blowing in great clouds from the sea and forcing its way under doors and into the cottages, farms and seaside villas that crouch for protection behind the hundreds of rocky outcrops.

Facing Ireland, the cliffs are twisted and gnarled and fall into a sea of reefs and rocks. To the north, where the South Stack lighthouse juts out below Holyhead mountain, the cliffs are most spectacular and vertical. On ledges sea-birds of all kinds nest in the spring: razorbills, guillemots, puffins and kittiwakes, and many others too. A mile out to sea, a foaming turbulence marks one of the most dangerous races off the west coast of Britain.

It did not take me long to fall under the spell of the island's mood. The storms, the sea mists, the wrecks, the wailing sirens, and in summer the peculiar haze that hung over the island, all made Tre-Arddur

45

Bay a very special place, and I was lucky to be there in a school as happy and well-organised as Tre-Arddur House.

The school was founded, owned and run by Mr Iorweth Williams, a dark, vital, bespectacled little man who came of an old Anglesey family. Mrs Williams, whom he had married just before I went there, was fair, English, kindly and unflappable. They made a good combination and the school worked easily under their careful guidance. However Welsh Mr Williams may have been, it was run on very English lines: the discipline was rigid and of the kind that small boys understand, and great emphasis was laid on good sportsmanship. Games and work seemed to be of equal importance. We won our school matches and our open scholarships with equal regularity.

I suppose I was happier there than I have ever been. I was reasonably bright; I enjoyed games. Above all I loved the place, the sea, the rocks, the sand and the birds.

When I arrived at the school in May 1925, a week before my seventh birthday, I was a fair and skinny little boy who could only prevent his short white trousers from falling down by keeping his hands permanently in his pockets. At that age it seemed that the good Lord had forgotten to give me hips. Though my head and body had not grown very fast, my ears had. Large and pink, they flanked my tiny face. It wasn't long before I had been christened Jacko.

I was supposed to be delicate, and therefore was never allowed to have a cold bath like all the other boys. Instead I suffered the humiliation of a ritual spongeing. This was performed every morning in the Headmaster's private bathroom, where I had to strip to the waist while Mrs Williams, always clad in a schoolboy's pale-brown dressing gown, sponged my chest and stomach with cold water.

Even though the presence of my elder brother made life comparatively easy for me, I was nervous. Darkness still brought the terror of the giant Cormoran's larder. I was terrified of being the only member of the dormitory to be left awake after the lights were put out. This naturally preoccupied my mind with listening to the other boys' breathing until, realising with horror that they were all asleep, I would get out of bed and fearfully make my way out through the bedroom door, and along the passage to where a light under a door told me that Mr and Mrs Williams were inside. Sometimes I curled up against the door until voices or movement made me race back to my bed to dive under the enveloping security of the bedclothes. They only caught me once.

We wore white shirts and shorts all the year round and a white sweater in winter. On special occasions we put on a bright red blazer with a badge of chariot-horses, encircled by a motto: 'They can be-

cause they think they can.' By Saturday our whites were woefully dirty, but on Sunday morning we rose to dress once again in immaculate attire, ready for chapel in an asbestos hut, where Mr Williams conducted a simple conventional service. The chapel was rather a show-piece, and parents came to sit silently at the back while their treble-voiced offspring tried vainly to compete with the harmonium.

Most parents remained silent, but not my father and Aunt Mamie. They were Welsh, children and grandchildren of parsons, and had been brought up to lead the congregation. Furthermore, Aunt Mamie had been trained as a soprano in Brussels, so there was no holding her when the hymns started. I stood in utter humiliation as she and my father trilled and bellowed from the back of that asbestos hut. Small boys turned round to look at me with scorn: this was not done in a school in which nearly all the boys were English. Shame overwhelmed me and I longed to disappear through the floor.

Dick was better than I was at nearly everything. He was brilliant at work, whereas I was a good average. He was bigger and stronger, he was handsome, and on the rugby field he played with tremendous energy and courage. I, timorous by nature, was terrified of tackling boys larger than myself. Schooldays suited Dick. He was organised and knew where he was, whereas I came into my own in the holidays, wandering away by myself, climbing trees and rocks and exploring the small streams that rushed down from the mountains. Dick, instead, would stay at home reading, acquiring the knowledge that finally won him a scholarship at Shrewsbury. At school he realised that I was the frailer and always acted as my shield, helping me with my work and siding with me in any trouble. He was immensely kind and always on the right side of the law; in fact I know of no other boy who went through his preparatory and public schools without ever being punished.

Small, skinny and frightened as I was, I nevertheless enjoyed the games at Tre-Arddur and always had great dreams of performing prodigies of valour on the football field. My hero at this time was a distant relative, a red-haired, freckle-faced boy called Patrick Plunkett. At work Pat was unbelievably stupid, but on the rugby field he rivalled Marshal Ney himself in courage. He played full back and always threw himself at his opponent's ankles, never at his thighs, with the result that after every game his face was a mass of lumps, cuts and bruises. Pat never worried; grinning, he waited for the next game.

His father was a wayward Irish peer called Lord Louth, his mother Dorothy Hampton-Lewis of the Henllys family. At the end of each term, as his mother had died, Pat went to stay with his formidable grandmother, Mrs Hampton-Lewis, in nearby Bodior, one of the old

47

houses of Anglesey that lay at the south end of Holy Island surrounded by some of the few trees that were brave enough to grow on that wind-swept soil. Pat managed to stay only a few days, for soon his love of the school drove him back, and Mr and Mrs Williams found him on their doorstep once more.

Poor Pat, never very bright, later failed to get into the Army, only managing to join the supplementary reserve of the Inniskilling Dragoons. His courage remained unchanged and I remember him and his friend Arthur Trevor catching the redoubtable Spark in a field in Llansadwrn. Round and round the field raced the wild and energetic cob, frustrating all efforts to catch him. Suddenly Pat climbed up a small oak tree that grew on the perimeter of Spark's circus act, and as the pony thundered underneath he threw himself off a horizontal branch to land full square on the back of the terrified animal.

Pat secretly married a bus driver's daughter from Torquay and used to dash down from the barracks at Colchester to meet her. Returning one night, he failed to see a bend in the road, charged a bank in his small sports car and was killed.

Few other boys at school impressed themselves on me like Pat, but one large Welsh boy called Edward Jones always remained in my memory. He arrived at the school comparatively late in life; he was all of twelve and very large. We eyed this dreadnought with apprehension. He said goodbye to his parents, walked through a respectful group of boys to where his new tuck box stood opposite the shoe lockers, took out a pair of boxing gloves, sat firmly down and said 'Right, who's first?' There were no takers.

Nevertheless, Edward Jones turned out to be a kindly boy and was a distinct asset to the football team.

My greatest friend was Tubby Bardsley from Stockport, a small round boy with the same sort of imagination as I had. We conjured up strange worlds as we lay in primitive houses constructed among the gorse on the hillside and named 'Blue Heavens'. We created our own odd language and reproved other small boys if they tried to copy us. One fearful day we found we had to meet each other in a boxing competition. I stood with the blue of my Heracles House colours hanging from my belt. Tubby was from Leonidas and wore yellow. The bell was struck and we left our stools; we stabbed out our arms tentatively, we made contact, we started hitting until suddenly we were belting each other in a strange frenzy. Tears were rolling down my cheeks, mixing with the blood from my nose, and still we attacked each other. There was pain and anguish; I didn't want to hit Tubby, and yet I had to do so, partly from self-preservation, partly because I was determined not to give way. Suddenly it was all over: weeping, gasp-

ing, I was back on my stool. The result was a draw and Tubby and I were friends again.

Among the thirty or so boys there was one girl, Frances Webb, who only came because she was a relation of Mrs Williams. She was dark, brooding and very strong, and played an excellent game of rugby on the right wing. She slept in a small room off the sick room, but otherwise did everything with us. Even so, although she wore the white shirt and shorts of the school uniform, she was never of us and, even when she was not playing football, was always somehow on the wing.

Of the masters I remember little. Ray Bloomfield was the most memorable, possibly because he came to us for one whole holiday to coach Dick for his Shrewsbury scholarship. He was tall and studious-looking, drove a small yellow racing car shaped like a banana and eventually married the music mistress, Miss Gladys Fisher. Of the rest, Mr Bishop was bad-tempered, Mr Vezey specious and Mr Osborne a large good man whose sudden death from pneumonia shattered the whole school. Sentimentally, we removed his signature from our exercise books.

Mr Glazebrook was different, for he taught us art and could make trains disappear across bridges and into tunnels in a wonder of perspective. He also sailed and caught large pollock. One was larger than I was and a photograph duly recorded the event. In the carpenter's shop Mr Roberts, an imperturbable Welsh sailor, taught us to make bookcases and pipe-racks. He talked with a full Welsh accent and I felt at home with him.

Seldom in seven years did anything disturb the calm progress of the school, and then only the atmosphere told us that something had occurred. Mr Draper committed an enormity; so did Sister Mears; so did Tommy Onslow. We knew what Geoffrey Crabbe did because Mr Williams called the whole school together to announce that the wretched boy had been telling stories about the school milk being watered. Crabbe was ordered to stand in front of the outraged school while Mr Williams savaged him with his tongue. We were all on Mr Williams' side. Crabbe was a cad, a liar, a horrid unprincipled little boy. We duly sent him to Coventry.

This calm and happy life was interrupted when my parents decided Dick and I should have our tonsils and adenoids out. Parents were definitely unfashionable if they continued to allow their children the luxury of these excrescences. So one holiday when I was ten we entered a local hospital to have them removed. I was at this time a reasonable success at Tre-Arddur House, and Mr Williams had even hinted that I might be groomed for future headship of the school. Furthermore, I seemed to be getting brighter, and a Shrewsbury

scholarship was not considered impossible. The operation put an end to all these hopes.

My brother recovered quickly and returned to school, but I, with an incredibly painful throat, was told that I was too delicate and had to have a longer convalescence. The doctor was solicitous, the nurse was solicitous and I missed two whole terms. When I did eventually go back it was as a stupid dreamy boy who was quite unable to concentrate and who, it was obvious, would never win a scholarship or make a head boy.

It was only later that the truth emerged. The surgeon had had a heart attack in the middle of the operation and with a frenzied sweep of the scalpel had removed not only my tonsils and adenoids but my uvula and soft palate as well. Small wonder my throat was sore.

This unfortunate story was completed by my Aunt Mamie, who was always a very social little body, and felt it her duty to call on the surgeon's wife after the operation. Gaily she tripped through the conservatory that led to the doctor's front door, but as she made her way past the piled-up laying-out boxes she suddenly saw a pair of boots sticking out from among the watering cans. The body was hidden by geraniums, but as she leaned forward she saw with horror that it was the surgeon himself who lay there. He had had another heart attack and this time it was fatal.

As any idea of a scholarship was now out of the question, Mr Williams' attention was occupied with getting me through my Common Entrance, and success was considered rather unlikely. I sat the examination alone in a small class-room and the invigilator was the kindly, Pickwickian vicar of Holyhead. Most of the papers I managed fairly well, but the algebra paper so defeated me that anguish must have showed in my face.

'Having trouble, my boy?' asked the vicar.

'Yes,' I replied.

'Let's have a look at it.' He rose from his chair by the fire and came to sit on the bench beside me.

'Well, well, shall we go through it together?' he suggested. I knew that there was something strange in this; but he was a parson, a man like my forbears, so he should know right from wrong.

'Yes, please,' I said, and we went through it together, the vicar eventually doing the whole paper himself.

The papers were packed and sent off to Shrewsbury and I waited in suspense for the result. At last it came. I had passed in everything except algebra and this I was instructed to do again.

Once more I sat my algebra paper. Mr Williams invigilated and I

did it all myself. A few days later a short note said that Shrewsbury would accept me.

After seven years I was to leave, and I viewed this prospect with concern. No longer would I be on exciting Holy Island. There would be no more sea and storms and no more rides on shaggy ponies along the cliff tops to see great ships fast on the rocks below. I didn't want to leave. Something told me that my happiness was ending, and my intuition was right.

My last adventure was the capture of the cock guinea fowl that cluttered and squawked from rock to rock and infuriated staff and boys alike. Mr Williams had offered it to any boy who could catch it. This was a tremendous challenge, as we all loathed the ugly noisy bird. Parties of boys laid elaborate plans and each time the brute escaped. One by one the boys lost interest, but to me the challenge became greater every day. Through gorse bushes, heather and rushes I stalked it, and always it got away. The end of term was in sight and still I hadn't caught the exasperating bird. The last day came and all my hunter's instinct came out; I had to catch it, and catch it I did. I drove it into a small stream that flowed below the hill, and there in a flurry of feathers and spray I grasped it by the neck, and brought it triumphantly back to place it in a large wicker box.

5

From the age of eight until I was eighteen I lived in the hideous Plas Gwyn, near the village of Pentrefelin, three miles from Criccieth and five miles from Portmadoc.

Though the house was hideous, the countryside was glorious, with everything a boy desired. The mountains rose up close behind, and the reed-covered fields stretched down to the exciting marsh of Ystumllyn where sea-gulls and ducks of every description shared it with the herons, coot and moorhen. There were snipe and curlew and flocks of wheeling lapwing, and once we heard a bittern in an unattainable island of rushes near the old church of Ynyscynhaiarn.

The church was built on a lonely knob of land and always seemed dark and cheerless. Inside was a three-decker pulpit, and outside the remains of a tithe barn. My father played the organ to a minute congregation and vainly attempted to lead the singing as well. Huge gulps of damp air filled his lungs, and must have helped to bring on the bronchitis from which he eventually died.

Across the marsh from the church was Black Rock and the lovely sea of Cardigan Bay with its great sandy shores of Morfa Bychan and Morfa Harlech. Once again we had relations nearby, for my father's first cousins the Ramsays lived in a small house between Portmadoc and Borth-y-Gest. Ella, Fanny, Dora and Violet were all very different characters—Ella gentle, Fanny refined, Dora humorous, while Violet had a little bit of them all in her. Cousin Dora was always losing

her teeth and could never remember in which flower-pot she had put them. All the sisters were eccentric and amusing. They hated the modern houses that were being built between Hirgraig and Morfa Bychan, and as soon as one was occupied, the Ramsay sisters would call, bearing with them a liberal supply of cuttings of Virginia creeper.

They had one thing in common, and that was their culture. Sir Andrew, their father, was an earnest pursuer of all things artistic, while Great-aunt Louisa, their mother, had inherited an interest in art from *her* mother. Ella painted landscapes in oil and watercolours. Fanny was a professional portrait painter and studied in Paris under Bouguereau. Dora appreciated, and Violet, assisted by Fanny, created settings for precious and semi-precious stones and is represented in the Victoria and Albert Museum. They had beautiful pictures in their neat little house: a Turner in the drawing room, along with two Claudes that later turned out to be by Van Lint. In the dining room was a fine Marco Ricci. I loved to go to Hirgraig to see them and the pictures.

Their only brother, Alan, was an alcoholic who lived in Dyffryn and was supposed to own a worked-out gold-mine. I can just remember a short little man jumping up and down on his chair with excitement as we listened to the Grand National on an early wireless set. Drink and the horses proved to be Cousin Alan's undoing. He died in a home in Church Stretton. One by one his sisters died as well, to be buried either at Ynyscynhaiarn in the dripping churchyard or in the cemetery at Minfordd that has the dubious honour of having the finest view in Britain.

Eventually only Cousin Violet was left, and then Lizzie, the shrewd and unscrupulous housekeeper, saw her chance. The poor old lady's life must have been a misery as Lizzie forced her to leave her not only the house but a considerable amount of her money as well. Violet died and Lizzie inherited, but knowing that the people of Portmadoc were well aware of what she had done, she decided to disappear from the local scene. She sold the house, and with her ill-gotten gains bolted for the sanctuary of Birmingham.

My mother was at her best at Plas Gwyn. With her usual tremendous energy, she started a linen league for the local hospital and ruthlessly rounded up the villagers for miles around, persuading them to collect sheets, dishcloths and anything that could possibly be of use. Dick and I were looked after as well as ever and in this my mother was assisted by two maids: Kate, a genial red-haired girl from the village, and Annie, a tiny little thing from South Wales. My father also seemed to enjoy life there and got on with everybody, as he

invariably spoke Welsh to them. My mother, as always, refused to speak her native tongue.

Dick and I played ball games in the garden, but I grew tired of this and liked to wander away on my own into the fields and woods, over the rocks or down to the Ystumllyn marsh. Dick usually preferred to stay at home and read. Once when he wouldn't come out with me I hit him in the face in anger. He turned disapproving eyes on me, but never hit me back. This hurt me much more than if he had knocked me down.

We acquired a small Jack Russell terrier from the Tanatside Hunt whose name was Bonzo. The locals found this name quite incomprehensible and always called him Moscow. He was short-legged and sturdy, with a short white coat and black patches over each eye, and a smaller patch at the base of his stumpy tail. He was tough and independent and had, I feel sure, a bit of bull terrier in him. When set upon by sheepdogs he seemed to expand in some miraculous way, and I don't remember his ever losing a fight.

Bonzo and I spent hours together wandering in the fields after pigeon and rabbits, for by this time I had been given a lovely little .410 shot gun. Bonzo worshipped that gun as much as I did and the sight of it drove him into fits of hysterical joy. Often, after a few hours hunting rabbits, we would sit together on the top of Moel-y-gadair, a small hill in front of the house, and the whole world of Wales seemed to stretch around us, Cwm Pennant and the huge lump of Moel Hebog behind, eastward the Tremadoc rocks and a glimpse of the distant Moelwyns, then the stubby shape of Moel-y-gest brackened and heathered and sitting arrogantly isolated like the profile of the Duke of Wellington. The Rhinogs stretched away into the distance the other side of Tremadoc Bay, and across a silver sea I could absorb the whole scythe-like sweep of Wales to St David's Head. Away to the west past Criccieth castle the thrusting land of Lleyn disappeared in a turbulence of rocky hills to Bardsey Island. We used to sit there for hours, the small white dog and I, while ducks in the distant Ystumllyn bog gave sudden frightened quacks and Nan Tanycoed called the cows in down below.

Our landlord was Mr Owen of Bronygadair, a stocky dignified farmer who used to wander the fields tweed-suited, carrying a hazel stick and always followed by his old Welsh brindled sheepdog. His son Willie was a youthful version of his father, and was a good friend to my brother and me. One day he put me on the broad back of a ram. I sank deep into the thick wool and held tight as Willie set his sheepdog after it. Away we went leaping, bumping, skipping, until I rolled off into a wet patch at the far end of the field.

A very different family lived in Ystumllyn, the other big farm in the parish. Mr Williams the farmer was a rigid puritan, and one Sunday he caught me picking blackberries. His thin face grew hard as he told me of the enormity of my crime and the fearful retribution that awaited me in the next world. I couldn't really understand what he was talking about, but treated him with considerable circumspection afterwards.

Meanwhile, in Plas Gwyn, a pattern of life had evolved in which I gradually found that I was becoming, in my mother's eyes at least, a second-class son. She was invariably kind and solicitous towards me, but owing to the appalling reports that arrived twice a term from Shrewsbury, she became more than ever convinced that Dick was the important son and the true reflection of her father.

I became the hewer of wood and drawer of water. It was I who had to lift the potatoes, skin the rabbits, lay the table and at times wash up. Dick was exempt from any of these chores and had by this time been allotted a comfortable chair in the drawing room in which I was forbidden to sit. I accepted my lot without question, for I was well aware that my brother was not only far cleverer than I, but able to beat me at every game we played. It must have been his invariable kindness to his younger brother, his help with my school work and the fact that he never boasted of his superiority that saved me from resentment. There was seldom any friction between us.

My poor father must have come to the conclusion that he had sired a half-wit, and he treated me with increasing benevolence, providing me willingly with books on birds and animals whenever I asked for them. It may seem strange, but in spite of my mother's attitude she and my father managed to imbue me with a sense of rock-like security that has always remained.

It wasn't long before Dolly Lloyd was making plans to settle near us, and eventually she bought a small plot of land between Plas Gwyn and the road in order to build a bungalow. But Aunt Mamie had arrived first and had converted a small cottage called Pencraig into a delightful little house. We now had both Aunt Mamie and Aunt Dolly, and of course this meant that we all had to exercise the maximum of tact, for should Dolly sense any family preference for Mamie there would be immediate scenes and atmospheres; the door of her house, Tyn r'ardd, would be slammed and a black aura descend upon it. 'Oh dear,' said my mother once again. 'It's the meningitis. Perhaps she should really have been allowed to die.'

After one of these frequent tiffs she would appear beaming, and shout, 'Let's take Reilly and go.' Paddy Reilly was a humorous little Irishman who lived in Criccieth and owned a taxi. Dolly doted on him

and leapt at any excuse to hire him. A picnic place would be arranged, and in no time Reilly appeared up the drive, hunched over the wheel of his ancient landaulette. Aunt Dolly, eager as a child, organised us as we all piled in, Dick and I clambering on to the front seat so that we could see when the speedometer reached sixty. Up shuddered the needle to that miraculous number. 'He's doing it,' we whispered, 'a mile a minute.' Our joy was always shortlived, for in the back my mother's voice could be heard: 'Not so fast Reilly, not so fast.'

'Ah, begorrah, but it's nothing,' he would reply as, frustrated, he let the needle slip back to some hopelessly respectable speed.

The picnic place was invariably by some river, and as soon as we arrived, hampers were heaved off the luggage rack, warnings were sounded not to fall in and all the horrors of a prepared picnic would begin. And inevitably somehow and at some time, for some reason that we could never discover, Aunt Dolly got into a huff. It was never a temporary affair, but a gigantic and irrevocable temperament, and from that moment she sat resolutely with her back to us and we knew the picnic, indeed the whole expedition, was doomed. Aunt Mamie made gallant attempts at conversation and my mother offered sandwiches, but Aunt Dolly refused to speak, eat or co-operate in any way. The atmosphere hung over the party like a thunder-cloud as the picnic plates were collected, the cups were washed and we silently returned to the car.

Aunt Dolly would dissociate herself from us altogether and insist on sitting in the front next to Reilly where, upright, red-faced and tight-lipped, she always demanded to be taken home via Clynnog. This often meant a gigantic detour, but 'back via Clynnog' was the order and back via Clynnog we went. Home again, we crept stiffly and silently from the ancient car, while Aunt Dolly disappeared through her back door and we wouldn't see her for days.

Back in Plas Gwyn, 'Poor Dolly,' my mother would sigh; 'it's her meningitis.'

My mother's fondness for Aunt Dolly arose from pity. She had no such feelings towards my Aunt Mamie, of whom she disapproved. Mamie to her was a sponger, a professional visitor, a silly butterfly spinster. But her greatest crime was that she enjoyed life and admitted it. Whenever my father tried to stick up for his sister, 'Stuff and nonsense,' said my mother, and the conversation ended.

In reality Mary Dorothea Williams was in no way the greedy self-indulgent person of my mother's imagination but a woman of courage and generosity. Her poor crooked spine caused her to suffer agonies but never broke her spirit. She had very little on which to live; yet she gave of what she had in wild fits of enthusiasm. She was an incor-

rigible optimist and blessed with a spirit of adventure that horrified my mother.

She must have weighed about four-and-a-half stone, and on top of a thin, bent little body was her round, pale yet cheerful face, framed by grey curls. Always hanging over her tiny bosom were her lorgnettes, which she would open with a professional flourish at the slightest opportunity. Dick and I loved Aunt Mamie and sat enthralled in her little house as she told us the ramifications of the family pedigree. She could relate us to practically anyone she wished, from Cardinal Wolsey to the Duke of Wellington.

At times Aunt Mamie could be superbly positive. Once in Llan-rhuddlad church my grandfather read out the marriage banns of Lizzie Tanrhiw, a notoriously half-witted local girl. When he read the last part, asking if anyone knew any just impediment, up stood Aunt Mamie and in a firm voice said, 'I do.' Taid asked the engaged couple to meet him in the vestry. They met and there was no wedding.

Another time she took us to see the Swallow Falls at Betws-y-coed. Up to the gate we walked. We were met by the gate-keeper, a blue-black Jamaican who looked peculiarly out of place in the Welsh mountains. 'Money please, Mum ' he said. Aunt Mamie seemed to gain at least a foot in height. Her bent back straightened and her gentle voice had a whip-crack in it as she rounded on the unfortunate man. 'Indeed, I'll give you no such thing,' she snapped. 'I am a native.' She swept us through the gate, leaving behind a very baffled negro, and we never paid.

At one time she enlisted my aid in handling her tiny investments. 'I must do something with my German potash,' she said importantly. 'See what Monty Eddy says.' Monty Eddy, I discovered, was an old friend who used to stay at Llanrhuddlad rectory in the old days, and I was instructed to get in touch with him and ask for his advice as to what to do with the pathetic potash. After much searching, I found that he had become Sir Montague Eddy and a considerable financial genius. I also gathered that at the moment he was negotiating an eight million pound beef deal in the Argentine on behalf of the British Government. I did not dare to mention Aunt Mamie's potash to him, and she soon forgot all about it.

I was her godson and we understood each other. When she died, she left me her money and her share of the family silver. In truth there was no money to leave, and she had given away the silver years ago to another nephew in a moment of impulsive generosity.

Over the hump of the hill behind the house lay Cwm Pennant, a glorious but unhappy valley. It plunges northwards into the

mountains, first as wooded meadow-land beside the smooth river, and then, beyond the crouching cliffs of the Craig Isallt that divide the valley into two, as a bare brown bowl broken here and there by small untidy farms. It is a haunted place, and in the ruins of the old hall, gun dogs whimper in terror at things no human can see. There are many stories of how, long after the house had fallen down, people from the valley could hear ghostly music coming from the ruin and see lights blazing from empty windows. Dick and I used to go up there to see the dippers nesting near the bridge by the church or the ravens on the Craig Isallt, and we usually saw a kingfisher as well.

At the head of the valley lies Cwm Trwsgl, with its great fox earth, where we often found ourselves after a long day with the Ynysfor Hounds. Everyone followed the hounds on foot, or rather the few who were keen enough to put up with the ever-changing weather and precipitous rocky slopes that made it the roughest hunting country in Britain. I think I learnt most about the mountains from following the Ynysfor Hounds.

Ynysfor takes its name from the small hill that was once an island. That was, of course, before Maddocks built his great embankment down at Portmadoc at the beginning of the last century. The rocky and wooded mound that rises from the flat land around it is about half-a-mile long and a-quarter-of-a-mile wide. It has little bays and cliffs, but no sea has surrounded it for a hundred and fifty years, and today only its name remains to tell us that at one time it was one of the many wooded knolls that, at high tide, became islands in what was possibly the most beautiful bay in Europe. People have lived there since prehistoric times. The Phoenicians may have tied their boats there, and later the Vikings must have found it a safe base for their raids on the country around—a countryside that is rich in Romano-British legend. There are the remains of an old fort on one of the rocky outcrops, and the old house at Ynysfor was probably built from its stones. The Hendy is typical of the older type of Welsh house, with a big chimney a quarter of the way along the roof, and a stepped gable end in which there is a small dovecote. It stands above the stable yard and, like so many old Welsh houses, has no view. The working Welsh squire saw enough of the beauties around him throughout the day, and all he needed from his house was comfort and protection. The Hendy of Ynysfor is certainly protected, tucked as it is under the hill away from the south-west winds that drive up from the sea.

It was to the old house that Jackie Jones came with his hounds two hundred years ago to found the remarkable family of Jones of Ynysfor; they have hunted and followed their own hounds, and farmed and lived off their land as few Welsh landed families have done. Jackie

Jones was the son of a parson, and was sent up to Oxford presumably to follow in his father's footsteps. But he had been born with a passion for the chase, and instead of ministering to the spiritual needs of the neighbourhood, he seems to have given up his life to hunting foxes, otters and pine-martens over the mountains and in the rivers around Snowdon. His hounds must have been pure Welsh, rough-coated, sometimes black-and-tan, with lovely voices. Today, the cry of the Ynysfor hounds still echoes among the cliffs of Cnicht, Snowdon, Lliwedd and Hebog. Jackie Jones started a tradition that he passed on to his son Evan who, in his turn, lived, farmed and kept hounds at Ynysfor until, on his death, a new era began with his two sons John and Richard.

John Jones it was who built the new house in 1865. On rising ground, facing the magnificent peak of Cnicht, there rose the present Ynysfor, a stone-built house with sharp-pitched roofs and gable ends. It stands firmly and confidently, no architectural masterpiece but a good house for its period. It was well designed and built, with a good hall and well-windowed rooms; the squirearchy had become more sophisticated and the glorious views were better appreciated. Here John Jones and Lydia his wife brought up two sons and eight daughters who, although amazing individualists, were undoubtedly of the Ynysfor stamp. Evan and Jack were the boys, and Cordelia, Bessie, Minnie, Annie, Dolly, Freda, Sybil and Miggs the girls. Ynysfor must have been a lively place at the end of the last century.

When I first knew it Colonel Evan, Captain Jack and the Misses Minnie, Annie, Sybil and Miggs lived there. I used to go over often; in winter to hunt and in the summer to shoot crows and pigeons, to help Jack bring in the hay or just to be there to listen to the innumerable stories of the country round about and the people who had lived there. The family usually sat in the living room: Evan and Jack in the middle opposite the fire, while the sisters formed an outer semi-circle.

Meals were despatched with the utmost speed. Jack and I would come in from the fields when the stew pot was already in the dining room with a sister ladling out the contents. Before I could eat even a potato and a small piece of meat, the door would burst open and in would dash the raven-haired daughter of some tenant farmer with a large open tart, banging it down on the sideboard, and sweeping out again in a second. The tart eaten, Jack's voice would be saying, 'Well, John, there's that drain to be dug', as he wrung out his moustaches and disappeared through the back door. I followed him out into the fields again, stew and tart complaining from the depths of my stomach.

Sometimes I helped Jack feed the hounds. The slate-flagged kennels are two hundred yards from the house on the north side of the

island, surrounded by rook- and magpie-filled trees. One of the trees is used as a gigantic gibbet for the carcases of horses, cows and sheep, strung up by a winch and left to hang and season in the wind and the sun. When the bones are picked clean by the hounds and terriers, they are thrown down the bank below the kennels to become a fearful cemetery where the rooks and magpies quarrel over the pickings.

I suppose the kennels are the heart of Ynysfor, for, without the hounds, the character of the house would go and it would become just another dwelling. There are trophies of the hunt everywhere. In the hall, the masks of foxes from Arddu and Aran snarl at a stuffed pine-marten, and, in the living room (the room which I always feel is most typical) are family portraits, a fine Dutch still-life and the white pads of a large dog fox. This fox I remember being killed above Llanael-haiarn after a long hunt from Ynys.

It was in the living room that we used to have memorable teas, after a long day with the hounds. The Colonel and the sisters used to ply Jack with questions about the hunt: where they picked up the drag; where they put him up; where they checked; where they killed or where they ran him in. Questions about the hounds and terriers, the farmers and the locals who were out with the hunt, and many more in similar vein, were all answered by Jack in his own time briefly and very much to the point, as he tucked away a hearty tea of eggs and bread and butter.

Years ago, when I used to stay there, the house was lit by lamps, and I remember the hazardous walk to my bedroom, as I negotiated the polished stairs with an oil lamp in my hand and tried not to slip on the fox-skin rugs spread out on the equally polished landing. The water supply came from a pool above the house, where wild duck nested, and it burst from the taps like Guinness. Today, Ynysfor is connected to the main water supply, and has electric light.

From the front door you look down a drive flanked by rhododen-dron bushes away across the Traeth to the superb shape of Cnicht, and perhaps it is a happy chance that its peak is echoed by the sharp gable-ends of the house. Certainly it is appropriate, for somehow the house and the mountain have a strange affinity, formed by the two hundred years of hunts that have covered every inch of its sides and ridges. And somehow the house, guarded as it is by the mountain, retains a similar degree of permanence.

The first few years I knew Ynysfor, Evan was the centre of life there, but it was Jack I got to know best during the long days in the mountains together, sometimes on our own. He was of medium height and his wiry body was topped by an impressive head—two deep-set eyes on either side of a fine Welsh nose that plunged into a

bristling moustache like iron wire. His hands were cruelly twisted so that his little fingers pressed into the palms.

Some days we hardly spoke to each other, but talking was not necessary. The pattern of hunting was understood and I knew what was expected of me. With Jack I learnt the line of the foxes, sensed the places where they were likely to appear, and knew of many earths where they went to ground. I also learnt a bit about the craft of hunting: when to help hounds and when to leave them alone, how the strategy had to change with the weather and how with a foot pack patience was one of the most important attributes of a good huntsman. Jack had amazing patience, and I wondered at the way he nursed his tired pack on a stale line. In my ignorance I longed for him to carry them forward to where I was sure the fox had gone, but Jack was content just to keep in touch and encourage them occasionally with his raven's voice.

The farmers respected him, and this was tremendously important, for without respect and trust there would have been no hunting. The North Wales farmer is not by nature a sportsman, since his hard life gives him little time for luxuries. Some there were who were keen and helped Jack all they could. Outstanding among these was Dafydd Williams of Hafodllan in Gwynant. He had red hair and a red moustache and looked rather like the foxes that lived around his farm below the south wall of Snowdon. If we met anywhere near the farm, we invariably came across him and his son high up on the mountainside, strategically placed and with some vital information as to where the fox or hounds had gone.

I never really enjoyed that part of the hunt when, wet and tired, the fox had managed to dive into an earth. These refuges were usually deep down in great heaps of boulders or at the bottom of narrow cracks in the mountain, but sometimes they were sandy holes or drains. The battles underground were often long and bitter. If Jack wanted to bolt the fox, he put in a terrier that he knew would show the maximum of ferocity without actually getting to grips with the fox, but if the presence of farmers demanded a kill, he let loose the killers. The noise in the depths of the earth was increased by the baying of the hounds, as the fox moved from ledge to ledge, trying desperately to avoid being caught by terriers coming from two directions at once. Sometimes Jack himself would disappear until only the soles of his boots showed. I once remember hearing a far-away voice instructing me to attach a savage barb on to his stout hazel stick. I bound them together and passed the villainous weapon down to him through the mud and rocks. In no time there came another order, to pull him out, and heaving and straining, out he came, with the live fox grasped

firmly in his hands. A red flash rolled down the scree with hounds hurling themselves after it. I forget whether it got away or not.

Once a hunted fox ran into a sandy earth on the edge of the cemetery at Llanystumdwy at the same time as a local was being committed to the grave. The gravediggers shovelled the soil on to the lowered coffin, and then used the same spades to dig the fox out.

One hot summer day Jack was swimming in the deep pool where the Ynysfor river joins the Glaslyn, and as he enjoyed the cool water that flowed down from the mountains he noticed several policemen on either bank. A sergeant asked him if he had come across a body, as a farmer from the hills above had disappeared and had not been seen for a week. Jack was able to assure him that there were no bodies in the Ynysfor pool.

Many years later an elderly man by the name of Hansen, who had recently retired from the Indian police, came to my studio to learn the elements of water-colour painting, and one day, during a break for lunch, he told me an interesting story.

As soon as he returned to England he felt that he would like to visit Denmark where his ancestors had their origins, in order to learn something about them and if possible to find where they were buried. After enquiries in Copenhagen he discovered that the name Hansen was most common in the Skagerak and Kattegat; so eventually he arrived at one small island on which nearly everyone possessed his own name. The harbour-master, who combined his job with the position of mayor, could only speak Danish; so an islander was summoned who was reputed to speak good English. A short dark man appeared, and indeed his English was good, but surprisingly overlaid with a broad Welsh accent. He was obviously not a native of Denmark.

Hansen asked him why he had come to the island, and the Welshman replied that that was his own business. From churchyard to churchyard they went, gazing at hundreds of Hansen tombstones, and in each place my friend repeated his question, only to be met with the same refusal to answer. Finally he discovered the graves of his forbears, and on the quayside, as he bade farewell to his Celtic guide, he made a final request.

'Why, please, why did you come to this island?'

The Welshman looked at the ground, kicked a few stones as he made up his mind. Then 'All right,' he said, 'all right, I'll tell you then. It was more than twenty years ago I suppose and I was farming in the hills above the Glaslyn Valley in Caernarvonshire. One day Megan, my wife, came back from Portmadoc market with a bright yellow scarf in her basket. "Look, Ifan," she said, "I've bought this to

go to chapel on Sunday." Damn it was an awful thing that scarf, so I told her straight: "Megan if you wear that thing for chapel, I'll go away and never come back." Well, you know, sir, what women are like, for sure enough what does she do but go off to chapel the next Sunday with that horrid thing! "Damn," I says, "what a thing to do!" Making a fool of me she was. Anyhow, I didn't go off, but by damn I warned her that if she wore it once again for chapel I certainly would and that was that. Come next Sunday and there she was, going out of the house with that thing around her neck again. Defying me she was, and you know, sir, a man must have his pride. I watched her until she went through the gate at the bottom of the fields. Then I packed a bag and walked down to Portmadoc where a schooner was due to sail with a cargo of slates.'

'And it brought you here?' enquired Hansen.

'Yes, by damn, it bloody did, and I'm bloody not going back neither.' The Welshman looked defiant He spat fiercely into the water, then turned and disappeared among the warehouses on that distant quayside.

Small wonder that Jack could find no body in the Ynysfor pool.

Hunting and shooting, with a constant interest in birds and animals, became my real hobbies, if such destructive pursuits can be classed under that term. I continued to wage war on the rabbits and pigeon in the fields around the house. Once Bonzo, chasing a rabbit in an open drain, followed it under a stone wall and into an outlying covert of the Wern estate. Inside I could hear an unusual amount of barking; so, wondering what was going on, I unloaded my gun and climbed over the wall. There I saw Bonzo trying to get to grips with a very large black tomcat that seemed determined to stick its ground and not give an inch to the ferocious little terrier's assaults. Then I saw that it had one leg held firmly in the jaws of a steel trap. It didn't take me long to catch Bonzo and spring the trap. As the cat bounded away through the rocks, a man appeared from behind a tree.

It was Gordon Brill, the underkeeper, and one of a large family who we always considered to be friends. Old Brill, Gordon and I often went down the Ystumllyn bog to find nests of snipe and duck; so I greeted him as I always did. To my amazement he screamed at me in a high-pitched voice. He cursed me and threatened me, and finally said he was going to see his master, Mr Greaves, and hoped I would be prosecuted.

Shaken, not only by the threat of the police court, but also by the startling change in one whom I had regarded as a friend, I returned home and told my father.

'Get on your bicycle at once and go and see Mr Greaves,' he said, adding 'and I hope you get there before Gordon Brill.'

But of course I didn't. The butler ushered me into the large music room, where an old man was standing, tall and menacing. Once again I heard the curses and threats, but this time they were uttered with greater sophistication. Once again I was disillusioned, as only the previous Sunday we had all been to Wern for lunch with Mr and Mrs Greaves after church at Penmorfa. The tired bitter voice continued its heartless demolition as I stood terrified in that bleak room. I somehow felt surprised that I should be such a threat to his security—he, Dick Greaves, a man of substance, an owner of slate quarries and one of the biggest landowners in the neighbourhood. He finally let me go after making it abundantly clear that it was only his generosity that saved me from prosecution.

6

I entered Shrewsbury in January 1931 and joined my brother in Mr Mitford's house.

This was a disaster, as Cuthbert William Mitford was a pathetic creature who, after a Victorian education, had obviously feared the cut and thrust of the outside world, and had crept back for sanctuary to the womb of a public school. On leaving the university he had taught at Highgate, and his landlady there had been Miss Mary Josling. Fifty years later I was to be looked after by the same kind and remarkable person, and she told me how once she had had to bail Mitford out of Bow Street magistrates' court for removing a policeman's helmet on Boat Race night. This was the only human act that I had ever heard associated with my housemaster, and it was a pity I didn't have the knowledge of it when I was under his sadistic care in his house at Severn Hill.

Mitford had never grown up, knew nothing of what life was about and should never have been put in charge of boys. Furthermore, he had his favourites, and invariably these were the ones who were good at games or whose parents had plenty of money. These boys were of course made house monitors, and to them he delegated all power and discipline. From the safety of his study he condoned the appalling

sadism that only boys can inflict on each other, and small boys lived in constant fear of beatings.

For me Mitford reserved a particularly brutal kind of psychological warfare. When I arrived at his house I was the smallest boy in the school, a mere 4ft. 10in. and four stone ten. Mitford seized on this as a golden opportunity to exercise his warped sense of humour, and no chance was missed to make jokes at my expense; even when I was in my last year, and still pathetically small, he insisted that I should play the part of baby in the house Bump Supper play. He sat back and roared with laughter every time I appeared. It was hardly surprising that for years afterwards, when I had in fact attained the respectable height of 5ft. 10in., I still imagined myself to be a dwarf and always had to make a mental adjustment whenever I met people.

Cuddy Mitford was tall himself, with a head like a pea, small features, crinkly fair hair and gold-rimmed glasses. His long body surmounted two short bandy legs that caused him to waddle like an ill-proportioned giraffe.

As soon as I was settled in his house, Mitford decided I was too full of myself, and a campaign was started to break my spirit. Whenever I opened my mouth a monitor cut me short with terrible sarcasm and sometimes with a beating in the changing-room. All small boys were to be seen and not heard, and one so small as I had to remain entirely mute. Term after term the process of breaking me went on, until eventually they succeeded.

Mitford must have spoken to the headmaster about my unusual liveliness, for at the end of one term there was the comment at the end of my report: 'He could do well with a pinch of modesty.' For a tiny boy in the next to bottom form, with no great ability at games and no other attributes, this was a masterly summing up.

The headmaster in 1931 was a rubicund cleric called Canon H. A. P. Sawyer, who knew the name of every boy in the school and was adored by them all. He had been a junior master at Highgate and had also lodged with Miss Josling. He was utterly unworldly and would give anything he had on him to any beggar, to such an extent that Mary Josling had had to act as his banker and dole out weekly pocket-money. He was notoriously forgetful. His most famous lapse was when he went down to Shrewsbury station to meet the great man who was to give away the prizes at Speech Day. When the London train steamed majestically into the station Canon Sawyer leapt on board and was carted off to Chester.

My troubles were considerably ameliorated in the house by the presence of Dick. As a scholar, Dick had escaped the jungle of the Lower School and was firmly established as one of the promising

members of the house. He kept an eye on me and even helped me with my prep. Life would have been unbearable without him.

My first form was Lower 4 2B, which was presided over by a vague and humorous young man called George Simmons. He endeared himself to the boys by not conforming exactly to the normal image of a schoolmaster. As an officer in the O.T.C. he often prefixed his orders with 'The Company will, God willing and my puttees staying up, form close columns of fours'.

I found that my neighbour at the double desk was a very large, and obviously very stupid, boy. The morning after our first prep we were questioned, and we set down our ten answers on a slip of paper. The fat boy gave me his, adding, 'Give me eight correct and two wrong.'

'What?' I whispered.

'Fill in eight correct and two wrong.'

'No,' I replied, horrified at his suggestion.

He kicked me under the desk.

'All right then! If you don't, I'll beat you up behind the Fives courts after school.'

I looked at his size, his muscles, his ugly face; I thought of my upbringing at Tre-Arddur House, of my conscience, of honour. Then I considered my size and my chances against such a huge adversary. I filled in eight correct and two wrong.

Cheating, I soon realised, was the accepted way of getting out of the Lower School; I also noted that the larger boys terrorised the smaller ones into doing their work for them. The seating in the form room was so arranged that the top boys sat at the back and the most lowly in the front. It was noticeable that the successful toughs were as far away from the master as possible.

I was invariably bottom of the form. This was not due entirely to my stupidity, but mainly to the fact that I didn't cheat—which was not so much a question of honour or morals as of my terror of the dreadful retribution that would follow if I were found out. While my brother was the physical replica of my mother's father, I was at this time temperamentally my mother's son, and had inherited her fears and apprehension.

As the appalling reports came in termly, my poor father must have wondered if he had saved in vain to send me to Shrewsbury.

'Never in my whole experience of teaching have I met a boy with less ability,' wailed the Maths master.

'This boy has no power of lucid thought,' wrote the man who taught me English.

Mitford confirmed their opinions by saying that it was a pity I was the despair of my teachers. The amazing thing was that the masters

seemed sublimely unaware that the placing was entirely false, and that credit was always given to those who cheated most ruthlessly.

I did eventually emerge from the mess of the Lower School, but even then my form master Mr Key refused to be held responsible for getting me through my School Certificate. I was removed from his form and placed under the benign supervision of one David Bevan, who by his solid gentle confidence helped me immensely. 'Heute beginnen wir Deutsch zu lernen,' he wrote on the blackboard, and somehow the words were music. I was beginning to understand.

When I took my School Certificate I got a credit in every subject I took except General Science, and I did at least pass in that. My father's rather tattered faith in me was vindicated, and a series of letters to the headmaster reproved him for underestimating me for four whole years. The headmaster, who by this time was the military Major Hardy, counter-attacked and backed up his masters. There was a cutting and thrusting correspondence, at the end of which my father said that he had lost all confidence in the school and consequently he was going to remove me.

I was never happy at Shrewsbury. This of course was mainly due to Mitford; but, apart from him, it was a hard philistine place in those days. Boys only associated with others of their own house, and when Mitford saw me walking across the school site with a member of my form who was not in Severn Hill, he inquired whether I considered the members of his house to be unworthy of my company.

There were puerile traditions and wicked taboos. Day boys, scathingly called 'skites', were considered to be socially inferior, and it was deemed to be an honourable act to hurl one off his bicycle into a bramble hedge as he made his way home.

In our house any boy who arrived with a trace of an accent was given a month to get rid of it. A tutor, another small boy who had passed the test, was appointed, and if at the end of the month the boy was unable to say 'How now brown cow', he was beaten, and the tutor as well. I suffered agonies, both mental and physical, when I was made tutor to a north-country boy called Kenneth Crowe. His accent was broad and generous, but to the monitors he was eminently beatable. Day after day I coached him to no effect, and as the fearful month came to its close I knew that I was to be sacrificed.

In the bedroom one night, after the light had been put out, the bedroom monitor summoned Crowe to his bedside. 'Now then, say "How now brown cow",' he snapped. I shivered as I heard the well-remembered 'Haa naaw braan car' echo round the room. Kenneth Crowe was duly beaten, and then I was called from the depths of my bed to receive the same unjust punishment. I suffered many times on

Crowe's behalf, and I suppose that eventually his individuality was ironed out and he spoke in the same way as the rest of us.

Sometimes a refined type of sadism took place. The heel of a bedroom slipper would be removed, exposing a horseshoe of small villainous shining nails. This would be pressed sharply into the backside of the offender. A horseshoe branding of small pimples of blood would mark the spot, and hygienically an acolyte would anoint it with iodine.

Beating was carried to ruthless lengths by the hearty sports-minded monitors. Once or twice a term they would carry out what were known as 'strafes'. Together they would question the small boys to see if they had carried out their full commitment of sporting activities during the week. In the winter we were supposed to play football twice, play fives twice, go for a four-mile run twice and spend twenty minutes in the baths twice. In bad weather this was impossible and it was then that the captains of games would pounce. In desperate attempts to avoid the inevitable, we made alibis. 'Yes, Robinson, I went for a run on Friday with Bailey.' Bailey would be questioned and say that he had gone for a run on Monday and Thursday. Sadistic joy filled the hearts of the monitors and we were taken off to the changing rooms where, draped over the hot-water pipes, we were beaten. They always got their man and their little bit of unhealthy pleasure.

When Dick became a monitor he was the only one in my experience to refuse ever to beat a boy. This took considerable courage, but he had never been beaten himself, and with the others much of their brutality came from getting their own back.

When we won the Ladies' Plate at Henley in 1932, there was an upsurge of mass hysteria. I was caught up in an ecstasy of wild exhilaration. Bands of boys raided the science block and the main school building, turning on fire hoses, clambering on roofs to hurl down reeking dog-fish, retorts and other bits of equipment. The situation was out of hand and masters, realising this, just melted away. The boys were in command and anarchy reigned.

Suddenly someone shouted: 'Let's get Dunn!'

Mr Dunn was the grumpy and officious toll-gate keeper on the Kingsland Bridge, who aroused the continual hatred of the school by pouncing out of his hut to demand our precious pennies.

'Yes, let's get Dunn!' we screamed. 'Let's throw him into the river!'

Not realising that to do so would inevitably mean his death, such was the height of the bridge, we swept down the hill, a vast phalanx of heaving, sweating boys in the grip of something beyond our control.

Dunn must have heard us coming, for as we reached the school end of the bridge he leaned out of his hut to see the mob and to hear the

yell, 'Into the river with him!' Dunn was a brave man and decided to stand his ground. He just had time to dive into the hut and emerge with a broom, which he held like a battle-axe in front of him, ready to strike the first boy to reach him. We were on him; back went the broom to strike, and strike it did, not forwards but backwards and hard on the innocent head of Mrs Dunn who chose that moment to come and see what was going on. There was a thud and Mrs Dunn fell flat on her face. The mob was silenced; Mrs Dunn was unconscious; Dunn's life was saved. Embarrassed, we raised the limp figure and carried her to the hut. We muttered apologies; Dunn yelled abuse. Slowly, ashamedly, we wound our way back across the bridge and up the hill, a beaten army in retreat. The riot was over.

The next edition of the school magazine carried the following epitaph. 'We have Dunn unto Dunn those things we should not have Dunn unto Dunn.'

As a small boy I had a reasonable treble voice so I found myself in the school choir. Garbed in a white surplice and rich red cassock, I had my moments of glory, seated in the choir-stalls above the ordinary mortals, amazingly close to the headmaster.

Although I could understand little of what was said or preached, I nevertheless enjoyed the evening service on Sundays. Atmosphere and tradition gave me a feeling of security that was only spoilt by the thought of another week starting with first period the following morning. Even though I realised that Christianity was basically a good and beautiful religion, I could never really feel myself to be a true member of the Church. Worship I never understood, and as for the devil who every Sunday night was referred to as 'like unto a roaring lion seeking whom he might devour', I neither feared nor believed in him. When it was decided that I should be confirmed I weakly attended the classes held by Mitford and the Chaplain, but remained baffled. Cowardly, hypocritical, I accepted the laying on of hands.

None of us had any confidence in the chaplain. 'Human beings,' he announced with his eyes on the floor, 'are like unto peaches. They are smooth and beautiful on the outside, but deep in the centre there is a nasty gnarled stone, and this is sex.' After that we lost all faith in him.

In spite of my size I was fairly good at games and certainly enjoyed them. One day I found, to my alarm, that I could run long distances without getting tired or out of breath. If it had become obvious to the house running authorities, my life would have been spent chasing across the fields of Shropshire in competition with other houses and perhaps other schools. My natural lethargy shortened my stride and I never even represented my house.

Although I disliked the school, the town and the countryside were a continual source of joy to me. Visits to various relatives did much to alleviate the misery of school.

My Lloyd relations had come from Whitehall, a lovely old William-and-Mary house near the Abbey, and many of them lived in the town when I was a boy. The family had been ruined by the conscience of my great-grandmother's brother, the Rev. Thomas Lloyd. He was the rector of St Mary's, the finest church in the town, with a magnificent spire that was reckoned to be the next highest to Salisbury Cathedral. One stormy night it was struck by lightning, and Thomas Lloyd, feeling this to be the judgment of the Almighty on his priesthood, undertook to rebuild it from his own pocket.

When I was at school, the Lloyds were scattered round the town: the cheerful, aristocratic Ernest Lloyd and his family near the school; Cousins Alice and Polly in Dogpole; and Hattie and Edie in St Mary's Place. There was also a legion of Butler Lloyds who by name announced their relationship with the school and Samuel Butler. Apart from Cousin Ernest and family, I suppose I knew old Alice and Polly best, and I used their little house in Dogpole as a Sunday refuge; but Hattie and Edie were the most fascinating, obsessed as they were with the moral welfare of the girls of Shrewsbury. Garbed in nun-like outfits that were entirely personal, they flitted shadow-like here and there through the back streets of the town, purposefully bent on their good works. I don't remember them smiling and, although fascinated, I was secretly frightened of them.

Shropshire was full of my cousins. I was related to Corbets, Dugdales, Hunts and other old county families. Some I visited during the term. Sidney Dugdale always gave me a half-crown when I visited him and his family in the Clun Valley, but my favourite was Daisy Price, a bouncing little apple of a woman who lived with her sister Agatha in a small, square, red house near Oswestry, sited in a garden that seemed to attract every nesting bird for miles around.

When not down in the town I roamed about the countryside, usually on my own, since I found great difficulty in forming friendships with the boys in my house. They were for the most part the townbound sons of wealthy northern industrialists, and their home life was obviously very different from my own. Possibly the nicest were the Dehn brothers, Paul and Eric, and their cousin Roy; they seemed to find good in everyone, including Mitford, but then, perhaps more discerning than I, they were, at heart, sorry for him. Richard Wainwright, a shrewd and subtle little boy from Yorkshire with a large, serious head, was adept at avoiding trouble, while his wealthy friend David Gieve, of the Bond Street Naval Tailors, bullocked his

way around the house. We called him Malta-Gibraltar, which offended him considerably.

There was bullying, and one physically weak boy called John Slater Boddington was kicked, pinched and sat on unmercifully, but nobody, not even Boddington would have thought of breaking the public-school code of honour. So Mitford was never told. Perhaps we realised he would hand over the problem to the monitors and it would remain unsolved.

I remained at Shrewsbury for only one term after passing my School Certificate, and that term was to be the least unhappy. As I was leaving, I was put into a form composed of fellow-misfits, and our form master was a new arrival called McEachran.

On the face of it we were a potential threat to any master, since we were without aim or direction and were merely filling in time. I felt sure that McEachran's life with us would be one of constant misery. But his remarkable personality and contagious enthusiasm for litera-ture won the battle before it had even been joined. Poetry was his passion and he wanted us to enjoy it as well. He couldn't have had less promising material; and yet in no time we had fallen completely under his spell, for he hypnotised and drugged us with beautiful sounds.

Morose and silent, Richard Hillary sat at the back of the classroom. He was one of the non-co-operators of the school, a boy who seldom smiled and always stood on his own, apart from others, as if he some-how disapproved of his schoolfellows. Perhaps it was McEachran's enthusiasm which penetrated his reserve and struck a response in him that later materialised in his book *The Last Enemy*.

The previous year, I had gone with the O.T.C. to camp at Tid-worth. On the morning we were to leave for home I woke with a ter-rible headache and a feeling of weakness clouding my whole body. I stumbled rather than marched to the station, and I can remember Dick taking my rifle from me and carrying it with his own.

Back at home, after a journey of which I remember little, I was put to bed, and there I lay for two weeks, feeling that my head would split and only vaguely conscious of the frequent visits of the doctor and the ministrations of Miss Roberts the nurse. On about the fourteenth day everything cleared and I gradually improved. By the end of the holi-days I was completely fit and the illness forgotten. But what I had really been suffering from was meningitis, and its scar was to stay with me always. My mother didn't know until many years later, but by that time Dolly Lloyd had become a memory, and maybe the familiar words 'Poor Dolly, she should have been allowed to die' had ceased to ring in my mother's brain. She never outwardly connected the two cases, but then we never knew what she was feeling or thinking.

I left Shrewsbury at the end of the Christmas term in 1935, and nobody could possibly have said that my schooldays had been successful. One thing I had achieved: I had won Mrs Hardy's art prize. Even so, the pride of my achievement was small since only one other boy entered for it and Mrs Hardy, the headmaster's wife, was some sort of relation.

As Dick and I grew up, our sporting activities began to follow different paths: I longed for the loneliness of the fields, hills and marshes, and I was always wandering away with my small dog and gun. But Dick stayed at home, as if for security. When he wasn't reading, he was playing cricket, rugby, tennis or golf, at all of which he excelled. I often felt that he was uncertain of the rules when faced with the open spaces and therefore was naturally drawn to games in which it was laid down just what could and could not be done. Within these limits Dick went to the utmost in vigour, subtlety and courage.

He also hated hurting anything; so bloodsports were impossible for him. I only once remember him shooting, and that was one day when we tried to reduce the rook population at Ystumllyn. With his first shot Dick winged a bird. It came down tattered and awkward, to land a few yards away from him. I looked through the trees to see him standing, as if paralysed, with his eyes on what seemed, from the loud cawing, to be a very angry rook. Any bird flying is an object so detached as to seem abstract, but one on the ground, still alive, is reality. Faced with this situation, Dick's kind heard would not allow him to finish it off. I did the job for him, and from that day I don't believe he has ever killed a living creature.

When Dick played cricket for Portmadoc I often went with him and did actually play for the club on several occasions. They let me in, I felt, because they hoped that one day I might possibly emulate the feats of my brother. I had a cousin, another John Williams, who also played and was a very cunning bowler. One day when we were playing against Tywyn, Dick and John were the two bowlers, and whereas Dick had had no success at all, John had taken nine wickets. Foreseeing a unique feat of bowling, and fearing that Dick might spoil it, Will Hughes, the captain, decided to take him off and bowl himself. He sent down hopeless, impossible balls until John had collected his ten wickets and local fame.

When I first joined the club, we boasted two professionals, who by some strange coincidence were called Pike and Rudd. Pike was large and fatherly while Rudd was small and bow-legged like a jockey. They both wore cricket caps encircled by the club colours of green and slate.

Of all the clubs we played—Pwllheli, Bangor, Llanwrst, Tywyn

and many others—none presented quite such a challenge as Parciau, a team captained and organised by Colonel Lawrence Williams. In a clearing near the barrack-like house on his wooded estate in Anglesey, the old Colonel had made a very attractive cricket ground. He kept a permanent professional, but his mainstay was the droll and gangling Sandy McNab, who was a Free Forester and a very subtle bowler.

Sandy had first arrived at Parciau as a school friend of one of the Colonel's sons, and had become so enamoured of the place that he had settled down as a permanent resident. He was immensely popular, a brilliant shot and well known to every publican on the island. One evening, after some heavy drinking, Sandy lost control while driving past the Bull at Pentraeth and ended up in the field opposite the pub. Recognising the car, the publican dashed across the road with a glass of Scotch, so that when the police arrived he was able to say that the smell of alcohol emanating from Mr McNab was from the whiskey he had given him to steady his nerves after the skid.

Everyone liked Sandy, but the Colonel was the enemy. Not even Sandy in his cups would have said he was a good sportsman, since he used every trick he could to avoid defeat and had a very sharp temper. Will Hughes, our captain, used to brief us that it was imperative to let the Colonel break his duck; but as soon as he had, all hell was let loose as the field crowded in, determined to get the old man back in the pavilion as soon as possible.

One day we went over to find a formidable array of Free Foresters awaiting us. Dick went in and soon hit a magnificent six, the ball landing in a wood adjoining the ground. The umpire duly acknowledged the fact, and was promptly reprimanded by the Colonel, who said it was only a six if the ball cleared a wire fence in the middle of the wood. The umpire corrected his decision and signalled a four. Meanwhile Dick was flexing his muscles and, when the next opportunity came, away went the ball far into the wood again, beyond any possible wire fence. The umpire hesitated for a moment, looked at the Colonel and bravely signalled a six.

Visits to Parciau were the highlights of the cricket calendar, and however much we disapproved of the Colonel we were always grateful to him for the challenge he offered us. I don't think we ever beat him; I say 'him' because it was always the Colonel we were bent on humiliating, and not the team.

The most elegant bat in the Portmadoc team was undoubtedly our family doctor, Teddy Morris. He was tall and distinguished-looking, and radiated the confidence of the public school boy. He cut, glanced and drove with confidence and with equal confidence sat on the edge of our beds when we were ill. I don't know whether he was a clever

doctor or not, but the arrival of Dr Teddy Morris at Plas Gwyn, spruce and immaculate, always swept away what medical fears my mother might have harboured.

Teddy Morris was also one of the stars of the Criccieth Tennis Club, where certain local people, carefully screened to keep out the trade, disported themselves throughout the week and especially on club day, which was the Friday of every summer week. On club days, elderly laced matrons and ancient retired men sat and watched while the younger ones cracked the ball back and forwards with varying degrees of efficiency. Every week a lady member provided tea, cakes and sandwiches, and occasionally meetings were held to survey the applications for membership. The most ferocious black-baller was Colonel Armstrong, a pink rotund man with a grey military moustache, who always assumed the role of Marshal Pétain at Verdun. If the names of local tradesmen appeared, 'Ils ne passeront pas' was his motto, and the club was kept select and without character.

It was whispered that the Lloyd George family had once applied for membership and had been rejected by those who remembered their humble origins in nearby Llanystumdwy. Only once a year did a member of that notable family appear on the courts, and that was when Megan Lloyd George entered for the Open Tournament.

The tennis courts at Criccieth enabled me to ignore my father's continual admonitions that I shouldn't 'go bang at things'. Tennis balls just asked to be hit, and I clouted them with the utmost vigour and the most incredible inaccuracy. At one end of the grounds I was continually retrieving balls from the railway line, and at the other from the thistle-covered field that sloped away to the sea.

Gradually I attained a magnificent forehand drive that was practically unreturnable and certainly if it was returned I was so surprised that I lost the point. However hard I tried, I was far too impulsive to be a good player, and while Dick won cup after cup, I only managed a silver soda-syphon holder as runner-up in the mixed doubles in the club's close tournament. Ungallantly I forget my partner's name.

The great week for the club was when the Open Tournament was held at the beginning of August. It was really a very high-class affair, and Wimbledon players sometimes appeared, to add distinction. Dark green canvas covered the wire-netting barriers and preserved the spectators from the furious rushes of the more agile players. During this single week the club took on a new air, and Criccieth was proud of it. I think it is fairly safe to say that no member realised that during the same week every year the National Eisteddford was held somewhere in Wales. No member could possibly admit to an interest in culture, even if only amateur culture.

The Open Tournament had its heroes and characters who appeared year after year. A tall, loose-limbed buccaneer called Hollins won one year, and an energetic square man with the fascinating name of Antrobus came near to it several times. Wales was represented by the Rev. Tudno Jones, and I supported him enthusiastically until he met his inevitable defeat early in the week.

I suppose the most notable performer was a chunky, balding man called Slater, who played with little *élan* but considerable cunning. Two years in succession he won the men's singles, and then the club, fearing he might win a third time and so make the cup his own property, rather shamefully invited Lt. Commander P. F. Glover, R.N., the Navy champion, to compete. He and Slater were at opposite ends of the draw, and eventually they both won their semi-finals. The clash of the giants was at hand and the club waited confidently for the eclipse of Slater. They would no doubt have engineered the desired result had not their plans been scuppered by the arrival of a telegram recalling the Commander to his ship. Slater got a walk-over and departed with the cup.

The youthful prodigy of the Tournament was Johnny Briggs, whose father had a holiday house in Criccieth and was a member of the club. Among a flapping throng of long white flannels Johnny had the temerity to appear in shorts. In those days it was practically indecent, and the matrons sniffed. His serving fascinated me, and I used to position myself strategically so that I could see his eyeballs; when at service, Johnny's body swayed elegantly, his arm reached back and upwards and at its zenith his face became so contorted that his pupils disappeared altogether and two shining white orbs occupied his eye-sockets.

In my early days of membership, watching Johnny Briggs was the high point of the Tournament week, until I fell for a long-legged red-head called Nancy Smith. When I saw her scampering gazelle-like across the courts, Johnny's eyeballs were forgotten as I followed her fortunes from court to court with trembling heart. I suffered agonies as I watched her being eliminated from the women's singles, from the women's doubles and finally from the mixed doubles. I was in despair every time the fair Nancy bravely shook hands with her conquerors.

The female counterpart of the crafty Slater—the masculine conqueror of the courts—was Thelma Cazalet, who dominated the Tournament not only by her skill but also by her personality. She was dumpy and inelegant, and with her voluminous skirts, from which two tiny feet emerged, she looked strangely like a peasant doll. Almost hidden under an immense eye-shade appeared a sensitive and intelligent face. She was a supreme mistress of tactics, and standing almost

motionless on the base-line she tied her more youthful opponents into inextricable knots; and she was the only player who served under-arm. These services were quite devastating; struck from almost ground level, they suddenly appeared over the net to surprise her opponents by their speed and accuracy.

Thelma Cazalet always seemed to win, and I have memories of her tiny figure being driven away on the last day clutching a silver cup almost as big as herself. Her doubles partner was always Megan Lloyd George, though I don't think they ever won.

Every summer the Border Counties otter hounds came to South Caernarvonshire to hunt the rivers that flowed through the old Ynysfor country. The Jones family had long since given up the pursuit of the otter, as it made the hounds too slow when hunting the fox, but it was still their country and the B.C.O.H. came by invitation.

Hunting seemed to the Border Counties to be mainly a holiday pursuit with a bit of the festival thrown in. A few enjoyed a kill. This appeared to be a necessary blood-letting to the cheerful landowners, stockbrokers and businessmen who made up the hard core of the hunt. Also it gave them the maximum amount of pleasure for the minimim expenditure of energy.

Some locals joined them. Ancients, too lazy to indulge in more vigorous exercise, saw in this invasion a welcome opportunity to show off a manly interest or a decrepit hunt uniform. As otter hunting was so obviously a holiday and social occasion, hounds met late in the morning, and even if they were in the middle of pursuing an otter they were invariably stopped at lunch-time so that the hunters could consume their cold chicken and wine in comfort.

There were usually about sixty happy talkative people at the meet. The members of the hunt wore the uniform—a blue tweed jacket with red lapels, blue knickerbocker breeches above red stockings and strong black shoes. If they wore a hat it was of the Homburg type in grey and with the Hunt colour swathed round it. The Hunt servants were distinctive in their boots and deer stalkers. The women wore the same tweed over a white blouse with blue tie, sported Henry Heath hats and wore blue stockings. All carried tall otter-hunting poles, on which were carved notches for every kill.

The arrival of the hound van was a great moment. The grim little huntsman sat in the front with the driver, while the two cheerful whips leaned over the wooden bars at the back, keeping in order the baying hounds that remained invisible under a green tarpaulin. A word from the master, and the hounds spewed forth, a motley rabble of pure otter-hounds, pure fox-hound and real half-castes.

The huntsman blew his horn and away they went to the river bank.

I joined the hunt for several reasons. I am by nature a countryman and a hunter; I love the cry of hounds and the craft of hunting and I loved the rivers where the otters lived. Unfortunately I loved the otters as well.

As the hounds eagerly covered the river banks, Jack and Evan Jones, who had hunted these waters years before, meeting early in the morning and with only a few friends to make up the field, remained inconspicuously in the background, viewing the pantomime with a certain cynicism but always ready to dispense their great knowledge if called upon by the master. The field usually split into two groups; one massing the banks to view the possible chain of bubbles that showed an otter on the move, and the other laughing and gossiping in the buttercupped meadows.

Sometimes the country was at its best. The sun shone; the water, glistening and racing, sang as it ran down towards the sea. I always enjoyed it most when we met on one of the mountain streams, for the country was most beautiful and the chances of killing an otter were very slight. Here were fast-running streams, waterfalls and deep pools, and the voices of the hounds in the gorges created glorious echoing music.

One day, after meeting at Tan-y-Bwlch in the Maentwrog valley, hounds found an otter on the low-lying tidal stretch of the Dwyryd and chased him up in the deep gorge where the river Prysor crashes down from Trawsfynydd in a series of waterfalls. It was a slow, unsatisfactory hunt for the hounds, for they were unused to the precipitous slopes and dangerous water that swept over rocky ledges to deep green pools below. Eventually under a tall waterfall the hounds became silent, and word went round that the otter had indeed been killed and its body had sunk to the bottom of a deep slimy pool.

The Border Counties had their man for such a moment. Bravington-Smith, a tall grizzled ex-England rugby player, who always wore hunt uniform with blue shorts instead of knickerbocker breeches, volunteered to retrieve the body. He took off his coat, his shoes, then his snow white shirt, and with a faint breeze playing on his hairy chest he stood for a moment, an heroic figure on the rock above that black pool. There was a gasp of admiration from the ladies as with a superb dive he plunged downwards and out of sight beneath the chill waters of the Ceunant ddu.

We waited silently until in the middle of the pool a grey head appeared. Bravington-Smith brushed the water from his mouth with one hand. 'I've got it!' he cried, and a cheer went up as he made for the rocky bank dragging a sodden weight behind him.

Admiringly we watched as he scrambled ashore. The masculine rugby torso emerged, and he stood like some Greek water-god with the river Prysor lapping his mighty frame. 'Here he is!' he cried, and raised the object above his head with a great muscular heave.

No cheer went up now, for we saw to our horror that the object was no otter but the decomposing body of a mountain ewe.

Bravington-Smith dropped it with a roar and scrambled back on to the rocks as it slowly disappeared once more to the depths from whence it came.

Someone laughed, but a hunt official silenced this unsporting out-burst with a withering glance. Someone said, 'Bad luck, old boy,' and a murmur showed that everyone agreed. The horn blew and slowly we left that horrid place and made our way down to the welcoming meadows of Maentwrog.

It was in the low-lying land of Lleyn, where the streams ran narrow like gutters, that the Border Counties Otter Hounds found it easier to kill, but even so, without the help of supporters who screamed their 'Tally Ho's', they would have been hard put to it to win a victory.

The Erch, the Soch and the Cymerau—these were the rivers that gave the hunters a chance to carve yet another notch on their poles, and it was on the Cymerau on a hot and lovely day in August that I witnessed a so-called hunt that will leave me with a feeling of shame every time I remember it or pass that way.

Near the bridge below Penmaen and the Bodegroes woods the river flows silent and narrow between reedy banks and poor meadowland. Nowhere is it very deep. In this large ditch they found an otter. Hounds' voices broke into a great chorus that brought the hunters running to line the banks and gaze down with excitement to catch a glimpse of their quarry. Brave men leaped into the water up to their waists and formed barriers of legs and hunting poles that hemmed the otter into a strip of water a hundred yards long. The banks were solid with people, the river was blocked as effectively as if there were lock gates; and in this overpopulated piece of water was one otter that had no hope of escape. The huntsman callously threw thirty hounds into the muddy gutter.

I should have gone home then, but somehow I couldn't tear myself away from the scene. This wasn't hunting, this wasn't sport; it was killing, and everyone seemed happy at the thought of it, and savoured the agonies of the animal they said they admired.

A small head came up to breathe among the reeds, but he was spotted immediately and the whole pack was hurled in as the otter slipped away into the churning mass of water. Soon the olive green

was turned to the brown of milky tea as the mud was stirred up by the threshing hounds.

'There he is!' came the cry twenty yards away. 'Tally Ho,' came another cry further on, as the tired animal surfaced more frequently from weariness.

The sun beat down on the festival scene. The well-lunched field was getting its money's worth and was joined by hordes of locals who had heard the noise of hounds and hunters.

An hour went by, and still the otter avoided the frustrated hounds. Sometimes its whole body could be seen as it rolled over feebly, to dive again from the snapping jaws. The human barrier or stickle moved inwards: heartless men determined to destroy. After about an hour and a half the hounds were almost snapping at themselves as they swam in this ever-decreasing pool with the half-drowned otter somewhere between their legs.

A pathetic head poked up between the reeds near a large fox-hound. Hound saw otter and lunged forward to kill. Amazingly, there was just enough strength left for the otter to slide away, but the jaws bit somewhere into that drowning body so that the muddy water was stained with red.

The slow murder continued until there was a sudden silence. It seemed as if the otter might have managed to slip through the stickle or creep into a drain in a last effort to elude his tormentors. The people on the banks waited, the stickles were motionless, the hounds were mute. Then slowly a brown body rose to the surface of the muddy water. It was the otter and it was dead. Dead not because it had been killed by thirty hounds and sixty men, but because it had drowned. In one way I suppose it had won a victory since they were unable to take it alive; but the hunters didn't think so. There was a cry of triumph and the huntsman leaped into the water to drag the corpse from the frenzied hounds.

Cheerfully they brought it ashore; jolly men and women crowded round as it was ritually dismembered. The rite had been observed, the festival was over. Happy people retired to the road to unload hampers, to drink whiskey and cups of tea and to eat cool cucumber sandwiches.

7

I was born with an uncontrollable imagination and always dreamed of performing deeds of unbelievable valour. I scaled previously unconquered peaks; I saved beautiful damsels from most fearful situations and scored more tries for Wales at Cardiff Arms Park than any other Welsh Walter Mitty.

One of my most persistent dreams was of Ensign Williams charging at the head of a troop of cavalry, sword flashing, the thunder of hooves in his ears. But early suggestions that I should join the army, and of course it had to be the cavalry, were turned down by my father because of our lack of wealth. The idea of becoming a farmer then filled my mind, but this too, I gathered, needed capital. My father, realising

how much I loved the countryside, articled me to Messrs Yale and Hardcastle, land agents of Pwllheli, the biggest town in the Lleyn peninsula, and it was to them that I went when I left Shrewsbury at the age of seventeen.

We were still living at Plas Gwyn, and having passed my driving test I drove in every morning in my father's small Ford eight. Pwllheli in those days was a little market town of considerable character, lying half-way along the northern arm of Cardigan Bay. Our only relative in Lleyn happened to be a ghost. My father's rakish old godfather, Ben Ellis, who had died fifty years ago, had returned to haunt a local house in an unnecessarily violent way. When he materialised he was easily identified by the well-known twitch of his right arm, and having identified himself, he proceeded to throw people out of bed. In daylight he contented himself with twitching.

The office I worked in was sandwiched between High Street and Penlan Street and was approached by a tiny gutter of a passage. The principals, George Frederick Cunningham Yale and Donald Alderson Hardcastle, were as different as any two men could have been. George Yale was a racy member of the Welsh landed gentry, or bonheddigion. Distinguished and impeccably dressed, he drove round the estates as if he owned them, stopping occasionally to talk his anglicised Welsh to the lock-touching tenants, who respected him for his background yet seldom seemed to trust him as an agent.

Donald Hardcastle was born in Worksop of comparatively humble stock, came to Pwllheli as a young man for his health and by sheer hard work had eventually been made a partner. He never spoke Welsh, had a good Nottinghamshire accent, was unbelievably honest and was trusted by everyone on the estates. George Yale took me under his wing, and he used to drive me over the bumping roads of Lleyn as he sucked his small pipe and told innumerable stories of the tenants and their wives, shaking with wheezy laughter.

Nanhoron was the estate I liked best. The house stood, solid and stone-built, on a grassy slope in the lovely Nant Saethon, a deep valley that plunged down below Garn Fadryn to the Llangian bog on the edge of Porth Neigwl, or Hell's Mouth as it is called in English. Everything grew big there. The trees were big, the horses were big and the members of the Lloyd-Edwards family who lived there were big. One of them in the eighteenth century, a giant of 6ft. 7in., had commanded the Guard of Frederick the Great. He was so proud of his stature that he insisted upon being buried vertically not horizontally.

The estate in those days covered much of Lleyn, so I found my way all round the peninsula; and since George Yale considered that shoot-

ing was part of my education, I often accompanied Will Owen, the keeper, when he shot the outlying parts of the property.

I shot at or close to Nanhoron once a week in the winter and sometimes joined George Yale for a covert shoot in the valley. Will Owen took his beaters up to the top end while we took up our positions in rides cut in the thick hazels. There would be a distant note from Will's silver horn, and soon the woodcock came flashing over the stubby trees like bullets. It was a triumph to hit one, but with three guns we sometimes got twenty in a morning.

When I was in the office, May Gough, the last of the Lloyd-Edwards family, lived at Nanhoron. She was tall, stately, stone-blind and a benevolent snob. Once as I sat in the kennels with Will Owen he remarked, 'Mrs Gough always checks up on a person's pedigree before he is asked to shoot here.' Evidently mine had passed the test.

The Broomhall estate was the biggest and the one with which I was most closely associated. It lay east of Pwllheli and covered in all about 30,000 acres. The house, originally Weirglodd Fawr, had been rebuilt, been anglicised to Broomhall, and become the home of the Lloyd Evans family. A humble ancestor had gone up to London, qualified as a solicitor and engineered the divorce of a handsome woman on the undertaking that she marry him subsequently. The woman, he knew, was one of William IV's illegitimate daughters; so his descendants owned part of Regent Street, Beak Street and Brewer Street. The Welsh estate flourished because of this wealth and was always looked after impeccably.

Old Colonel Lloyd Evans, who had died long before I went into the office, felt that the easiest way to acquire culture was to buy the most expensive picture each year at the Royal Academy. The result of this indiscriminate patronage was a house full of large and worthless pictures. 'The Empty Saddle', 'The Cavalier's Return' and many more appalling efforts ruined what was really a very agreeable house, and embarrassed his son William who owned the estate in my time.

William Evans had been in the Navy and was young, cheerful and an excellent landlord. From his airfield above the house he used to take off and fly over his estate to look for any blemishes on the farms below. He hated red, and if he saw a ridge-tile or chimney-pot in that colour he would land, jump into his green Ford V8 and dash into the office to give orders for them to be replaced by blue or grey.

One still day he took off from his airfield not realising that there was a slight breeze from the south-west. As the plane left the cover of the trees this was enough to force it down, and William flew straight into a bank. He was killed instantly and the Broomhall estate lost a good landlord.

After I had left Shrewsbury I met Sandy Livingstone-Learmouth. He was a red-haired, red-moustached Scot from Hampshire, had married a grand-daughter of old John Greaves, the Lord Lieutenant of Caernarvonshire, and had joined the family firm that ran a slate mine at Blaenau Ffestiniog. Sandy, I soon realised, loved people indiscriminately and spent more of his time as a philanthropist than in the firm's office in Portmadoc. He was unfailingly courteous. As a fellow-Celt he understood the eccentricities of the Welsh, and they in turn accepted him wholeheartedly.

He was a keen and excellent shot, and one day suggested that I should join the 6th Battalion Royal Welch Fusiliers, adding that I would undoubtedly get plenty of good shooting if I did. I was eighteen and my sole military qualifications were Certificate A and a reasonable ability to blow a bugle, since I had for a year been a member of the Shrewsbury School O.T.C. band. Nevertheless these qualifications seemed adequate and I duly filled in my application forms.

My medical examination took place in Caernarfon. A doctor arrived an hour late, stood swaying drunkenly in the doorway and managed to ask me what the hell I wanted. When I told him, he lurched forward and caught me a wicked blow in the stomach that knocked me over backwards.

'D'you feel that?' he shouted.

Dragging myself to my feet I assured him that I didn't. He snatched the paper from my hand and shambled away into a small room where I heard the chink of bottle on glass. After an age he emerged, my papers were signed and I had passed my medical.

My commission had not come through, but nevertheless I was invited as a guest to the Battalion's St David's Day dinner at the Anglesey Arms Hotel, Menai Bridge. The first of March was a wild blustery day and Sandy had asked me to shoot duck at Afonwen before going on to the celebrations. On the edge of the pools near the sea, a biting north-east wind blew from the mountains, and the sky was ominous and the colour of mustard.

We drove separately to the Anglesey Arms and I found I was to share a room for the night with Warren Whittacker, an old friend who had applied for a commission at the same time as I had and who, like me, was still without one. The dinner was merry and while the goat was led round the uniformed company, the young officers, one foot on the table, ate the traditional leek. I, throughout the proceedings, must have consumed a small amount of beer and a glass of port. Afterwards Colonel 'Anzora' Evans thumped the piano and we all sang 'The Old Grey Mare' and 'Sospan Fach'. I went to bed at about 12.30 happy and sober.

I don't know when I woke, but I remember lying beside the open window. It was unbearably cold and I was covered in snow. There was a taste of blood in my mouth and my tongue was terribly painful. I must have become unconscious, for the next thing I remember was waking up in bed with Warren and Mrs Ellis of the Anglesey Arms bending over me, looking worried and sympathetic. My tongue was agony, but I got up, dressed and unsteadily made my way downstairs to breakfast. I don't think I ever got there, because once again I found I was in bed, my tongue was worse and everything seemed unbelievably vague. At the end of a haze of hours Sandy seemed to be carrying me downstairs, through the deep snow and to his car. There was a slow skidding drive, during which I was only briefly aware of the world around me. Before I reached home I had lost consciousness, and didn't regain it until the following day, when suddenly I saw my mother bending over me staring in fear and bewilderment. A smile of relief warmed her face as she saw my eyes open, but even then I don't remember her kissing me.

The doctor came, and whispered conversations took place in the doorway. I was kept on drugs, and a few weeks later when I felt quite well again I went to Liverpool to see Dr Henry Cohen, a dapper and confident neurologist. He examined me carefully and expertly, tapping, probing, searching and questioning. Finally he told me that I had had an attack of *grand mal* epilepsy, that the pupil of my left eye was fixed and didn't react to light and that I had no reflexes in my knees. He prescribed luminal and a foul-tasting mixture of belladonna and Irish moss, and said that on no account was I to use my brain excessively and that I should not contemplate taking any examinations.

I returned home and a few days later received my commission in the 6th Battalion Royal Welch Fusiliers.

Later in the year we left Pentrefelin and moved into a pleasant house on the Broomhall estate. It had the strange name of Doltrement, and stood on a gentle slope overlooking the sweep of Cardigan Bay and close to the village of Abererch. Protected from the southwest wind by a small church-topped hill, the stone-built houses faced each other across a road that meandered down to the old bridge over the Erch. Hydrangeas grew among the cobbles in front of the windows.

The Vicar was the Rev. R. Wynne-Griffiths, a cheery little chestnut of a man who had been a convert from Nonconformism. He was in his seventies when we came there and found it hard to carry the whole burden of the service on his shoulders. I was asked to read the lessons, and this I did, on condition that I chose my own. I now feel that I must have been a dreadful hypocrite, but it certainly eased his Sunday

labours. His sermons were always read from some tract sent to him weekly. He used to stand in the pulpit, his small red face barely visible over the top, and read to us like a schoolmaster.

'And you may escape damnation by a hair's breadth,' he read. 'Hairs and not hares, breadth and not breath, my friends,' he would explain, spelling out each word, and my father, who was very deaf at the time, turned to me and bellowed: 'Can't hear a word the old fool says!'

It was my mother who felt it her duty as the daughter of a parson to instruct him in the proper paths, laid down through ecclesiastical centuries. Often the old man swayed up the path to the front door, sat heavily in the drawing room and when he had really settled down my mother would launch her attack.

'Vicar, why did you have a purple frontal on the altar on Sunday?' she snapped. 'You know quite well it should have been white.'

'Well, Mrs Williams—'

'It's no good making excuses, Vicar. See there is a white one on next Sunday. And have you called on the Pollecoffs yet?'

The Pollecoffs, an orthodox Jewish family, had settled in a farm on the hill.

'Well, no, Mrs Williams.'

'And why not? They are very good people and send their servants to church regularly.'

'Well, Mrs Williams, you know what I feel about the Jews.'

'And what may that be?'

An unusual look of ferocity crept into the pink face of the vicar as he counter-attacked.

'I will never forgive them for what they did to Jesus Christ.'

'Stuff and nonsense!' said my mother.

The vicar staggered away to lick his wounds and a few days later, 'Can't understand the clergy these days, they never call,' my mother complained.

I was very much at home in Abererch. I got to know the people and the countryside as I wandered along the Erch below the house with the two dogs Bonzo and Wufi. There were duck there—teal, widgeon, mallard—and plenty of snipe. As it was part of the Broomhall estate, I was able to shoot as often as I liked.

The dogs made a magnificent pair. Bonzo had a wonderful nose, but he only retrieved for his own consumption, whereas Wufi, a handsome and energetic Welsh springer, presented to me by Sandy, had a poor nose but was reasonably efficient as a retriever. He had an immense respect for my shooting which was entirely unjustified, and every time I fired he assumed I had brought something down and was

off bounding and leaping, hurling himself into rivers and pools, over walls and barbed-wire fences, running himself breathless in his enthusiasm. I am afraid he was usually disappointed, but his faith in me never left him.

One day, as the dogs optimistically searched for a duck I had missed, I heard a well-known voice behind me, 'John, your dogs lack discipline.'

It was Mr Lewis Jones, who lived at Glanafon, a house in some fir trees near the river. He was large, completely bald, and managed the local branch of Barclays Bank. We often played tennis on his court, and in his drawing room on his grand piano rested, in an important silver frame, a signed photograph of the Kaiser. I never had the courage to ask him why it was an object of such veneration.

I agreed with him readily about my dogs. He beamed as he said, 'Do you want to see real discipline, John?' I said that indeed I did, and immediately 'Rufus,' he shouted, 'Here boy!' From behind a bush crept his large neurotic red-setter, a lean apprehensive animal that could be seen creeping down the local lanes scared of its own shadow.

'Rufus,' his master ordered, with an imperious sweep of his arm. 'Into the water, boy!' Rufus duly obliged and was soon swimming powerfully to the far bank of the river which, at this spot, was deep and clear.

Suddenly to my horror Mr Lewis Jones shouted, 'Rufus, sit!'

The dog stopped swimming, his head turned in the water and two pathetic eyes were fixed on his master.

'Rufus sit, sit boy, sit!' Again the terrible cry rang out, and Rufus slowly slipped beneath the surface of the water.

There was a sudden silence, then a violent upheaval in mid-stream as a red object surfaced in an explosion of spray. Rufus raced for the far bank in a frenzy and, reaching it, lay there exhausted, while small waves spent themselves at our feet.

'That, John,' said Mr Lewis Jones, 'is discipline.'

The river above Abererch meandered swift and tree-lined between farms of Eisteddfa, Bryn'r Aur and Wern Sais. This was the outback to me, for in those farms they could speak little English, and I enjoyed myself trying to improve my very poor Welsh. The dogs were in their element for there were rats in the banks. Eagerly dashing backwards and forwards, they bolted them into the water where I, standing up to my waist in the fast-running stream, tailed them and hurled them back for the dogs to demolish. The rats were invariably the common brown sort that had left the village to spend the summer on the river bank.

One day Bonzo found an otter under a huge tree. A tremendous

battle ensued, but as I waded across the river the otter slipped from Bonzo's grasp and disappeared up stream.

Below Wern Sais there were splendid dragonflies, and on hot summer days I went up there to watch them dancing and glistening in the sun. The silence, broken only by the gentle noise of the running water, intoxicated me, and I luxuriated in my loneliness.

Soon I was back in the office, but was no longer to work for my Surveyors' Institute examinations. All serious brain work was forbidden, and I continued my articles, accompanying George Yale on his visits to outlying farms and doing the office plans.

The office at that time consisted of the two partners and two clerks, Walter Williams and Arthur Jones. Walter was the senior and roosted upstairs, very much the personal assistant of Mr Yale, while Arthur, receptionist and typist with a passion for the horses, remained in the small downstairs office. When Messrs Yale and Hardcastle were away we played an unusual form of office golf, belting a rolled-up piece of paper up and down the stairs with walking sticks to hole out in waste-paper baskets in the various rooms. I didn't take things very seriously, and surprisingly never considered the precarious state of my health.

Visits to farms with Hardcastle were humourless tours of duty, but with George Yale they were always an adventure. There was leg-pulling and laughter, fat farmers' wives would be shocked into peals of mirth, and the little Ford would have bumped its way down the farm track before the farmer realised he had forgotten to mention the cracked 'popty' or the slates off the roof of the 'beudy'.

So I was lucky in my two partners and lucky in the amazing characters I met, especially on the day of the rent audit. Abram Pritchard always burst in like a red bull, swearing and grumbling. Prehistoric-looking farmers appeared from distant holdings in the hills of Lleyn. There were sleek and polished farmers from the lower land. Many of them could speak no English, so I had to do my best to make myself understood in my halting Welsh. Fists would be banged on the table, rustic eyes would flash: 'Now chwarae teg, Mr Yale,' and an appeal for time would be made as George Yale laughed it off. Smiling and grumbling at the same time, the farmer backed out of the office to complain to his neighbours propping up the walls of Penlan Street.

All Lleyn came into that little office. There were Griffiths, Owens and Parrys, and hundreds more. David Parry, the auctioneer, was a true Welsh country character, blunt, humorous, rough and cantankerous. Never at a loss for words, he ran his cattle auctions in a shed on Abererch road, where he shouted and encouraged the farmers of Lleyn. I drew up plans for him as well as for Yale and Hardcastle.

Six months after my first *grand mal* attack, I had another. I had

been to a dance in Beddgelert, had taken no alcohol and had returned home at about 11.30 p.m. The next morning I felt reasonably well but was found unconscious on the pavement near Pwllheli station while on my way to lunch. I regained consciousness about twenty-four hours later. Again there was the taste of blood in my mouth and my tongue was unbearably sore.

After my first attack I had hardly considered that my illness was to be of any permanence, but now, as I had collapsed again, it became evident that I was in fact an epileptic. Strangely, this never worried me, for in those days I knew little of the illness and was entirely ignorant of the stigma attached to it among unknowledgeable people. Furthermore, I never enquired about it and continued as if nothing had happened.

Obviously excitement of any kind was bad for me, but I had always been one to wander the countryside alone, wrapped in my own thoughts, and I suppose I escaped in this way from the unfortunate situation that had developed. The drugs I was taking also played their part in insulating me from any worry, so I never associated the Bible stories of epileptics and the casting out of evil spirits with my own illness. I was never ashamed of my epilepsy or hid the fact of it from other people, and eventually I conceived a warped kind of conceit in my difference.

I developed an amazing energy that found its outlet in pursuing the Ynysfor hounds once a week across the mountains of Caernarvonshire, and also in setting myself tremendous tasks of physical exertion. About six or seven miles away, to the north of Abererch, was Yr Eifl and its attendant peaks of Carnguwch and Tre'r Ceiri. Further still lay the grassy slopes of Gyrn ddu, and these became my challenges. From Doltrement I set myself four hours to reach the rocky summit of Yr Eifl and get back again to the house. Gyrn ddu took a little longer. I used to leave the house after lunch at two o'clock, walking, running and scrambling across the fields and over the hedges, and leaping over the huge rocks on the mountain side, and I would race back muddy and excited in time to hear the time signals that heralded the six o'clock news on my father's wireless. It was crazy but satisfying.

In the summer I fished for trout and sea-trout in the stretches of the Erch that wound like a white ribbon below the house on its way to Pwllheli and the open sea. I met great characters down there and I learnt a lot about the catching of trout. Possibly I learnt most from a weird quack dentist from Pwllheli who haunted the river. He was grey-haired and filthy, but extracted huge trout from the most difficult places and was equally efficient with worm, fly or minnow. He

always looked vaguely guilty and was loth to let me into his secrets. After about two years I realised he was no longer fishing the river. I enquired in Pwllheli and learnt that he had suddenly disappeared and nobody knew where he had gone. Years later, when I was at the Slade in Oxford, I walked into the Randolph Hotel and there, resplendent in the uniform of Head Porter, was my sinister friend.

'Parry,' I exclaimed. 'How nice to see you again!'

He looked the other way.

'Parry,' I went on stubbornly. 'You remember me on the Erch at Pwllheli.'

His back remained turned on me. Then suddenly he wheeled round, a look of fear in his long ashen face.

'Yes, yes,' he whispered urgently, 'but for God's sake don't tell anyone I am here.' And in a flash he had disappeared into the nether regions of the Randolph. I never solved the mystery.

My best friend on the river was Will Jones, who earned his living as a painter and decorator. Will was patient and subtle and chose his flies with amazing effect. One day I had flogged the river unsuccessfully with a beautiful teal and silver fly and was about to give up and go home when I saw Will fishing near the main road. I crossed the meadow and asked him how he was doing.

'Lovely,' he said. 'Fifteen beauties.'

'Fifteen!' I exclaimed. 'What on earth are you using?'

'Teal and silver,' he said, as he drew his line off the water and showed me what only amounted to a hook with a bit of silver paper round it. We compared our flies.

'Dduw, that would scare the buggers stiff,' he remarked when he saw my glorious yet inadequate fly.

My remarkable energy at this time drove me to run all the way back to Abererch for lunch every day, a distance of about two-and-a-half miles, and after gobbling my food I often dashed off a feeble water-colour before returning again to the office.

My articles had expired at the end of 1938 and I had no idea what to do. I had had yet another attack of *grand mal*, so my mother and father were naturally worried about my health. I still lived a strange, sheltered, drugged existence, and in this way was content to wait on events.

I hadn't very long to wait. Europe was preparing for war, and I, amazingly, was still a Second Lieutenant in the 6th Battalion Royal Welch Fusiliers, Territorial Army. The outbreak of war in 1939 temporarily solved my problems.

8

Sandy Livingstone-Learmouth was in charge of the Pwllheli detachment of the 6th Battalion Royal Welch Fusiliers when I received my commission in April 1937, and under his patient guidance I learnt how to command a platoon of infantry.

The men were poachers, farm labourers, railwaymen and slaughterers from the abattoir; an ill-assorted lot who had joined specifically to enjoy a fortnight's holiday each summer when the Battalion went into camp.

The detachment consisted of about twelve Joneses, ten Williamses, ten Robertses and a sprinkling of Owens, Parrys, Lloyds and Griffiths, most of whom naturally were referred to by nicknames. There was Will Chimp of the huge flapping ears, Huw Baboon, fat and neanderthal, General Franco, small and neolithic, Willie Christmas, Little Titch and hollow-legged Hughie who could consume unending pints of beer and still stay sober. They might have come straight from the pages of the Mabinogion. A Finn called Ezra Johannes Eklund added a little continental flavouring.

Corporal J. O. Jones, a little weasel of a man from out in Lleyn, went by a whole string of different pseudonyms: Jonah Jones, Jack R.A., Jack Myntho or Jack Llidiart dwr—they all were Corporal J. O. Jones. How he ever achieved non-commissioned rank I cannot tell, for he had an uncontrollable appetite for women, and would even break

rank on parade to pursue some unsuspecting female. He was always in trouble, but miraculously he survived.

Gwilym Jones worked as a sweeper in the Pwllheli slaughterhouse, and was always known as Raspberry. He had a solid ruddy face and a squashed potato of a nose above a short strong body. He possessed immense courage and was a great man in a fight, the eternal infantryman who had served with every army in history.

'I'm getting married,' he confided to me one day.

'Oh good, Gwilym! Who to?'

'To a bloody gorilla,' he roared. 'She'll have my flippin' ears off as soon as look at me,' and a gigantic grin cracked his rubicund face.

Some of the men of the Nefyn contingent could speak only Welsh, which complicated their training. Will Jones was killed in Burma without ever having mastered any English.

Patiently Sandy and Sergeant-Major Howells, our regular N.C.O., drilled and beat this rabble into some semblance of order, so that when the King and Queen came to show themselves to the people of Wales after their coronation we were reasonably able to perform the more elementary movements. Khakied and putteed, we were joined by an impressive detachment of the Welsh Guards, resplendent in scarlet and bearskins, who were to act as the Royal Bodyguard. The 6th Battalion Royal Welch Fusiliers were merely detailed off for street-lining duties.

Up at the Barracks in the morning, Edward Cadogan, the regular adjutant, instructed the young officers in sword drill, and afterwards I unwisely had a glass of lager. We were shown our positions on the Royal Route, and I found that I and my farm labourers had the doubtful honour of lining up outside the public lavatories, on top of which a statue of Lloyd George fiercely waved its fist, and directly under Queen Eleanor's Gate where the Royal couple were to make their appearance. A misguided benefactor had presented the platoon with a barrel of beer and we smuggled it into the Gents. All through that hot summer afternoon 'Permission to fall out, sir?' came the continual cry, and fusilier after fusilier dived for the sanctuary of the public lavatories and the refreshing ale.

Gradually and with considerable consternation I began to realise that the 'Permission to fall out' was becoming more frequent and more slurred as my farm labourers swayed away to refresh themselves, and drunken laughter echoed round the tiled interior of the public convenience.

After what seemed an age, a martial cry rang out: 'Royal Salute, Present Arms!' and on to Queen Eleanor's gate came the King and Queen. I flashed my sword in the sun while behind me came an

inebriated rattle of rifle slings. The sun blazed down, a loyal roar burst from the crowd, a band broke into 'God save the King', and I, slowly and gently, became enveloped in a haze of incomprehension. I vaguely remember wandering up the hill towards the square, I saw the sun gleam on the buckle of the R.S.M.'s Sam Browne and was amazed by its brilliance—then nothing.

I am told that I attempted to take command of the detachment of the Welsh Guards and in doing so revealed a determination I did not normally show in everyday life. I am told I marched at their head to the camp across the river, and gave the order, 'Fall out the officers and non-commissioned officers!' as if I were a regular soldier. All this is hearsay. I am sure it is true enough that Sandy came to my aid, put me into his small car and drove me home. It was not the last time he was miraculously in the right place at the right time.

It was the next day before I became conscious. I had not had a *grand mal* attack, but merely gone into a state of amnesia in which I had no knowledge of what I was doing. It was comforting to know that it was nothing too drastic. In spite of my epilepsy and amnesia, the Regiment did not seem to want to dispense with my services. It was all very friendly. Even though officers and men alike were fully aware of my strange state of health, never for an instant was I made to feel in any way different.

We went to a divisional camp at Hereford that summer. I was put on light duty, which meant that a groom presented himself at my tent at 8.30 each morning, and mounted on two uncontrollable horses we would canter off to the training areas, where I did nothing except try to look superior and pray that the horse would behave.

One day I was returning alone up a lane towards the camp. Half way along, the horse stopped, and only great efforts on my part persuaded it to dance and sidestep its way to the top, where I saw the reason for its behaviour. In the field between the lane and the camp were the massed bands of our four battalions, headed by our goat mascots. It was these reeking beasts that had caused my horse to behave so oddly.

To reach the camp I had to pass in front of the bands, behind the bandmaster and alongside the main Worcester-London railway line. All went well as I forced the unwilling animal past the stinking goats. The bandmaster couldn't see me as he raised his baton. Down it came, the massed drums beat, and the horse, rearing and bucking, did a rodeo act in front of about a hundred laughing bandsmen. Amazingly I held on and eventually the animal assumed a horizontal position. Too soon I breathed a sigh of relief: there was a noise like a hurricane as, with whistle blowing, the Worcester-London express thundered

past. The horse lost its head and I lost control. Across the field at full mad gallop the terrified animal went. A small gate barred his way to the camp but he sailed over it and into the middle of the tents and the startled men. There was a sudden lurch as, tripped by a guy rope, the horse pitched into a bell tent. The pole snapped; men shouted; but I landed softly on a pile of canvas while my charger bucked its way back to the horse lines.

It was a strange camp that year. The War Office had become aware of Hitler; so we had orders to parade every afternoon. There was a near mutiny over this, for the annual camp had always been regarded as a holiday. Indignation abounded and we had a sorry time enforcing the new regulations.

Back in the drill hall, on the harbourside in Pwllheli, we were the proud possessors of one Bren gun, but our fire power was mainly based on the Lewis gun, a weapon that seemed to be permanently jammed.

We used to go down to our range along the shore at Penychain, and there, with a bass called Griff Owen as our intercommunication, we prepared ourselves for Hitler's war. Sometimes we blazed off at cormorants flying out at sea, but we never hit one. Inquisitive seals occasionally surfaced, and as likely as not they would see Jonah Jones making a pass at the Sergeant-Major's wife behind the range hut.

Sergeant-Major Smart died when I was in charge of the Pwllheli Platoon, so it fell to me to provide a guard of honour and a firing party for his funeral. We halted outside his dismal house in North Street to find a scandalous row in progress. The landlady, a tough old woman from the Caernarfon Road, was inside, swearing and threatening, and shouting that she had ordered her lackeys not to allow the body to leave the house until the rent had been paid. I handed over the money, the coffin was brought out and we began our slow procession through Sand Street, High Street, Salem Terrace and up the steep hill to Denio Cemetery. The procession swelled as shopkeepers and townsmen left their houses, pulling on their coats and shouting cheerful greetings to their friends already there. Bob James, the barber, put down his red-hot scissors and joined us. Nelson Roberts left his bicycle shop. The crocodile swelled. So did the noise, as to the nailed boots of the fusiliers was joined the scuffling of the townsfolk who, laughing and joking, were enjoying an afternoon out.

We trailed slowly up the hill and through the cemetery gates to where the open grave waited to receive old Smart. We formed a single file on either side, while the vicar read the service, and the swaying coffin was lowered into the earth. Suddenly from the depths of the dreadful hole came an anguished cry—'Diawl, Gweitia funud bach'.

The coffin was halted, stayed swaying drunkenly, and a fearful silence descended on the terrified group surrounding the grave.

'Get me out of here,' came the voice.

Strong men caught the ropes, the coffin was dragged up again and placed on the muddy boards. With awful fascination we craned our heads to look where the voice was coming from. Mrs Smart burst into tears. Slowly, helped by an undertaker, the grotesque figure of the gravedigger was pulled out from the depths of the grave where he had been having a quiet snooze.

Once more the coffin was lowered. We fired a ragged volley and marched away.

I went on a course to our Barracks at Wrexham and was surprised to find that the officers were seldom out of hunting kit. I also went on a course to Sandhurst, where I gained a report containing the brief statement: 'This officer is immature.' It reminded me of the story of the young cavalry subaltern whose report read: 'I would not breed from this officer.'

When I returned home it was time for the August Camp of 1938, and we were under orders to assemble in the Isle of Man. When the day came for us to leave, I found I had unusual difficulty in putting on my puttees. Great gaps of bare leg always seemed to show however many times I tried. I remember my father shouting to me to hurry up, and I vaguely remember getting into the train at Pwllheli station and hearing Sergeant-Major Howells barking out orders. The world became increasingly confused as the troop train progressed past Afonwen, Penygroes and Caernarfon. I heard doors open. There were officers' voices somewhere in the compartment but they were very far away.

Soon I slipped away into unconsciousness, and as the train left Prestatyn I had yet another attack of *grand mal*. Again it was Sandy who looked after me, and I came to briefly to see that I was in a car driving along a leafy road and somewhere nearby there was Sandy. Soon I was away again, and the next day my room at home appeared with my mother bending anxiously over my bed.

Still the army kept me, and as the war drew nearer I became more and more occupied with training my carefree band of part-time warriors. The Adjutant's visits became more frequent. Orders came telling us how to deal with the civilian population if panic were to arise. We were put in a state of emergency, and at the end of August we were told to be prepared to move at two hours notice. On 1 September, the orders came through for us to depart.

Two large buses drew up outside the Drill Hall on the harbour side,

and groups of mothers, wives and sweethearts stood miserably in small whispering groups. Suddenly the word was passed round, 'They're off to Egypt', and tears began to flow into the harbour.

Handkerchiefs waved in the sun as we disappeared towards the unknown, but this turned out to be only Portmadoc, twelve miles away, and there in the Drill Hall the Company assembled under the command of Dick Homfray, a reassuring quarry manager from Blaenau Ffestiniog.

On 3 September I took the Company on church parade to St John's, Portmadoc. Archdeacon Jenkins mounted the pulpit, announced a text that I can't remember, and then, leaning menacingly forward, he boomed in a flat dull voice, 'Doubtless in a few months' time you will all be blown to pieces'.

'Iessu', came the combined exclamation of 'B' company, and the back of my neck was bathed in their alarm. At the end of the service I marched them back to the drill hall to hear that war had been declared.

More orders came. We were on the move again. Once more the mothers, wives and sweethearts arrived, but in greater numbers, for we were now at company strength.

'They're off to India,' came the cry, but we only went to Old Colwyn, where we formed up as a Battalion under the command of Lt. Col. 'Anzora' Evans.

There we marched and drilled, and Gwilym cooked for the officers of 'B' company. He had a passion for onions and they turned up with everything. Meals were always served with onions laced with anecdotes of Gwilym the Soldier, Gwilym the Lover, Gwilym's wife the Gorilla, and his little girl, the Baby Gorilla. He was dreadful yet superb.

Our Battalion goat was a very wild beast indeed and only one man, our goat major, could control it. When he was passed unfit the problem of his successor was an urgent one. Battalion orders announced one day that the post was vacant and all applicants were to parade at a certain field the next day, where the goat, tethered to a strong stake, was munching grass.

As the job was a bit of a sinecure, there was a considerable crowd of all the worst malingerers and scroungers in the Battalion at the gate of the field, as one by one they were led in by the R.S.M. By this time the goat had been untied and stood pawing the ground like a bull in a Spanish bull ring. Slowly each fusilier approached it. Down went the horned head. There was a short attack, and the fusilier was racing for the gate and safety. Nobody passed the test, and we were relieved one day to hear that our 9th Battalion at Penmaenmawr needed

a mascot and had a man vastly experienced in the handling of goats.

A corporal accompanied Billy and handed him over to a fusilier who seemed to be fully in charge of the situation. Off they went on to the mountain for an afternoon stroll, but there was no further sign of them until, as darkness descended, a harassed monk from a local monastery burst into the orderly room shouting that he had come across an unconscious soldier on the mountain with a goat sitting on top of him. A party was despatched, the fusilier was brought down on a stretcher, and the goat was cornered and sent over to my cousin Winnie's home in Anglesey, to graze happily until with the formation of an old crock's battalion there was a joyous reunion between Billy and his previous goat major.

We stayed for a peaceful and fruitful month in Old Colwyn. We learned to live with each other, and in a small way mastered such fearsome weapons as Bren guns, Boyes anti-tank rifles and carriers, until orders came for us to move. Yet again there were tearful farewells and the dreadful word 'Egypt' was once more passed from wife to wife, from sweetheart to sweetheart, as we, hardened, month-old soldiers, awaited our departure.

The train stood in Old Colwyn station loaded with drunken fusiliers and completely inebriated N.C.O.s. Somehow a roll was called and one man was found to be missing. It turned out to be Gwilym. Angrily, Edward Cadogan, our regular adjutant, paced up and down the wet platform with me alongside him.

'Where is your wretched man?' he complained. 'Have you no control over them?'

Backwards and forwards we marched, Edward anxious and looking at his watch, as time went by and still no Gwilym appeared. Suddenly we heard a metallic clatter in the subway. We dashed to the head of the stairs and there was Gwilym, drunk as if he were rolling out of the Mitre on a fair day, one hand holding his tin hat and the other the muzzle of his rifle, as he pulled himself upwards, dragging it and banging the butt on every step.

Edward gazed horrified at the unmilitary sight. Lurching and swaying, Gwilym eventually reached the platform.

'What on earth is the . . .?'

'Enough of that from you,' Gwilym's intoxicated voice interrupted. 'Don't you speak to me in that tone of voice. Wait until we get to bloody Ireland and by damn I'll bloody get you.'

He swayed off down the platform, a lonely truculent figure.

We moved off through the night through Liverpool, Preston and Carlisle to Stranraer, and from there across by a Clyde river boat to Larne on our way to Lurgan in County Armagh, where we were to be

billeted in Brownlow House, a huge mansion of three hundred and sixty-five rooms.

In Northern Ireland the 53rd Division was to be put on a war-time footing, and the men, happy holiday territorials, were to be beaten into the shape of a fighting unit. The War Office hardly reckoned on the natural characteristics of the Welshmen. Discipline we resented, authority we rejected; never until face to face with the enemy is the Welsh soldier at his best, and here in Northern Ireland we were as far away from any war as we could possibly be. Try as our few Regular soldiers could, we still remained an easy-going bunch of farm labourers, quarrymen and poachers, and even the I.R.A. failed to stimulate us to any martial awareness.

Once when our regular adjutant was sick, another was sent to replace him, obviously with instructions to beat hell out of us. He arrived, a great shambling bear of a man who despised us utterly and took no pains to hide it. The Royal Welch Fusiliers is an old and distinguished regiment, but hardly any Welshmen have risen to command a battalion in battle. This is due to an English caucus in the regiment that mistrusts the Welsh officer. Our new adjutant was typical of the more obtuse type of English officer, and his one aim seemed to be to find fault.

I was temporarily commanding our company when he decided to make an unheralded inspection of our billet. I heard his coarse voice long before we met. Stamping and swearing, he searched for an excuse to give full vent to his ungovernable temper. At last he found it: a rolled up piece of paper on top of a cupboard in the Company office. He rounded on Hugh Morris, our C.Q.M.S., a Portmadoc postman, and it was Hugh who received the full force of a professional soldier's anger. I remember thinking that people didn't speak to our postman in such a way. I was a very young soldier. The young officers compared notes and found that this sort of thing had happened in every company. Resentment grew. After I had left for Wrexham the subalterns' patience ran out, and one night they collared him in the grounds of Lurgan House and threw him into the lake. He left the next morning.

One day as I sat alone in our Company office there was a knock on the door.

'Come in,' I shouted.

Three embarrassed fusiliers appeared.

'Permission to speak, sir,' stammered their spokesman.

'Go ahead,' I said.

'Well, it's that Mr Salter, sir.'

This Mr Salter was a young officer who had been attached to us and

who, I had noted, was a fierce martinet and viewed by the company with violent antipathy.

'What about Mr Salter?' I asked.

'Well, sir'—there was silence while the fusiliers shuffled and looked at the floor.

Suddenly the spokesman stood to attention.

'Well, sir, we only want to tell you that if we go into action he's for the silver bullet.'

'Good God,' I exclaimed. 'You can't do that!'

'We just thought we'd let you know, sir.'

'Thank you very much,' I said, unnerved by their determination to kill my brother officer.

It was a delicate situation. They were good men; they were my men. Salter was not one of us and was certainly a tyrant. As there was no obvious sign that we were going into action I decided to do nothing for a time and was greatly relieved when the offending officer was transferred to another regiment.

We were still very much territorials; they were local boys, and I was a local boy. The interview could never have happened in a regular battalion.

I became very fond of Northern Ireland and its kind hospitable inhabitants. Lurgan was a small town split by a broad high street into two sections, one Protestant and the other Catholic. The I.R.A. was invisible, yet active. We officers had the humiliation of suffering escorts as we went around the town. All rifles were chained to the floor of the armoury for fear of raids, and I had to impress on the guards of our Company billet the importance of challenging in English, not in Welsh, as they invariably did.

Soon after our arrival an attack of paratyphoid struck the Battalion. There was little room for nursing the casualties, so the people of Lurgan took it upon themselves to care for the sick. Temporary hospitals were set up in houses in the town and for a time all training ceased. Our Medical Officer, Major Ardwyn Roberts of Portmadoc, was so overworked that he was forced to drug himself to keep going. He had also contracted paratyphoid himself but refused to go to bed. Noticing his seemingly drunken state, an insensitive temporary adjutant put him under close arrest and only when he became very ill indeed was he taken off to hospital in Belfast.

The officers were soon made honorary members of the Working Men's Club. This may sound like a strangely democratic and typically Irish gesture, especially as no N.C.O.s or men were allowed in. One day Colonel 'Anzora' Evans received a letter from their president to say that they understood we had had to leave our regimental mascot

behind. They therefore wished to present us with a local goat and would be delighted to entertain the Colonel and Officers in the Working Men's Club for the presentation.

The day arrived, and we converged on the Club to be met by the president and conducted to the billiard room, where speeches of welcome were made. Suddenly a door opened and to our horror we saw an extraordinary-looking animal led in by a local gossoon. It was an immense castrated goat with a body the size of a calf's and two pathetic horns like a chamois'. As it was led round the billiard table it relieved itself continually.

The Colonel excelled himself in tact, the ceremony came to a close and we agreed to collect our Billy at a later date.

One of the results of the presentation was that two officers were invited to attend a shoot organised by the Working Men's Club at Tanderegee Castle, the late home of the Dukes of Manchester. The invitation was accepted and Dicky Homfray and I were asked to represent the Battalion. We arrived at the castle gates to find an amazing collection of men and dogs. Hardly had they greeted us when they burst through the gates and disappeared into a jungle of rhododendrons. No instructions had been given; so Dick and I followed cautiously. We soon realised that Tanderegee rabbits never went to ground, for they ran from bush to bush pursued by barking dogs and shouting men. Occasionally a red-faced Irishman dangerously clutching an ancient hammer-gun emerged from the undergrowth. 'And which way was he after going?' was the enquiry. Dick and I pointed somewhere and with a look in his eye like that of a hefty rugby forward the sportsman hurled himself into the thick rhododendrons. Shots whistled through the air, and Dick and I felt that the safest thing to do was to creep away to a bare knoll, where some tall fir trees grew, and there to wait for pigeon.

Deep in the jungle the warfare continued, until suddenly the cry went up, 'A woodcock, a woodcock!' There was a terrifying volley and a wild Irish voice cried, 'I have him, begorrah, I have him!' We were all summoned and the hero of the hour pulled a bottle of whiskey from his pocket and the sportsmen drank his health. The woodcock was forgotten until someone said, 'And where's the burrd?' Searchingly we moved forward to where the woodcock had fallen. It was still there, but when we reached it, up it got and flew away, fresh as a lark, sliding and slinking between the trees. There were terrible Irish oaths, a very ragged volley, and more ferocious imprecations when it was realised that the bird had gone for good. As things in the depths of the rhododendrons got more and more out of hand, Dick and I slipped away.

Occasionally the men used to go home on leave, the monoglot Welsh clutching a label on which was printed their name, rank and number and in large letters at the bottom, the words, 'Passenger to Pwllheli, I speak no English'. They always arrived.

Gwilym went home once and on the way back on the *Munster* was torpedoed. He returned a hero. 'There I was in my bloody underpants having a shave,' he said, 'when, dduw, there was a crash and into the ablutions came a bloody torpedo. Straight through my legs it goes and there was me in my underpants swept out to sea riding it like a bloody bronco.'

But I was declared unfit and had been since the beginning of the war, so one day orders came for me to leave the Battalion and join our Regimental Depot at Wrexham. As always, Sandy and I were posted together and away we went leaving our cheerful, lazy and inefficient locals to others who would only know them as army numbers and be intolerant of their individual ways.

In Wrexham everything was unbearably regular and efficient, and Sandy and I, used to the happy-go-lucky ways of the Territorial Army, felt entirely out of place there. I lived in the mess, shared a room with Edward Cadogan, our old 6th Battalion adjutant, and had as my servant a regular soldier called Lewis.

The barracks were commanded by Colonel Watkins, a small, sad man with a nervous smile and continual whistle. Something had happened in his past life that had imprisoned his emotions for good, so there was little contact to be made with him. Dick Kelly, the adjutant, was also a sad figure. Dark, handsome and gloomy, he organised the barracks, occasionally having an adjutant's parade, at the end of which we would find ourselves irrevocably mixed up. Dick Kelly used to stalk away and let the R.S.M. disentangle us.

Floods of men poured in during our periodical intakes. Men from North and South Wales, from the hills of Montgomeryshire and Radnor, and also scousers from Liverpool and sharp boys from Birmingham. We formed them into squads under drill sergeants and at the end of twelve weeks gave lance-corporal stripes to the best. They always went to the English boys, as the happy-go-lucky Welsh could see no point in the square-bashing and training and made no bones about registering their contempt.

May came, and with it the fall of France. Our first Battalion was over there and soon news came back of men missing and killed. Gloom descended on the barracks, but Dunkirk was at hand and there was work to be done. A train-load of muddy warriors from innumerable British regiments arrived at Wrexham station. We formed them into threes and they straggled wearily up to the depot, shambled past the

guard and collapsed on the Barrack Square. Behind them and distinctly apart marched a detachment of the Welsh Guards under the command of a sergeant. They had fought and suffered like the rest but they were the Guards. Their drill was impeccable, their equipment polished and in good order. When they passed our guard, 'Eyes left!' came the sharp command, and even in Chelsea Barracks they couldn't have turned their heads more smartly.

French submarine men from Brittany came as well. Their boats, the *Surcouf*, *Sfax*, *Dunon* and *Minerve*, had come to British ports, but their sailors had decided to be repatriated rather than join the Free French. I was put in charge of them and very difficult they proved to be. I hadn't come across French 'honneur' before and I found that any suggestion I made touched on this. They would do nothing except sleep, eat and clean their matelots' uniform so that they could go and break the hearts of the Wrexham girls in the evenings. I organised a game of football against the barracks. This was quite an event, and sergeants' and officers' wives turned up to watch, oblivious of the fact that the sailors used to relieve themselves on the field whenever they felt so inclined. The C.O. beckoned me at half-time and asked me to remonstrate with them and to point out that we didn't do such things in Britain. On to the field I marched and called them around me.

'Il est défendu de pisser sur le champ de football . . .' I started, but the rest was drowned in Gallic laughter, and I returned to the touch-line, a ridiculous figure, the jeers of the Frenchmen ringing in my ears.

The invasion scare was upon us and we were on immediate notice to take up defensive positions. We played pontoon interminably while the Barrack Square filled with buses and vans that were to take flying squads of fusiliers to attack the Germans at every point at which they landed.

One Sunday morning after breakfast, Dick Kelly made his dignified way to the orderly room, where the duty officer the previous night had been one Vaughan—a dentist sent to us by our greatest enemy, the Cheshire Regiment.

'Well, Vaughan,' said Kelly. 'Did anything happen last night?'

'Oh aye,' drawled Vaughan. 'Sergeant Rogers comes in to say his mother's sick so I gives him compassionate leave.'

'Well done. Anything else?'

'Aye, now ye come to mention it. Some chap rings up and says Cromwell. I says no, me name's Vaughan, and rings off. On he comes again and says code word Cromwell and I tells him not to be bloody funny and tucks in for the night.'

Dick Kelly cursed him for a fool and immediately began to set in motion the elaborate plans for repelling invaders.

Code word Cromwell meant there was danger of immediate German landings. At that moment we should have been holding a line fifty miles away in the mountains between Beddgelert to Maentwrog. We were twenty-four hours late.

I was on church parade as a fusilier rushed to whisper the news to me. Softly, I passed the word around, and one by one the men left their pews and fell in outside.

Back in the barracks all was chaos as, dragging our packs, tin hats and rifles, we piled into the buses. I checked the vehicles, summoned the despatch riders and gave the order to move. Our destination was the Oakley Arms, Tan-y-Bwlch, where by some strange chance my company commander, Captain Percy Moody, was spending the week-end. Out through the barrack gates we wound, four old buses and eight vans. The despatch riders dashed alongside like sheepdogs. At Acrefair the first van had broken down, at Llangollen another, and when we passed through Corwen a harrassed D.R. told me we had only two left. As we creaked through Pentrevoelas we had none and were off to meet the enemy without food or ammunition.

On the steep hill past Yspyty Ifan the two buses came to a complaining halt. Our weight was too much, so in files on either side of the mountain road we escorted them to the top. There, ahead of us, lay the lovely Maentwrog Valley, the Oakley Arms and the sea. It seemed impossible for any German to be around. We slid down through Ffestiniog to draw up outside the hotel, where I was ashamed to report to my company commander the arrival of 150 men, no food and no ammunition. He took it very well; he was an old soldier.

I was sent to the mountain village of Rhyd to billet my platoon. There were only two possibilities, the school and the chapel. Being a well-brought-up Welshman, I discounted the chapel and went to interview the schoolmaster.

'Oh, certainly,' he whined obsequiously. 'Take it, sir. Put your boys there. No trouble at all. I can go to the chapel.'

All was well, and into the school we went and lay down on the floor to sleep and await the arrival of the enemy.

I knew the area well, as I had hunted round there often with Jack Jones. So I had no difficulty in finding suitable firing points and road blocks. We practised small tactical exercises and felt fully confident of giving any German a good beating, for by now our weapons and ammunition had arrived.

One day as I sat in our company office in the Oakley Arms the telephone rang.

'This is the War Office,' came a voice. 'And may I speak to Captain Moody?'

'I'm sorry but he's out. This is his second-in-command, Mr Williams, speaking.'

'Not the Mr Williams we are so furious with?' came the reply.

'Well, I'm the only one,' I said nervously.

'What the hell have you been doing? The Merioneth Educational Committee say you have forcibly ejected a schoolmaster and his pupils from his school. He says they have nowhere to go to the lavatory and has complained that you acted in a most arrogant manner.'

I tried to explain the servile acquiescence of the wretched schoolmaster; how I had asked with the utmost gentility. It was no good. The Education Committee had to have its pound of flesh and I, the only man who knew the district like a map, was removed and sent on a messing course in Ripon.

On my return I found that my brother Dick had arrived on attachment from the Royal Corps of Signals. He had joined as a signaller and had been sent to their training depot at Prestatyn. He had applied for a commission in the Royal Welch—the Signals didn't really know what to do with him—hence his presence in Wrexham. As the Colonel had told me that it would be unseemly were I to be seen in the company of a mere signaller, I had to make illegal assignations with him. Lewis, my servant, acted as messenger and carried my notes across the barracks square to the Specialist Company where Dick was housed. By devious routes we would meet in secluded spots down in the Clyweddog Valley.

There was a dance one night at the Wynnstay Arms in Wrexham and I went with a party of officers. It was noisy, and as the room was unbearably hot, I asked a fellow officer to get me some water when he went to collect some drinks. He came back and handed me a glass of clear transparent liquid and I took a long draught. The intoxicated subaltern was having a little joke, and it was neat gin.

Excitable and taut, I couldn't sleep that night. The next morning I was in a daze, but was conscious enough to remember that I was due to command a company for inspection by Lord Digby, the Inspector General of the Forces. I had a slow and hesitant breakfast and returned to my room to prepare for the parade. As I was buckling on my Sam Browne the epilepsy struck me once again and I had another *grand mal* attack.

When I came to at about two o'clock my tongue was not bitten, and although slightly dazed I didn't feel too bad. Of one thing I was obsessionally aware, and that was that I was due to play rugby for the Depot against some other regiment at 2.30. I got out of bed, put on my rugby kit and ran out on to the field. Suddenly I found Lewis at my side, saying, 'You can't play, sir, you're not well.'

Angrily, I tried to brush him aside. 'Get out of my way Lewis, I'm perfectly all right.'

'No sir, no sir, you're not; you're sick. Please, sir, don't go on the field.'

People surrounded us, officers confirmed Lewis's words and gradually I realised what had happened. I left the field certain that now, away from the Battalion, the Army authorities would get rid of me as soon as they could.

They sent me to Moston Hall Hospital, Chester, where for two weeks I did nothing and nobody did anything to me. The following week I was ordered to leave the barracks and to return home to await further instructions. Hugh Roberts the Shop, Abererch, came to collect me and sadly I left the regiment for good.

9

In a strange vacuum, I waited to hear from the War Office. I felt perfectly fit; yet the Army had no use for me. My energy found a ready outlet in following Jack Jones and his hounds, and one day after a particularly arduous hunt on Moel Meirch I came down to Gwynant to find Paddy Reilly waiting on the roadside with his car and a letter telling me to report to a Military Hospital outside Oxford where I was to undergo certain unspecified tests.

The next day I arrived at Oxford station and was driven to a sinister building about four miles from the city. Huge gates were opened and secured behind us, and I entered a drab office and announced my arrival. A sergeant told me I wasn't expected, but when I showed him my letter from the War Office he sent an orderly to find a doctor.

'Rather a grim sort of hospital,' I remarked as I waited.

'Can't expect much from a looney bin, sir,' replied the Sergeant.

Surprised, I suggested that perhaps there had been some mistake, and was relieved when the Sergeant said that he couldn't find my name on any of his lists.

'Hold on a minute, I'll give the 'ead injuries 'ospital a buzz,' he said, and dialled a number. Indeed they were expecting me, and in no time an ambulance arrived and I was comfortably settled in a room in St Hugh's College, which under the supervision of Dr Hugh Cairns had become the major head injuries hospital in the country. There I stayed for two weeks, sharing a wing with Battle of Britain heroes and other officers who had been wounded in battle. I felt rather ashamed.

My first test was the inevitable lumbar puncture. This was followed a few days later by the electro-encephalogram, the first machine of its kind to be assembled in this country. I sat in a wire-netting rabbit-hutch and a strange permanent-wave machine hung above my head as terminals were attached to my ether-soaked hair. At the other end of

the room a girl pressed a switch, and a large metal hand started to draw a crazy graph on some paper pinned to the wall.

'Close your eyes. Open them. Close your eyes. Open them,' she said, and all the while I was hypnotised by the rhythmic ticking of the machine.

Finally it was over, the ticking ceased, the rabbit-hutch was opened, the terminals removed and I returned to my room.

The next day in came my doctor.

'What are you going to do when you leave the army?'

'Why can't I stay in?'

'All the tests have shown that you are abnormal.'

This came as a bit of a shock.

'Oh. I was a land agent before the war.'

'Oh no, I don't suggest that,' came the soft confident voice. He looked up, a gleam of inspiration in his eyes.

'As you are, in fact, abnormal,' he announced, 'I think it would be a good idea if you took up art.'

This struck me as a most remarkable suggestion and my mind turned to my art prize at Shrewsbury and the few pathetic imitations I had made of Peter Scott's paintings. I returned home disappointed but still unbeaten. Determined to stay in the Army, I appealed to the Military Secretary and went down to Cheltenham for an interview. It was brief. 'Frightfully sorry, old boy,' said a genial Scots Guards Major. 'The jolly old medicos always have the last word.'

That seemed to be the end, and all I gained from my visit to Cheltenham were some exotic flies called Ashley Jones. I gave one to Will Jones, and for a brief and glorious spell we lifted large fat trout from the Erch. Gradually they seemed to get wise to its dangerous attraction and Mr Ashley Jones became redundant.

My final medical board took place at the R.A.M.C. Headquarters at Millbank, where I was invalided from the Army in considerable style. Generals, brigadiers and civilian specialists sat round a table and smiled encouragingly as I entered. It was a civilian who examined me. He told me to cross my knees and struck below the top one with a small hammer. As I expected, my leg remained limp and gave no jerking reflex. He struck again and again but without succcess.

'Hold your fingers together and pull hard,' he said. I did so; he hit me again but still nothing happened.

'Dash it, the feller won't work,' he said in desperation. Generals and brigadiers had a go, and failing returned to their seats.

'Well, old boy, you can't stay in the Army, y' know,' announced the chairman, and out I went, a civilian bursting with energy and not allowed by the Army to use it in any way. I was miserable, but

although I did not know it, my rejection was the best thing that could possibly have happened to me.

I applied for several dull and unsuitable jobs and got none of them, and then in the summer of 1941 an artist turned land-girl, who had fallen out with her goat-loving employer, came to us for refuge. She was a beautiful gazelle-like girl who had been trained at the Slade and, I learned later, had been one of the most brilliant students of her year.

Her name was Gwyneth Griffith, and she helped my mother in the house and infuriated her by her amazing lack of punctuality and fascinating inefficiency. Eventually she drove my mother into a state of antagonistic silence, which was partly due to jealousy, since I was beginning to find Gwyneth very good company indeed.

One day I went down to the river to try to get a sea-trout and Gwyneth came with me to collect some mushrooms. For an hour I cast my line with the wind behind me so that the flies lay invitingly on top of the water, and for an hour nothing stirred. In desperation, I crossed the footbridge below Cemlyn, and without any confidence cast in from the other side. The flies fell in a disorderly heap on the water. There was a silver flash, and I was into a large sea-trout. I landed it and saw that it was the finest I had ever caught. Triumphant, I bore it home, and entered the drawing room where my mother was hidden behind a newspaper. I proudly told her of the size of the fish; the paper never moved. I told her the weight and still she hid in jealousy behind her paper shield.

I was surprised; then anger got the better of me. I turned and walked down to the village where I knew a boy was sick in bed. His mother opened the door. 'Here,' I said. 'Something for Morris.' I handed over my fish and returned to the house and mother's wrath.

It was Gwyneth who wrote to the secretary of the Slade to see if it was possible for me to go there. A letter came back by return to say that because of the war any man would be welcome. I went for an interview and showed Professor Schwabe my immature efforts. He was surprised at my inability and obvious lack of talent but in his kindly way suggested that I should enter for a term to see how things went. This at least was something, and I returned home with a vague sort of career ahead of me. Gwyneth had started me off and I was very grateful to her.

I went to the Slade in October 1941 and lodged in Observatory Street with the Singleton family. Mrs Singleton, a big happy woman, was gloriously Irish. I never knew her to be ill-tempered during the whole of the three years I was there. Her husband was a little wisp of a man with a large-browed head and humorously lined face. I never found out what work he did, but I think he was an odd-job carpenter.

He spent too much of his time telling stories and laughing at them to do anything very seriously.

Stanley, their son, played the saxophone. Mrs Singleton said he took it up to take his mind off an accident he'd had in Dublin as a boy when a coalman unloaded a sack of nuts over him. Stanley, she explained, had been a bit odd ever since.

I suffered silently in my little room overlooking the Observatory as Stanley practised his instrument below. I had never liked the saxophone and it wasn't long before I hated it. Mr and Mrs Singleton and Florrie their niece sat in the same room, their complaining Irish voices rising and falling in an odd accompaniment to the music. I sometimes sat with them as the old man talked politics in an attractively illogical way, chuckling and poking me with his pipe while his beaming wife filled us with cups of tea.

The Slade had been evacuated to Oxford and had amalgamated with the Ruskin School of Art for the duration of the war; so we had as our two professors Randolph Schwabe and Albert Rutherston. There were few men there at that time and the girls outnumbered them by about eight to one. We had few masters and were really left to learn as much as we could on our own. We were housed in one wing of the Ashmolean Museum and most of the students seemed to earn precious pocket-money by firewatching. They slept in dormitories set aside for them at the top of the building. As I had been in the army, I didn't fire-watch, but joined the Home Guard instead.

Artistically, I was certainly the weakest student. I had hardly drawn before and looked with awe at the amazingly efficient drawings of everyone else. My attempts were inept, but nobody laughed, and I fumbled on until I had at least mastered the proportions of the human body.

Shortly after my arrival at the Slade a senior student invited me to visit one of the many coffee houses in Oxford. 'I have been watching your work,' he said. 'Perhaps I can help.' Coursing the perimeter of his coffee cup with a long sensitive finger, he questioned me. 'Now what sort of a shape do you think that could be?' I assured him that I considered that it was undoubtedly round. A superior smile crossed his face. 'Ah, yes, I thought you would say that. Of course you must realise it is square.' Thinking he was joking, I looked at his pale aesthetic face. It was obvious that he was serious. 'You must accept,' he continued, 'that there are certain things about which you know very little. Some day you will understand.' We paid the waitress and returned to the Ashmolean: one bewildered student, and another who had no doubts.

My first sketch-club criticism was humiliating. I had entered three

water-colours of Boar's Hill of which I was reasonably proud. 'When I saw the first of these,' the master adjudicating announced to the assembled students, 'I said, "Great Scott!" When I saw the second I said, "Good Lord!" and when I saw the third I said, "Heaven help him!".' He got his laugh and I stayed away from the Slade for two weeks.

Professor Schwabe was every inch the professor, and looked as if he should have been absent-minded, but he wasn't. He moved wraith-like among us, occasionally doing some small and exquisite drawing on our paper or making a critical remark in his kindly stammering voice.

He had a passion for limericks and would stop me in odd corners of the Museum or even in the streets of Oxford with a new one he had heard.

'There was an old man of C-C-C-C-Cal-c-c-cut-t-t-ta who smeared his t-t-t-tonsils with b-b-butter . . .' His Adam's apple waggled and his gold-rimmed glasses danced on his nose in his effort to complete it. As I was older than most of the male students I saw a lot of Schwabe and he became a very good friend.

His partner, Albert Rutherston, was the Ruskin master of drawing. He was a neat little man who nipped around like a bow-tied sparrow. They were always known as Schwabe and Albert, which showed in which direction our respect lay, but I feel that to most students Albert was the more approachable.

My first term was certainly a trial, but I survived and Schwabe said I could return to finish at least one year.

The next term had hardly started when a telegram arrived to tell me that my father was dying. I was met at Pwllheli station by Aunt Mamie and she told me that he had died during the night. When we arrived at Doltrement my mother seemed entirely unmoved and re-mained so throughout the days ahead. I was told that my father had suffered a severe attack of bronchitis and had slipped away easily into unconsciousness. The Home Guard acted as a bearer party and car-ried the coffin from the house and down the lane to St Cawrdaf's Church where we laid him to rest.

It was hard for me to gauge my mother's feelings, since there was little communication between us, but after the burial service she enter-tained the mourners as if she were presiding over a normal tea party. I felt sure that as soon as it was over her iron reserve would crack, but it didn't. From that day on she never mentioned his name again, and she seemed to forget him as she went back into the world of her father.

When I returned to Oxford she insisted upon my taking Bonzo with me. She was devoted to the little white dog and this must have been a

considerable sacrifice. But sacrifice was part of her nature. Wufi remained at home and kept her company.

My father's death was the first of a series of blows. Two months later my mother's wayward brother Owen died. Then, in late summer, I woke up one morning to find my left foot swollen to an amazing size, the skin shining as if I'd been bitten by a snake. I tried to put on a shoe. This was impossible and it was very painful to put my foot on the ground. A naval doctor, living with us at the time, was baffled as to the cause. I hobbled about all day, and in the evening the swelling had subsided enough to allow me to wear a bedroom slipper. The next day it was perfectly all right and showed no sign of the curious affliction.

Two days later I received a letter from the commander of a battle school in the south of England. It was to inform me that my brother had stepped on a bakelite percussion grenade and had had his left foot blown off. This had happened on an early morning exercise the same day as my own left foot had behaved in such an inexplicable manner.

My mother was moved in a way I had never seen before. The cumulative effect of the deaths of her husband and her brother, followed by the crippling of her elder son, broke her iron reserve. I tried my best to comfort her, but had to leave for the hospital at Bovington Camp where Dick had been taken.

He greeted me as if nothing had happened, assuring me that he felt as if his foot were still there, though his leg had been amputated below the knee. I was amazed to see how stoically he took the whole affair. He was very much his mother's son, and would never have allowed me to see him dispirited. We compared notes about the timing of his accident and the amazing swelling of my left foot, and found that my telepathic communication had come through half an hour before the explosion This, I later found, was usual in such cases.

The next day I went over to see him again, and then returned home to reassure my mother that he was in remarkably good spirits and well looked after. The blow did in fact strike him hard. He could have left the Army, to continue his law studies in Pwllheli; but this seemed to him an easy way out, so he served for the rest of the war as a staff officer in Britain and the Middle East. After a brief spell in Germany after the war he came home to the solicitor's office and his career.

At the Slade I continued to wrestle with the immense problems that beset me. As the worst student there, I was ashamed when I compared my insensitive life-drawings with those of seventeen-year-old girls. They all seemed so talented.

Apart from Schwabe and Albert, the permanent staff consisted of Allan Gwynne-Jones, who taught painting, and George Charlton who

instructed us in drawing and anatomy. The History of Art was dealt with by Professor Borenius. His voice was soft, his accent atrocious, so we learned very little. Slides appeared on the screen in the Ashmolean Lecture Hall and occasionally we heard expressions such as 'monumental simplicity'. Usually the blurred voice produced a kind of hypnosis, and one by one we went to sleep.

Our examination was a farce. The Professor would appear, top-hatted, morning-coated, to put on the screen twelve selected slides. We had to say what the date of the painting was, to which school it belonged and who had painted it. Students formed groups and each member learned a different period of art history, so that when a slide was shown the student covering that particular period could inform the others. As there were several groups and many spokesmen, loud arguments took place. Borenius seemed oblivious of what was going on, and everyone always got first-class honours.

Because of the war we were very short of models, and I often used to wander off down to St Ebbes to bribe an old man or woman to come and sit. This they did with considerable embarrassment, some of them taking exception to particular students. One fierce old man was very particular about who drew him, and as the morning wore on he dismissed us one by one until only a few survivors remained.

One model was a Christian Scientist who insisted upon posing nude when she had measles. She took off her dressing gown to expose a terrifying rash. The students backed away against the wall and somebody sent for Schwabe. With commendable bravery, he approached the spotty girl and ordered her to go home. She refused. As far as she was concerned she was perfectly fit, and nobody was going to stop her posing. I think we all bolted and left her alone in the school. She didn't turn up the next day.

I had joined the North Company of the Oxford City Home Guard, and at first my company commander was the chaplain of Hertford College, the Rev. G. I. F. Thomson. We were a strange lot, mainly university people, professors, dons, students and schoolmasters; but we were efficient and it was impressive to watch Dr Parker, the distinguished Keeper of the Ashmolean, dismember a Browning gun. Whenever I asked him if he would talk to the Slade students on old master drawings, he excused himself by saying he never gave lectures; but when I enquired if he could demonstrate some weapon to my platoon, he accepted with alacrity. Corporal Atkinson, the woman-hating Professor of Military History, who had been a captain in the Boer War and a sergeant in the 1914 war, was the warlike armoury corporal. He owned a succession of black cocker spaniels which he trained to bite Brasenose men.

I was given a platoon of undergraduates. Students of theology, forestry, medicine and chemistry, they were scattered around every college in Oxford and it was my unfortunate duty to try to get them all on parade at the same time. I suppose I could have done it if I had spent my entire spare time padding from college to college; but I didn't really bother, knowing that they were all fit, intelligent and reasonably efficient.

As the majority of my platoon were not only lazy but mutinous, I had to have a good sergeant. I chose Ian Kelsey-Fry, a medical student from New College who was also captain of the university hockey team. I couldn't have made a better choice, since he was firm, tactful and cheerful. It was he who coped with Solomon Erulkar, a rebellious Beni-Israelite from Bombay who seemed determined to sabotage all my military plans.

The theological students were the most conscientious and certainly the most ferocious. With martial screams they dug their bayonets into sacks filled with straw: 'In, out, on guard!' and with a crusading gleam in their eyes the fledgling priests would retire to prepare for another assault on an imaginary infidel.

The North Company of the Oxford Home Guard always assembled at their armoury, which was an annexe of the Pitt-Rivers Museum. Here, covered in ill-fitting battle dress, came the professorial soldiers to drill incompetently but studiously. Awkward but efficient, they would have fought most ferociously if ever they had gone into action. This ungainly company was leavened by a few technicians from an engineering works, who were unbelievably professional in comparison with the rest of us; and it was with their assistance that we were welded into a competent fighting unit.

In the winter, night exercises took up much of our time. We scouted and patrolled in the parks or along the banks of the Cherwell, or ventured further afield to the village of Marston. It was there one night that one of my more undisciplined undergraduates let off a thunderflash under an innocent caravan. I heard a fearful crack and, after brief silence, a tumultuous human disturbance. A male voice roared, a female screamed, furniture crashed inside confined quarters. Then, with a heave, the caravan door flew open and two figures in night clothes leapt out and fled across the moonlit field to a nearby wood. I summoned, admonished, cursed, threatened, but eventually, infected by the grins of sadistic satisfaction on the faces of my men, I joined them in their wicked pleasure.

My elderly cousin Jack Kyffin was a medical orderly in another company, and as he had been a Lieutenant-Colonel in the R.A.M.C. in the First World War, he proved a difficult man to handle. He even

put his company commander on a charge one day for unpunctuality, and was supported in his insubordination by the Battalion Commander. Jack Kyffin lived at Headington with his wife Dorothy, and grew prize carnations and bred cocker spaniels. When he was a young man he had been a great all-round sportsman, and like his father, Canon Tom Kyffin of Beaumaris, he had excelled at boxing, winning his last fight in Alexandria at the age of 51. He used to explain that this was only because he was a Lieutenant-Colonel and his corporal opponent was afraid of hitting him. When I was at Oxford, he was in his seventies and proud of being Chairman of the University Boxing.

Chaplain captains, colonel corporals, professor sergeants and artist lieutenants, we were a peculiar body of men. Everything worked magnificently; for somewhere a master-mind was organising us. Perhaps this was the joint effort of the C.O. and the Adjutant? We saw little of them, and I can't remember their names.

After my life as a prospective land agent and my spell in the Army, the world of the art student seemed strange and my Home Guard activities acted as a shock absorber. I still had little idea of what art was about. Vaguely I believed it to be merely copying as efficiently as possible the world around me and the objects that filled it. I might have continued to stumble on in this unintelligent way had I not visited the Ashmolean Library one day and opened a book on Piero della Francesca.

I turned over the pages mechanically, until I came to a sudden stop. There was Piero's 'Resurrection' with the sublime figure of Christ rising from the tomb above the sleeping soldiers. The shock was followed by a feeling of intense emotion. I gazed at this beautiful picture until I could no longer see it; for tears were rolling down my cheeks. It was not the religious content that had so powerfully affected me. It was the amazing compassion which Piero had managed to put into the eyes of Christ. Here was a face of such strength and love that for the first time I began to realise what great art is—an intangible thing, impossible to rationalise, and far removed from mere representation. After this experience I returned to my art studies with a new sense of purpose and direction.

At this time we were lucky to find among us H. M. Bateman, the humorous draughtsman. Small, neat and blessed with a refreshing humility, he sat on his donkey and drew with the same searching care as the most serious of the more youthful students. As a draughtsman he was immensely accomplished and no trace of his humorous style could be discerned in his life and portrait studies. He often came to visit me in Observatory Street. He talked of his admiration of Caran d'Ache, of his passion for the work of Lucien Pissarro, of whose work

he was an avid collector. Sadly he told me how his distress at the out-
break of war had curbed all desire to create any caricatures, but never-
theless he did do one of me. I don't believe he meant to, but quite
suddenly he picked up a writing pad. Chuckling continuously, never
looking at me for a moment, he created the remarkable, if racy,
caricature that I am proud to own.

As the military build-up was intensified we continued to live as if in
another world. We rowed Schwabe and Albert in a flotilla of boats to a
meadow above the Trout where we held our Slade picnics. We ate
strawberries and played rounders, but it wasn't long before the pitch
was deserted as couples vanished among the trees and reeds. At inter-
vals throughout the night, boats were tied up at the boat-houses in
Port Meadow, and inebriated students reeled back to their lodgings.
I can't remember what happened to Schwabe and Albert.

One day during my second year Schwabe looked at a drawing of
mine, sighed heavily and commented, 'Oh, Williams, why do you
always make your nudes look like oak trees? You can't draw, so you
had better see if you can paint.' I took his advice and immediately
found that the rich pigment appealed to my sensuous nature. As I
tackled my first life painting, I fell completely under the spell of paint
and produced something which, even if it was incompetent, was un-
like anything else in the school. The more I painted the more I began
to realise that this was my real means of expression. When my third
year came to an end I had even won the Slade Portrait Prize.

On a summer's evening, as the Professor and I were walking up the
High, he stopped in the middle of one of his inevitable limericks, and
casually remarked: 'Do you know, Williams, that we have a Slade
Leaving Scholarship? I always forget to award it. Would you like it?'

Not usually at a loss for words, I was rendered speechless by sur-
prise for a moment. Eventually I managed to say that I would like it
very much indeed.

'All right then,' said Schwabe, 'you can have it.'

So I became a Robert Ross Leaving Scholar.

10

When I went to the Slade it was with the sole intention of becoming an art master at some comfortable public school; no idea of ever being a serious painter had entered my mind. Bent upon doing what my housemaster had done before me, I indulged in thoughts of playing fields, rooks nesting in trees behind the chapel, the gentle civilised life of a master at a public school. I seemed to have forgotten the cruelty, the stupidity of my own school days and only recalled the best, most nostalgic, memories of Shrewsbury.

I was lucky that my Home Guard Commander was Major Greswell, a tall, venerable, grey-haired man who was also the secretary of the Oxford University Appointments Bureau. It was to him I went when in my last term I came to consider my future. He reacted with amazing speed and efficiency. The headmaster of every public school in the

country was canvassed and in no time the replies came pouring in. Most were already fixed up; some, awaiting the return of their permanent man, only wanted a temporary art master; but a considerable number expressed interest.

Mr R. H. Moore, the headmaster of Harrow, who was an assistant master at Shrewsbury in my day, invited me over, and his ancient doormat of a cocker spaniel, evidently remembering some schoolboy indiscretion, promptly bit me. Mr Moore, obviously impressed by the opinion of his faithful dog, said he had no place for me.

My next choice was as an assistant art master at Christ's Hospital, and I was duly summoned for an interview in London with the headmaster, a huge grizzled rugby forward called Flecker. Undeniably a man of action, he dismissed me after five minutes and ordered me to catch a train at Victoria; his art master, he said, would meet me at Christ's Hospital station.

The train drew into the bleak Sussex station and there was a single lonely figure on the platform. It was the art master. Tall, thin, immeasurably sad, he greeted me without enthusiasm.

'If you ever want to be an artist,' he said with a sigh, 'there are two things you must never do; teach and get married. I have done both.'

It was not an encouraging start, and the art room was even more depressing, for on every drawing-board were pictures of fairies, pixies and goblins.

'Just look at it,' the art master groaned. 'This is the influence of my assistant. We are getting rid of him.'

Somehow I didn't take to the place, and I later heard from the headmaster that they didn't take to me, so once again I went through my list of schools, and feeling that it would be a good idea to be in London decided to try Merchant Taylors. I was short-listed with one other for the post, but a letter from the headmaster eventually told me that he had decided to appoint the other man since he had previous teaching experience. He added that it might interest me to know that he was at the moment the assistant art master at Christ's Hospital.

My pride wounded, I returned to my headmaster's letters and saw that Mr Geoffrey Bell, of Highgate, needed someone permanently to run their department, which had closed owing to the evacuation of the school to Westward Ho.

I was given an interview and was met by a tall, genial, long-faced man with a mop of white hair that fell across his brow. This was Geoffrey Bell, late headmaster of Trent College, a man of considerable charm and ability. We liked each other and I got the job. It was one of the luckiest moments of my life, though at that time I didn't realise it.

My mother seemed interested when I told her that I had landed a

permanent job at a public school; yet I feel sure she was secretly delighted. She still showed no sign of grief at my father's death, and whenever I mentioned his name the subject was changed. I noticed that she talked about her father more and more.

Meanwhile, I attached myself to the Abererch Platoon of the Home Guard and became a kind of military adviser to the Pwllheli Company, commanded by the ebullient Mr Lewis Jones. He drove me round the outlying platoons like some sort of mascot, proudly asking me to give lectures and organise demonstrations. One evening at Chwilog I talked on the subtleties of patrolling, and afterwards asked Corporal Ellis Jones, an ancient porter from the station, and veteran of the First World War, to give a demonstration. He and seven men departed as if they were walking down the village street to catch a train. Most of the time they didn't bother to bend down, and when they did their posteriors stuck like monstrous lumps above the sky line.

When they returned I pointed out their shortcomings. This hardly met with the approval of old Ellis, who rounded on me in rage.

'Don't you talk warr to me my boy! I wass doing bloody warr before yous wass bloody born.'

I was more successful in Abererch, where I fitted in with all the other John Williamses. There was John Williams the Platoon commander, Sergeant John Williams, Corporal John Williams and a host more John Williamses in the ranks.

They were a cheerful and fearsome lot who would have dealt most effectively with any German invader. Their shooting was brilliant, and no detachment in the whole South Caernarvonshire Battalion could compete with them.

My first year at Highgate was a long-drawn-out struggle with no holds barred. The boys had never worked at any sort of art before, and it seemed as if they had all decided they weren't going to do any with me. Things were made doubly difficult since I had decided that art and punishment didn't go together. To begin with, this was seized upon by the more unscrupulous boys as a chance to create trouble, but soon they realised how lucky they were and started to behave like human beings.

'Are you married?' a small boy asked me one day. I told him that I wasn't. 'Oh, I thought not,' was his confident reply.

Surprised at his reaction, I asked him why he was so sure.

'Oh well, sir, it's obvious; you're always so cheerful.'

This gave me an early insight into the marital life of North London.

Early on, when the war was still being waged in Europe and the Far East, I talked to a form about the National Gallery, stating that the

collection had been removed to Wales for safety. This remark provoked an unexpected response. The whole form was reduced to a state of uncontrolled laughter. Schoolboy guffaws echoed round the art school. When I managed to make myself heard, I asked the reason for their mirth.

'Well, sir,' said one boy with a huge grin, 'they wouldn't be very safe in Wales.'

'Why ever not?'

'Haven't you ever heard, sir? "Taffy was a Welshman, Taffy was a thief",' and once more the form erupted.

I was staggered by the spontaneous reaction of twenty-five boys, for until that moment I had never realised what damage the libellous nursery rhyme had done to generations of English children.

Even though I had offered to supervise practically anything from football to dramatics when I applied for the job, I found myself only pressed into service with the Officers' Training Corps, and put in charge of the Signals Platoon. All the signallers, carefully selected, were knowledgeable scientists, and as I knew nothing whatever about wireless sets they happily ran the show themselves. Sometimes I suggested that they should go to different parts of the school grounds to pass messages to each other: but since nothing came through to me, listening in patiently in the art school, I presumed they went to the village cake shop. They were cheerfully efficient but undisciplined.

Field days took place in the open country north of Barnet, where in the summer the boys committed terrible urban crimes such as advancing in line across fields of ripe corn and leaving gates open through which flocks of sheep and herds of cattle would dash. The London boys had no knowledge of country life. One day we found ourselves crawling through a prisoner-of-war camp, while huge Germans stood bewildered as small immature soldiers snaked past among their huts.

The flying bombs stuttered and fell. Masters on night duty would order the boys down to the boarding house basements when the message of an approaching missile came through. Edward Bullen, an elderly master who was affectionately known as 'the Egg' by reason of his shape and baldness, acted as a magnet to these bombs. Blown out of his house in Talbot Road, he moved to Bisham Gardens, only to be blasted from there. Finally, while he was taking a class in the cricket pavilion, one landed on the pitch outside. There was a terrible bang and the interior of the pavilion became a haze of dust and plaster. When this had subsided there was no sign of the Egg, and a blackboard lay over his desk. Eventually, composed and undefeated, Edward Bullen emerged, yet again unscathed. Soon after, I was

invited to his house for supper. In the middle of the meal we heard the familiar stutter above us; we dived for a cupboard under the stairs and in the distance there was a faint explosion. The Bullen jinx was broken and the Germans bothered him no more.

The most exotic member of the staff was Prince Fethi Sami, a member of the mighty Ottoman dynasty that had ruled Turkey for five hundred years. He was in charge of physical training. Sami, in his middle thirties, was a virile figure topped by a balding dome, his face often lit by a huge, generous grin. He was passionately pro-British, an attitude he had inherited from his father, Prince Sami Nedjib, a captain in the Turkish Lancers. Because of these feelings, the family was put under house arrest during the First World War and lived in the Balta Liman palace on the sea of Marmora.

Sami had endless stories of Turkey and the Turks and always felt they and the British had much in common. The Turks, he said, admired honesty and courage beyond all things, and the British had similar views. He told me once how a British submarine surfaced in the sea of Marmora beside a Turkish melon boat and the captain demanded the contents at pistol point. The melons were handed over and the surprised owner was paid in British gold. Next day the water was covered with melon boats.

After the Greeks, with the blessing of Lloyd George, had landed at Smyrna, the Turkish mob turned on the pro-British Samis and besieged the Balta Liman palace. As a boy of thirteen Sami was given a rifle and a window to shoot through and was told by his father that he was to stay there to defend his post until he died. This proved unnecessary, for a British officer arrived and offered to take the whole family away in a cruiser. They had only two hours in which to leave, so could take little with them, and the palace and all its treasures was left behind to be looted. The prince and his family landed at Malta in 1922 and eventually settled in Menton, where Sami became a boxer of Olympic standard. In a non-title bout he defeated a reigning gold-medal holder.

Their peaceful life in the South of France was broken by the outbreak of war in 1939. Well-known for their anti-German feelings, the family decided to find refuge in England, and in 1940 left Cannes in an overloaded boat and landed at Liverpool. They were now, in the middle of the war, in the country they admired so much, and Sami, denied the chance of fighting, entered Loughborough Training College, passed out with an Honours Diploma, and arrived at Highgate to take charge of physical training.

I had lunch with Sami every day in the village, and listened to his stories of the Middle East, of the Sultans, of the Turkish people, of

Lord Lloyd who was a great friend of his father's. It was a different, uncomplicated world and utterly fascinating.

I always returned to Wales at the end of each term, and during the summer holidays of 1945 I went to the memorable sale of the contents of the Glyn-y-Weddw Art Gallery.

Glyn-y-Weddw was an old house at Llanbedrog that had been bought by one Solomon Andrews of Cardiff. It was he who built the west end of Pwllheli, where huge boarding houses lined the sea front and the West End Hotel tempted visitors to the capital of Lleyn. He instituted one-horse trams that ran along the sand dunes to deposit their occupants in Llanbedrog and he envisaged an Art Gallery as the cultural mecca of this expedition. Solomon Andrews had a friend in Christies; so he offered the firm £300 for three hundred pictures which had been left for years in their cellars. The offer was accepted, and one day huge pantechnicons arrived to unload a mass of pictures with the name of every great European master on their frames. Rubens, Titian, Velasquez, Turner and Constable—they were all there, and the occupants of the horse-tram gazed in wonderment at these works, nearly all of which were copies.

One day David Parry, the auctioneer, rang me up. 'Hello, friend,' came his usual greeting. 'I've got to sell an Art Gallery. Can you come and tell me which are the oils and which are the water-colours?' I met him in the old house and duly instructed him. The majority of the pictures were dreary rubbish, but there were a few good ones. There was also china, furniture and armour, which David Parry knew more about than I did.

On the day the sale began everyone assembled in the entrance-hall. It was still war time. There were few visitors, and of course rationing of food and clothes was still in force.

David Parry struck a table with his gavel and the sale began. 'Lot Number 1!' he shouted. 'A coat of chain mail. What am I offered?'

'Ow many coupons, chum?' came a Lancastrian voice from the back of the throng. A timorous burst of laughter was immediately silenced by the auctioneer: 'Coupons? No coupons, friends; iron rations.' There was a roar of appreciation, and from that moment the sale was a tremendous success.

On one occasion I found that my art enabled me to get round the problem of clothing coupons. Needing a new coat, I bought some of the old brown and white Brynkir tweed and sent it to Mr Roberts the tailor in Portmadoc with my measurements. As I always carried such diverse objects as rabbits and sketch books, I asked the old man if he could give me two large, poacher's pockets.

'Dduw no,' he said. 'Can't do it with the coupons.'

Then a cunning look came into his small eyes. 'You pull pictures, don't you?' he enquired.

The Welsh for 'to paint a picture' is 'tynnu llun', or to pull a picture. Having little connection with the visual arts, Welsh people use the phrase for taking a photograph or pulling the lever of the camera.

Knowing what he meant, I said that indeed I did.

'All right,' he announced. 'You pull my face and I will give you your two hare pockets.'

He gave me some paper and the pencil that lurked behind his large ear, then took up a Napoleonic pose, while I attempted to pull his face; but I had been taken unawares and did a very bad drawing. Evidently he agreed with me in thinking it so, for when the coat arrived it had only one poacher's pocket.

The following year I began to feel an increasing urge to paint. Finally I went to Geoffrey Bell, explained my feelings and said that I must leave my job at Highgate.

He looked at me as a father would look at an imbecile child. 'Have you a private income?' he asked.

I replied that I had not.

'Well then, you must be an idiot to think of it,' he said. 'How about teaching just three days a week and getting a friend to do the rest?'

It was a generous unexpected suggestion, and one I would never have thought of making. Readily, I agreed, and once again Highgate proved lucky for me, for this arrangement, for which I have been eternally grateful to Geoffrey Bell, formed a basis for all my future painting.

£200 a year was not much with which to keep myself in paint and canvas, let alone board and lodging, and to begin with, before my salary started to rise, I was very often extremely hungry. Relief came by way of a shop in Hampstead that held minor gambling sessions after hours. If I played poker or pontoon the chances were that I would lose heavily, but if I played rummy I knew I would win enough to buy myself an evening meal. Naturally I was a frequent visitor to this establishment.

I had started to paint landscapes at the beginning of 1945, but as I was teaching full-time it wasn't a serious occupation, and was mainly confined to such few weeks as I had at home in Caernarvonshire. It wasn't until the summer of 1947 that I first painted pictures which gave me some belief in my abilities. I had found that, in expressing the massive bulk of the mountains, the palette knife was a great ally, and so I began to knead and model the paint. I painted Snowdon, Cnicht, the Moelwyns, Hebog and Cader Idris and began to draw incessantly.

My vast energy was beginning to be harnessed to something worth-while, and it was during this summer that painting took obsessional hold on me.

Secure in my Highgate lodgings, unassociated with any art school, I was able to survey the London art scene with detachment. What I saw I didn't like. It took me a few years to realise my good fortune in being so cut off from the world of art. Teaching in a secondary school and painting in isolation, I was able to develop in my own way, free from the pressures of fashion and the contagious influences of art schools.

It was when my pictures had reached a state in which I was begin-ning to be able to communicate my feelings that I was lucky enough to meet a group of Welshmen who were passionately interested in art. Ralph Edwards, the Keeper of Woodwork at the Victoria and Albert Museum, had met Professor Schwabe in the Athenaeum and had asked him if he had found any young Welsh painters of late. Schwabe gave him my name, and Ralph Edwards bought a picture for himself and one for the Contemporary Art Society of Wales. He wrote to his friend, Captain Geoffrey Crawshay, and one day an immense man arrived at my lodging in Highgate and burst into the house. He bought two pictures and invited me to his annual grouse shoot.

Captain Crawshay's shoot was unique in that the guns were selected as representatives of different facets of Welsh life, rather than for their ability to shoot straight. It was democratic in a singularly Welsh way; and, for a week, soldiers, sailors, parsons, architects, bards, druids, singers and policemen shot under the leadership of their host. The shoot took place on the slopes of Plynlimon where the Severn and the Wye rise, and it was at the Lion at Llanidloes that the party first stayed. Later, it moved to a temperance hotel of the same name in Llandinam where Mr and Mrs Savage provided magnificent food which rejuvenated the members of the shoot, who were unused to the rigours of the mountainside.

Llandinam, still almost feudal, was lorded over, benevolently but puritanically, by the first Lord Davies. He it was who decided when the people of the village should be in bed; he who turned the master switch that plunged the village into darkness at an annoyingly early hour; he who ordained that his tenants and guests should all be teetotallers. On 11 August cars converged upon his domain from North and South Wales; boots were opened and crates of alcohol were heaved into the temperance hotel, to be secreted in cupboards in the dining room.

During the war, when petrol rationing prevented the party from

taking their own cars up to the moors, a taxi used to come from Llanidloes, driven by a small man known as Duodenal Jenkins. But when petrol flowed more freely, car-loads of characters left the Lion every morning and wound their way up the Severn Valley, down narrow, hazel-hedged lanes, through fords, to bump and sway along cart tracks to the selected portion of moor.

There we would find Jarman, a local farmer who acted as keeper, a beaming little nut of a man, lithe and bursting with energy and humour. He was an incurable optimist.

'Are there many grouse around, Jarman?'

His 'Sure to be' answered every question.

'Any black cock, Jarman?'

'Sure to be.'

If we had suggested ostriches we would have received the same reply.

Jarman was no respecter of persons. After Sir Wynne Cemlyn Jones had failed for the fifth time to hit the only birds on the moor, 'Damn you for a fool!' he shouted, took off his hat and jumped on it. He was always accompanied by his two lean sheepdogs. They had magnificent noses and could find any bird. Unfortunately, Jarman cannot have fed them very well as they dismembered anything they found. When they caught a bird and grabbed it, they were pursued by Jarman, cursing, swearing and heaving lumps of peat at them, as they disappeared over the brow of the hill to consume their grouse at leisure. Jarman sometimes appeared on a sturdy Welsh cob, which later carried the Captain when his angina became too bad for him to walk.

Geoffrey Crawshay directed operations, getting the guns into line and organising the drives. Up great heather slopes we sweated. Down into immense gulleys, where small immature rivers glistened in the sun, we slid. If a covey got up when we were breathless, there would be an unprofessional volley, and away would go the birds to pitch near a distant forestry plantation.

Once, 'Get that gun away from Tom before someone's killed!' ordered the Captain. The Rev. Thomas Hollingdale was disarmed and we continued with a lighter step. We plodded through the great forestry trenches, sometimes along them, sometimes over them, stumbling into bogs, enveloped in the thick, coarse grass that grew high up in that distance place.

Sometimes we saw the Captain sink to his knees in agony as the angina struck him. We waited for what seemed an age until, with infinite slowness, he dragged himself to his feet, stood swaying for a moment, then signalled us to move forward again. Nobody said anything, but we all knew that his complaint was growing worse, until

eventually Jarman's cob turned him into a cavalry leader and we into his infantry.

Sir Wynne Cemlyn Jones was never challenged in his capacity as the most eccentric character on the shoot and undoubtedly its worst shot. In fact nobody, during the many years of the shoot's existence, had ever seen him remove a feather from a bird. Cemlyn was unusual in everything he did, but in spite of it he was the possessor of a very acute legal mind.

One day in the Twenties he was driving up the Mall towards Buckingham Palace. Being a learner, he proceeded with circumspection. A car approached him on the other side of the road. It was a large, stately car and from its bonnet fluttered the Royal Standard. In a panic, Cemlyn realised that the King and Queen were about to pass him; and, always a loyal subject, he took both hands off the wheel to remove his hat. The car lurched to the right. There was a sudden, violent impact and the two cars were locked together in embarrassing proximity. Paralysed with horror at what he had done, Cemlyn, when he was able to scramble out, hopped around the royal car like some agitated bird, muttering apologies that were ignored by the royal couple who sat composed and dignified at the back. The chauffeur got out, eyed him viciously, then walked away towards the palace. Cemlyn was left alone, miserable thoughts beating through his legal mind. The tower, the law courts, Cemlyn the regicide, all possibilities were envisaged as he waited until the chauffeur returned with another car. The King and Queen changed vehicles and, still without a glance at the culprit, disappeared in the direction of Trafalgar Square. Cemlyn never drove a car again.

One misty day, as we advanced in wet irregular lines across the moor, we realised that Cemlyn was not with us. 'Cemlyn!' the cry went up, and hung in the rain-sodden air.

'Cemlyn, where are you?'

Our voices seemed dead in the great empty stillness of the mountainside. Cemlyn had vanished, maybe over a precipice, maybe into a swollen stream.

'Cemlyn!' we shouted. 'For Heaven's sake, where are you?'

Of a sudden from far, far away, over a distant, an invisible, hill-top, there came the muffled sound of two shots.

'Damn, there he is,' said Jarman.

'Where in the hell has he got to?' roared the Captain.

We shouted, we waited, until at length, through the mist, a figure materialised. It was Cemlyn, damp gold-rimmed spectacles on the end of his nose, his mackintosh hanging on him like a badly erected bell tent, and in his hands a brace of grouse.

'Cemlyn, you never shot those!' we yelled.

'It's impossible, you must have brought them with you from the larder,' we suggested. Cemlyn beamed.

'Where did you get them?'

Cemlyn pointed to a hillside just appearing out of the mist. After the Captain we went, stumbling our way over rock and through peat bog until, at a spot pointed out by Cemlyn, we stopped. There, on the orders of our commander, we erected what came to be known as Cemlyn's cairn. No doubt it is still there.

A round, heathered hill called the Groes was my favourite spot. To reach it we took the old Machynlleth road from Llanidloes, past the disused Van copper working, up to the top of the Trefeglwys valley where buzzards wheeled and mewed. Through a gate on the left near Staylittle we dived down a steep, winding track to where, far below, was the infant Severn and beyond it the Groes.

Strange wrinkled little men with a motley collection of dogs would meet us. The men were obviously all related, and so were their dogs; in fact the animals and humans bore the same snipey appearance. They seemed to be a happy incestuous lot, who must have poached the river and the moor from time immemorial.

It always seemed to be a warm day when we shot the Groes. With the Captain standing near the top, we wheeled round it, driving the grouse and an occasional black cock ahead of us. We got fifteen brace there one day besides the odd hare and snipe from near the river.

Deep in the heather, we lay and devoured Mr Savage's magnificent lunches, while the Captain sat on a shooting-stick and viewed his recumbent troops.

When the rain came creeping down from Plynlimon we hid in an old house or barn, and as it came down heavier and heavier, 'Clearing shower!' shouted the Captain, and the cobwebs in the roof shook with his laughter.

If the weather became too bad for a shoot, we went to Gregynog, a half-timbered house deep in a wooded valley near Newtown. Here the Misses Davies, sisters of Lord Davies, kept their splendid collection of paintings. As the cars crept up the long drive, the guns who were also members of the Arts Committee of the National Museum of Wales laid bets on the chances of the pictures ever going to Cardiff.

When I joined the shoot, only Miss Margaret Davies was alive, and she met us in the hall, a gentle soft-voiced woman diffident yet welcoming. We wandered through the house past Gauguins, Renoirs, Van Goghs, Monets and some old masters as well. The best of Sickert, John and Gilman could be seen beside the work of contem-

porary artists. I so much enjoyed those visits that on one day of the week I always prayed for rain.

On Sundays we went on church parade. Nonconformists padded off to the chapel on the Llanidloes road, while the churchmen, led by the Captain, plodded up the path to the squat little church where we bellowed out hymns and psalms.

On the last night of the week we ate some of the bag, and Watcyn sang to us. Everything was against him; the room was too small and I sometimes accompanied him on the piano. His professionalism was hurt, for my playing was abominable, but if the Captain wanted a song, Watcyn Watcyns, the baritone, who had been the Captain's servant in the Welsh Guards, would sing as he must have sung far away in Flanders many years before.

The next morning we went away to our different parts of Wales. The Forestry was swallowing up the moors and we knew that our shoot was doomed. But what concerned us most was the knowledge that the Captain was a sick man. His heart got worse yearly. Walking became a cruel strain and his eyes were shiny pools. His laughter never ceased, though; nor did his activity.

One November day I went with him to Herne Hill to watch the London Welsh play Moseley. He threw himself into that game as if he had been playing it, shouting, exhorting, and cheering. I dined with him in the evening and we went to see 'On the Waterfront'. The next day he returned to Cardiff, and Cemlyn found him dead in his room at the Angel when he went to meet him for dinner.

II

When I came to London in September 1944 my first lodgings were with Mrs Redmond Browne, a ponderous lady like a hippopotamus who dressed like Queen Mary, and tried to assume her regal manner. She was a snob of heavy calibre, and my enquiry as to whether she enjoyed cooking put a black mark against my name.

'Mr Williams,' she boomed, 'I was never brought up to do such menial work.'

A few months later I saw her sailing up the path to the front door, topped by a picture-hat the size of a spinnaker. She met me on the landing with a look of confident superiority. 'Mr Williams, I have had a most enjoyable afternoon at Lords. It was so nice to be among my social equals again.'

My days in Shepherds Hill were numbered when Archie Erskine arrived; for he was an Etonian of a good Scottish family, so could do no wrong in the eyes of Mrs Redmond Browne. Archie's girl friends could come and go when they liked. Soon I realised that Mrs Redmond Browne had visions of her house becoming an Old Etonians' hostel in which Williams had no place at all. The blow fell sooner than I expected. John Evans, an old friend from Cardiganshire, who was at that time studying at the Slade and sleeping in the waiting-room at Paddington Station, came to see me one Sunday. He had

walked across the Heath and on his way up the stairs had accidentally deposited a microscopic piece of mud on the carpet. This provided an excuse for a curt note which told me that mud on her carpet, and on a Sunday too, was more than a genteel lady like Mrs Redmond Browne could bear. I was given a couple of weeks in which to move out. It was only later I found out by chance that the grand airs put on by Mrs Redmond Browne had come to her through her father, who had been a gentleman's gentleman.

As the flying bombs came over and the sirens wailed, Mrs Redmond Browne, wrapped in a Chinese dressing gown, with her hair in curlers, cowered under the stairs, her great suety bulk quivering in terror. She lost no time in finding a hostel in the country, to which she departed for frequent rest cures.

I didn't have to move far when I left 15 Shepherds Hill, as I found a room near the Underground station in Priory Gardens, where my landlady was a broad-beamed Lancashire woman called Mrs Kenyon. Lazy but kind, in her blunt north-country way she did her best for me. When I came down for breakfast her solicitous 'Ow are yer bowels this morning?' warmed me to her after the first shock of verbal impact. My room was small, silky and so unbearably smart that I could do no painting for fear of splashing some hideous object. So I had to find a more permanent lodging where I could work unconstrained, with space enough to stand back to a canvas. After a few enquiries at Highgate School I was introduced to Bisham Gardens and Miss Mary Josling.

Miss Josling came of Saxon yeoman stock. She had been born and bred in Castle Hedingham, an old Essex village, near the Suffolk border, and was eighty when I arrived for the first time at Bisham Gardens. She was of medium height, with light silver hair pulled back into a bun, deep set eyes, a strong nose and gentle sensuous lips. She invariably attracted the weak and the suffering. Tramps would sit for hours on the basement steps waiting for food. Men and women, boys and girls from Highgate, Holloway and Kentish Town came to her for help and advice. Every week she went to her women's club in the poorer part of Highgate. Not only humans, but animals too, were attracted to No. 12 by instinct. Stray cats and dogs were always being fed in that never-failing basement.

For my move I hired Mr Gay the fruiterer's pony and cart, and we heaved our way up Jackson's Lane, the cart piled with canvasses and trunks, and belted down Bisham Gardens to stop triumphantly outside No. 12.

A fantastic ten years lay ahead of me. It didn't take me long to find out that everyone and everything in the house from humans and

animals to the wiring system and plumbing was neurotic. Like a rock in the middle of this ebb and flow of neuroses stood the calm patient figure of Miss Josling.

When I arrived the household consisted of herself, her maid Alice, and Mr Scott and Mr Pound, her two lodgers. Mr Scott was retired and lived in comparative luxury on the ground floor with the two best rooms in the house, while Mr Pound, a legal clerk, inhabited a loveless room on the first floor. There was a hard chair, a bed and several large boxes. Bleak, uninviting books cluttered the shelves and from this bare room Mr Pound emerged every morning, black-suited and pale-faced. To it he returned punctually every evening to shut himself away in his solitude. Miss Josling told me his sad history: how he had been brought up by the Plymouth Brethren to fear the wrath of the Lord and eternal damnation if ever a joyous thought came into his head. He had come to her with no interest in living and no love for anyone; but she had found him an allotment and gradually made him enjoy his work on it. Pound had come to worship her and she was very fond of him. When, after a few years, I got to know him, I found that he was a very kind, good man.

Alice the maid was a plain but pleasant girl who came of a long line of Wiltshire swineherds. As some women take upon themselves the physical characteristics of their pets, so Alice and her family had become like their charges, and one by one, these aboriginal Wiltshire porkers used to come and stay in Bisham Gardens, huge, sweaty snub-nosed men and women who sat in the kitchen, only occasionally grunting but continually eating.

Mrs Iles, the mother, had, by the time I arrived in Bisham Gardens, lost the power of speech; this, Miss Josling said, was due to her congenital lethargy. If I met her on the stairs or on a landing, she performed a sort of porcine war-dance, waved her arms round and round like a fast bowler limbering up, and towards the end of my stay in Bisham Gardens, waved her feet as well. This, Miss Josling explained, was her way of greeting me.

Every afternoon Alice placed a little round hat with a cord of daisies swathed round it on the grotesque head of her mother. It sat incongruously above the expressionless face, with the nose flattened upwards and lips hanging downwards, the lank grey hair falling like some diseased crop on to her shoulders. Together they walked down Bisham Gardens, turned right at the end, and there, in front of the Post Office window, Alice would leave her. All afternoon Mrs Iles stared vacantly at the blocks of writing paper, the fountain pens and post cards, her gaze fixed on wares she could not comprehend. At four o'clock a built-in alarm clock sounded in her stomach, and punc-

tually every day she left her pitch and shambled back to hump at the kitchen table. Her greed was enormous. It governed her whole existence.

Albert, Nellie and Bessie used to come as well, adolescent versions of their mother. Albert came to court a little Cockney girl called Jinnie. For seven years they rode round London in silence on top of a bus. Neither could understand the other's dialect. This strange courtship ended when Albert, in a sudden spirit of adventure, decided to go on a river bus. Jinnie refused to accompany him. It was the river bus or Jinnie, and Albert chose the river bus. They never met again.

Alice was a good worker and was very fond of Miss Josling. One evening she went on her own to a fancy dress dance in Finchley, masquerading as a bunch of violets, and immediately caught the horticultural eye of Ern Collier, a jobbing gardener. He was sixty-eight and a widower with fourteen grown children, but those violets and Alice inside them made his blood race. He started to court her with great energy. He sat for hours in the kitchen, and took Alice for rides in his loathsome three-wheeler, until with Miss Josling's blessing they married and moved into the top of the house.

Ern was a good solid Englishman, tall and thin with a white moustache. He was hardworking and honest, but, alas, had an incorrigible stutter. Whenever he tried to speak, out stuck a vast red tongue and it remained wedged between his lips while he spluttered and soaked whoever he was trying to address. How he managed to propose I know not, and his first meeting with Alice's mother must have ranked with the great encounters of history.

Highgate village was full of characters when I first went to live there. I made friends with Joe Conn, the Jewish owner of the Health Food Stores, who had been a famous boxer in his day. He had once fought Jimmy Wilde while he had Spanish 'flu and lost on points. A few years before I arrived he had taught boxing at the school.

Gerard Hoffnung had just left but came over to visit the school from his home in Hampstead. His housemaster, Tommy Twidell, told me that Hoffnung was so naughty that he was due for a beating every Saturday night; but since there was obviously no malice in anything he did he was rewarded with a glass of port instead. Hoffnung used to stuff the pipes of the school organ with paper so that remarkable sounds emerged when the music master played a voluntary before the chapel service. Hoffnung also secreted musical instruments beneath the lecture room and every time the science master turned his back to write on the board, a boy would drop through a manhole and start playing. Eventually the master would find to his surprise that he

was teaching about two boys, while below the stepped benches an orchestra was playing.

I always had my lunch in the village cake shop and a pretty girl from Kentish Town brought me my food. She was the daughter of Welsh parents and her name was Margaret Owen. Sometimes when she wasn't busy she sat at my table and talked of the days when she was a member of a gang of small girls who haunted the cemetery that sprawls over the southern slopes of Highgate Hill. Their greatest joy came when hearses brought the bodies for burial. Unknown to the mourners, eager little faces peered from behind tombs and crosses until, the service over, the last mourner departed, and the coffin covered with its mound of soil, they burst from their hiding places, running madly towards the place where the floral tributes lay. There, tearing and screaming, they fought for the ribbons that swathed the wreaths. When they had torn them from the flowers and tied them in bows in their muddy hair, they danced and sang, a weird pagan throng among the marble memorials to generations of worthy London citizens.

Highgate village is one of the better places to live if you have to work in London. Living on the edge of Waterlow Park and close to the Heath, I had plenty to paint, but did very little. Once in my room, my thoughts turned to Wales, and I found myself making pictures of the landscape I knew so well. Mentally I ceased to be in London; the room became peopled with farmers and sheepdogs, and bounded by stone walls and rocky cliffs. Loneliness I enjoyed, austerity was no hardship, and energy, almost terrifying at times, came to my aid so that I found I could paint an eight-foot canvas in a day and feel the better for it. I even played rugby for London Welsh Extra 'B', but when a large St Thomas's Hospital forward flattened me and apologised with a 'Frightfully sorry, sir', I realised the time had come for me to become a spectator.

Nearby in Cholmeley Park was a Home for the Blind and I often went to paint the men and women who lived there. When they sat for me, I never had to worry about producing a likeness, so was able freely to represent their faces in whatever way I wished. I saw their lips wet, constantly moving; their eyes as pits of emptiness. In order to convey this, I usually painted their faces in shadow against a light background, as though there was immensity behind their useless eyes. They sat well and enjoyed being of use. When the pictures had dried I often took them back so that they could feel what I had painted. Their sensitive fingers meandered across the thick paint, feeling their features in a kind of pictorial braille.

As Miss Josling got older, her cooking became worse and worse. Her sight was failing, and she stood in front of the minute Baby

Belling stove and felt her way around the vast kitchen table on which lay everything she needed, placed so that she didn't have to look for it. My breakfast became daily more horrible. At length my kipper reached me cooked in the *News of the World*, in which it had been wrapped when it left the fish shop. After this, every morning I deposited my meal in the dustbin on my way to school and went to work hungry.

Miss Josling slept in a huge four-poster in the basement. Her cries frequently brought me downstairs to burrow underneath her bed and kill one of the rats which often crept in. Her dog, Sally, was of no use as a rat-killer. Like all the other animal inmates of her home, Sally was incurably neurotic. She was a bomb-shocked Irish terrier, always lurking in corners, ready to squeak and scuttle away whenever anyone approached. She looked as if she had been placed as a puppy between two vast book-ends and squashed, so that she was higher than she was long. I didn't care for Sally and Sally viewed me with distrust.

Another of Miss Josling's pets was Sandy, a scabby marmalade cat who lived almost permanently on the kitchen table. As he was in a constant state of moult, I must have consumed a sackful of his fur during the ten years in which I survived his owner's cooking. He too, was a lurker, hiding behind the cauliflowers, depositing his fur on my bread and butter.

The most revolting of all my landlady's animals was Bobby, a mangy manx. It first arrived at the top of the basement steps one cold winter's day; and there it sat until food was placed for it at the back door. Then, slowly, suspiciously, it descended, gobbled the lot in a sudden frenzy and was away up the steps, across the road and over the back-yard fences of Highgate High Street to disappear in the direction of Pond Square. Every day the brute reappeared, a small, evil, skinny creature of a dark tabby colour, until eventually it came inside the house to eat its meal. Once inside, it stayed for good, taking up its pitch on the flap of Miss Josling's Baby Belling and never moving when she cooked, so that my food had the doubtful benefit of a season-ing of both marmalade and tabby fur. Occasionally it made ex-peditions upstairs and inevitably relieved itself on my table. It was, moreover, unable to retract its claws, so that I was constantly infuriat-ed by the sinister clip-clop sound of those claws on the lino in the hall. Bobby was so revolting that I was really frightened by my hatred of him, in case he possessed some evil power with which to punish me. Miss Josling was devoted to him. One day, as he sat in her best chair, his forepaws over the arm, one of his eyes fell on to the floor. Bobby was unmoved by this experience. As she swept it into a dust pan, 'Just fancy that, Bobby,' said Alice; 'just fancy that.' After this episode I kept as far away as possible from him.

The whole wiring system in her house was archaic and produced unbelievable effects. One evening I was sitting in my easy chair reading a book when the electric fire started to emit a sinister buzz-buzz. I let this go on for a while until I realised that the noise was similar to the ringing of a telephone bell. Vaguely, I lifted the receiver, and was staggered to find that it had indeed been the telephone bell ringing inside my fire. I asked the friend who was trying to get through to me to ring me back. This he did, and again the buzz-buzz came from my electric fire. I felt I ought to inform the Post Office engineer of this strange happening, and accordingly dialled the number:

'This is Mountview 4410. I want to report that my telephone is ringing in my electric fire.'

There was a heavy silence. Then: 'If this is some sort of a joke, sir, I don't think it very funny.'

'I am absolutely serious,' I explained. 'Can you come and fix it in the morning?'

'But it's impossible,' came the angry reply. 'I am far too busy to have my time wasted.'

'I am a schoolmaster at Highgate School.' (I thought this might prove my respectability and sanity.) 'And when I say the bell is ringing in my fire, I am telling the truth.'

At half past eight the next day a cheery-faced workman greeted me.

'Is this the 'ouse where the telephone is ringing in the electric fire?' His question was followed by a great belly laugh.

I let him in and showed him the fire and the telephone. He immediately dialled a number and said with jocular insolence, 'Speaking from Mountview 4410, the 'ouse where the telephone rings in the electric fire. Give us a ring back, Charlie.'

Lolling against the mantelpiece, he gave me a look that said only too plainly 'I'll fix you!'

I was the first to hear it, the mysterious buzz-buzz. The sceptic went on grinning at me aggressively, until it began slowly to sink into his mind that the telephone and the fire really *were*, in some strange way, connected.

'Blimey! But it's impossible, ruddy impossible!' He made a grab for the receiver. 'Charlie!' he bellowed, 'it is! It's ringing in the bleeding fire!'

Bisham Gardens was a short liver-coloured street running east-west. From my bedroom window I could look over Waterlow Park to the dome of St Pauls. No. 12 was a house with character, if not with charm. To say that it was sordid would be uncharitable. The hall

was painted institutional green, the woodwork picked out in dung-coloured brown; the pictures, painted years before by Miss Josling, had through age and dirt become incomprehensible pieces of canvas in ill-fitting Victorian frames. A wall of smell assailed you as you entered. This was due to a co-operative effort on the part of cats, dogs, cabbages and Miss Josling's stock-pot. I used to dive for the sanctuary of my own relatively clean room whenever I came through the front door.

Upstairs on the first floor was the bathroom in which, encased in rotten dung-coloured wood, crouched the bath. It was quite the most inhospitable tub I have ever met—its rusty bottom dared one to lower one's own on to its corrugated surface. I restricted my bathing and executed my ablutions swiftly and always in a vertical position.

I roosted on the top floor in company with Ern and Alice. Next to my room was a tiny cell in which an occasional visiting Iles would snore and grunt.

There were some more remarkable denizens of Bisham Gardens, of whom the Misses Tunks were the aristocracy. They indulged in a passion for calling the fire brigade, the police or an ambulance at the least provocation. The park keeper had only to set fire to some autumn leaves for one of the Misses Tunks to dive for the telephone and sound the alarm. The curate would only have to raise his voice across the street for an assault on his wife to be assumed and 999 to be dialled. All this gave interest to life, and certainly enlivened our street. These alarmist sisters used to shuffle, arm in arm, down Bisham Gardens. One, bent almost double, eagerly pressed forward, while the other, mouth open, and clutching the lead of a fluffy, unwashed terrier, leaned far back. It was amazing that they made any progress at all. Perhaps they cancelled each other out and the terrier supplied the power.

Sammy Andrews kept a market garden near the High Street. A real countryman, he told me how in his first job as an assistant gardener, or bothy boy, in a large country house garden, his main task had been to read the Bible aloud to the Squire. Sammy Andrews was ruggedly independent and lived for years in a shed in his garden, where I used to go and talk to him on summer evenings, sitting at some distance from him in order to avoid the fumes from his villainous pipe.

Eventually ill-health forced him to take a room in Bisham Gardens, where, on Sundays, off came his patched, evil-smelling clothes and he made his way to church clothed in a smart black suit and a black trilby hat. But one day Sammy was missing. He hadn't been in all night. The police were called and I remember seeing one of his waistcoats being

put under the nose of an unfortunate police dog. The Alsatian gave a howl. It would have had to be very insensitive not to do so. The dog at once started to drag his policeman along the pavement, across the High Street and into the garden, where Sammy was discovered unconscious among the cabbages. How it was that he hadn't died of exposure I don't know. He was brought back, and a few days later was back at work, looking as respectable as ever on Sundays.

The cat lady came from the Holly Lodge Estate. A small, tight, ferocious little body, she had one passion in life—feeding cats. She chose them at random, regardless of whether they came from a well-to-do household, and they were given good and regular meals. If the cat lady fell for a certain cat, nothing would prevent her from feeding it. She broke into houses, shops, institutions—anywhere to satisfy her passion. Every morning she went down to Kentish Town to buy the fish. Every afternoon, with it neatly tinned and basketed, she started on her rounds, returning to 12 Bisham Gardens at about three o'clock. Only the evil Bobby was fed by her there. Sandy she drove away with a stream of abuse, which became even worse if Miss Josling had failed to put out the feeding bowl for her use. Miss Josling tolerated her intrusion. Sammy Andrews did not. She invaded the market garden where his cats grew fat on the fish ends provided by Mr Attkins, the fishmonger. I only once overheard what I'd been told was their daily encounter. Both became so inarticulate with rage that groans and hisses replaced words. Eventually, worn out by her exertions, the cat lady retired with the dignity of one who has fought the good fight. Sammy sat, simmering and swearing, pipe in mouth, for a long time in the refuge of his potting shed.

Perhaps Miss Josling was a white witch? She seemed to be a person of incredible goodness, and gifted with power to help people in trouble. Towards the end of my stay with her I had been unwell for some weeks and had given up hope of ever getting better. One morning I awoke feeling a new man, and made my way down to the basement to say good morning to her as I always did before breakfast. She was standing with her back to me, bent as usual over the Baby Belling, the abominable Bobby crouching on its flap. Without turning round she said softly, 'You are better this morning, aren't you?'

'Yes,' I said, astounded. 'Very much better.'

'I know,' she replied. 'I took it out of you and put it into my left leg.'

I stood in her dark kitchen bewildered. Did she guess that I had recovered because she had heard my lighter step on the stairs? All I know for certain is that her leg never healed. She had a running sore on it until she died.

Once she told me that if I ever left she would die. This disconcerted me. However as I went on painting, more and more stacks of pictures accumulated until my space became much too confined for comfort, so that I was forced to leave. But how was I to break it to her, and what effect would my ultimatum produce? I consulted her young and arrogant doctor, who said she was just a possessive old woman. He therefore advised me to leave. I consulted her niece, who seemed amazed that I had managed to stick that weird house for so long.

At length I got up the courage to tell Miss Josling that I had been offered a flat by some friends and felt I must accept. She heard me in silence. Not long afterwards she went completely blind, started to get hallucinations and retired to her four-poster bed, from which she never rose again except to go to hospital. I hoped that my leaving hadn't contributed to her collapse.

I never really felt guilty, only very sad. When she was in the geriatric ward of the Whittington Hospital I used to go to see her. She never blamed me; but always welcomed me cheerfully, and told me stories of her ward mates with her usual humour, seeming to believe that we were still in Bisham Gardens. So long as she stayed in the Whittington she felt she was still in Highgate; but one day I heard they had moved her to Tooting. Before I could visit her there she had died.

On the day of the funeral I joined the cortège at Waterloo station. Beside the hearse were two Rolls Royces, one for the family and one for the mourners, who consisted of Alice, her sister Nellie, little Jinnie, Pound and myself. The small procession moved off for Castle Hedingham where the funeral was to take place. Through the East End we went and out into rural Essex.

'Oh, look at the funny 'ouses with 'air on,' said little Jinnie as we came to our first thatched cottages.

'Isn't it a lovely day? Aren't we lucky?' remarked Alice.

Fatuity followed fatuity and all the while Pound was silent. If the others considered this to be a day out, he knew it to be the end of an era and deeply felt the loss of Miss Josling.

We crept into the lovely village of Castle Hedingham, attended a short insensitive service, walked to the new cemetery, listened to the grim words, 'Earth to earth, ashes to ashes'.

'Good day to you,' said the parson. And that was that.

A lifetime of service to others was over and hardly anyone cared. Alice grinned, the Nellies grinned, the relatives grinned, but Pound was near to tears.

As the relatives' Rolls had been going badly on the way there, it was decided that they should have the better car on the way back, so we

changed vehicles. Nothing would induce me to suffer more of the inanities that passed for conversation, so I got in next to the driver, a lugubrious peak-capped man with a dried-up skin.

'What did yer think of the other car?' he volunteered.

'Oh, very good,' I said.

'What did yer think of the engine?'

'Oh, excellent. Well, all Rolls engines are.'

'Are you sure?'

'Oh yes, it went beautifully.'

'Orl right, I'll tell yer summat,' he said proudly. 'What with creeping after corpses at eight miles an hour and at eight miles to the bleedin' gallon, I thinks it ain't flippin' well worth it. So I whips out the Rolls engine and sticks in a Bedford.'

Our car was missing on every cylinder and the driver nursed it gloomily through Romford and Ilford.

'We'll never make it,' he grumbled; and sure enough, in Crouch End Broadway there was a dreadful noise and the car was enveloped in smoke. Pig-like squeals came from the back, but I had had enough. I got out and walked away.

After leaving Bisham Gardens I went to live in the basement of a house in West Hampstead owned by some old friends, George and Sylvia Grimble They had suggested that I should pay the same rent as I had paid Miss Josling; and, as I had a kitchen studio as well as a bedroom and small hall, this seemed a generous offer. It wasn't long before I realised that I had to work my passage. I was to stoke the boiler, trim the vine, mow the lawn and in general wait on the family as their tame artist. In exchange for lunch on Sunday and Monday I lent them pictures to decorate their house. George was a solid, good-natured Englishman, but agonisingly predictable, while Sylvia was a fair, pretty girl who sometimes said 'Tee hee'. The children were efficiently organised by their parents, who strove to get everyone to love them. Unfortunately this was not always possible, so the insensitivity of their neighbours infuriated George and Sylvia, and bewildered Ivy Tupper, their devoted nurse and general factotum. Ivy was an immensely good-natured girl who so worshipped Sylvia that she adopted her baby-doll voice and aped her hockey-mistress manner.

Between them I became a kind of ball to be played with. Once Sylvia ran downstairs to my basement and demanded that I should apologise to Ivy for my rudeness. I said certainly I would, so long as I knew what I had done amiss. The next day Ivy came down red in the face. I had insulted Sylvia and must apologise to her immediately.

Again I denied any knowledge of any rudeness and Ivy retired upstairs to compare notes with her mistress.

I ignored these little sallies, as I was delighted to have a place where I could paint larger pictures and be able to stand back and view them from a reasonable distance. I started to paint portraits, and old men and women from a nearby old folks' home came to sit for me. This had been impossible in Bisham Gardens. Sometimes I borrowed the game that hung in front of a nearby grocer's shop. Pheasants, partridge and all sorts of duck I chose from this fascinating place, taking them back to my basement, where I hurriedly painted them before the shop closed.

The first inkling that I was becoming unpopular with my landlady came when I returned from Cardiff one evening after appearing briefly in a television programme. George was digging the garden as I made my way to the basement steps. With his usual generosity, he invited me to supper. I asked him if I could watch myself on their television set when the programme came on, and he readily agreed. As we sat round the kitchen table, I realised that in a minute I should be appearing; so with George's permission I switched on the set. The previous programme had a minute or two to run, but soon it was announced that the B.B.C. was going over to Cardiff. I waited with a certain apprehension and anticipation, but as my name appeared, 'Turn it off at once,' came the short, sharp interruption. I turned round to see Sylvia, flushed and furious. 'But I'm just coming on,' I appealed to her.

'Mary, turn it off at once!' And a small daughter eliminated me from the screen. I could only think that she was afraid the children would get an inflated idea of my importance if they saw me on television. George said nothing.

I realised that Sylvia was becoming unbalanced. Whenever I spoke to her, and such times became less and less frequent, her face aged at least twenty years and an amazing intersection of lines creased it. With great difficulty she asked me one day what I particularly disliked eating. I told her that ever since my school days I had loathed macaroni cheese. A few days later she casually threw off the remark that every Monday in future they were going to have macaroni cheese.

Sylvia began to hate me as I have never been hated before or since. On looking back, I realised that she was used to continual adoration from all men, and this was not forthcoming from me. I had once been in love with a friend of hers. That it had been her friend, and not her, had perhaps affronted her pride.

One evening, George asked me to come up to the drawing room, as he wanted to talk to me. Sylvia was sitting on the sofa doing some

sewing and didn't look up as I entered. George settled himself ponderously and began: 'Now Taff.' Unfortunately, I was always known as Taffy. 'You know, you are just not pulling your weight.'

Astounded, I asked what my lapses had been, for I paid my rent regularly and had even given them a life-size, full-length portrait of their youngest son. It did strike me that I hadn't mown the lawn lately, but George's reply was almost comic.

'You haven't been picking up the toffee papers from outside the garage.'

I admitted that I had not, but pointed out that they had been thrown away by his children and not by me.

'I know,' George went on, 'but we must all pull our weight.'

I realised then that he didn't want to admonish me at all but had been ordered to do so by Sylvia, who sat tight-lipped and menacing on the sofa. He wasn't putting up much of a show, but on he ploughed.

'D'you know, Taff, were I in your place I feel sure I would be an alpha plus tenant. I'm afraid you only measure up to a beta minus.' There was no point in recording all I had done—that I had never let their blasted boiler out once in three years, or that their house was full of my un-paid-for pictures. So without saying anything, I got up and went to bed.

I knew now that Sylvia was desperate to find a pretext for getting rid of me, so I decided to behave with the utmost correctness. In spite of her behaviour it still suited me to stay. When she asked me to employ Mrs Jones, her daily, every Thursday, I agreed to do so. But one evening at the end of a Christmas term I returned to my basement to find Sylvia's furious figure awaiting me.

'I can't stand you upsetting my household any longer,' she screamed. 'You must get out, get out, do you hear, you must get out! I can't have you in my house any longer.'

I asked what I had done wrong and she related a series of incidents that bore no relation to reality.

Ivy, of course, took her part. The children also had been brainwashed, and when I left for Wales next day they refused to speak to me. Friends had become enemies. A relationship which had started well had gone sour. It was only after two months of vain search for other lodgings where I could paint that I began to realise with frightening clarity how obsessed I had become with painting. In Highgate and West Hampstead I had painted whenever I wanted to, so I had not known frustration. Now, having been deprived of a studio room, I was attacked by terrible spasms of jealousy, even of hatred, for all those who had such a place. My evil rage surprised me. I sought out blocks of studios, found them occupied by anyone other

than artists. Ideal studios had been turned into living rooms for old ladies or families with no connection with painting. I canvassed my former pupils of Highgate and drove them to search for me. Eventually, one of them rang me up to say that he had seen a studio advertised in Holland Park. I rushed there to be met by Elizabeth Fletcher, a short, dark, capable woman who turned out to be a doctor. She showed me an annexe attached to the house that had been built as a children's roller-skating rink, and afterwards occupied by such oddly different people as the Harlequins Rugby Team and some nuns from a nearby convent. It was reasonably light and just large enough. A bed fitted into one corner. There was a small kitchen and off the hall was a bathroom. It seemed ideal and I took it forthwith.

Elizabeth's husband Tony was in the War Office. I soon began to see a lot of them and their four children, although, still smarting from the treatment I'd suffered from the Grimbles, I was wary at first.

One day I met Tony's mother, who told me how when she was young she used to stay with an old cousin Owen, a parson, in Anglesey. I dashed down to my room, unearthed an ancient photograph of Taid on the shore at Swtan, dressed in a crumpled suit and with a Jim Crow on his head. In the drawing room upstairs, I showed it to her. She recognised the old man immediately and delightedly told me that it was she who had taken the photograph.

From that moment I was one of the family. Never mind if the children yelled in the garden outside my room and huge mushrooms grew with alarming speed in my bathroom! I was with relations, however distant, and life became good once more.

It was an amazing change after living with the Grimbles. The Fletcher children, allowed to grow up naturally, were not organised into objects of admiration. In this easy-going atmosphere my painting improved, while the vicious rage and envy awakened by my inability to find a studio vanished as swiftly as they had appeared.

12

From 1945 onwards, my epilepsy started to take a new form. Since the *grand mal* was now controlled by drugs, the illness found a way through in minor epileptiform attacks which sometimes numbered as many as nine in a single day. Speed and violence invariably got past my defences; for I suppose there was a psychological side to these unpleasant experiences.

After a day's shooting, when I was just about to go to sleep, nightmare pheasants would start up from beneath my feet with a noise, a shock that left me limp and breathless in my bed. Sometimes I feared that I should not live to see the dawn.

As I walked along London pavements, cars would veer off the road and, in my mind, crash into me. Passers-by would lash out with their fists and hit me in the face. Each time this seemed to happen a violent shock went through my head or my body, eliminating all sensation and every emotion. This would be followed by acute depression, nausea and weakness.

Once in a restaurant I was tranquilly reading the sports page of the evening paper. Hammond, so the reporter wrote, was the batsman to whom he would least like to field at short leg. Of a sudden Wally Hammond leapt from his crease. There was a loud crack as the ball shot towards my eyes, getting larger and larger until everything went black and I came to to find my head on my plate.

Nevertheless, there were compensations, for sometimes, without warning, in the mountains of Wales or on the London Underground, I would hear music. Whole orchestras played symphonies that had never been heard before. With amazing clarity I could pick out every instrumentalist. Furthermore, it was my own music, and I gave myself up to it in an intoxication of sound.

At times I had a violent desire to paint. It wasn't necessarily any particular subject that prompted these urges, but a feeling that if I

didn't paint I should burst. Once, when driven by this demon, I had stayed away from school to work, and Geoffrey Bell looked at me next day with a kindly smile, 'D'you know, Kyffin,' he said, 'if you are down to teach, it makes things rather awkward when you don't.'

Teaching became increasingly difficult for me and it was hard to hide from my pupils that I was feeling ill. By this time the Art School was running easily, and due to firm discipline at the top I seldom had any trouble with the boys. They treated me as a cross between the chaplain and an eccentric uncle, a situation that pleased me. Nearly every boy, it seemed, had an Uncle George, a hearty, sensible fellow who pontificated on matters artistic and whose word was taken as gospel. But eventually I began to loathe this figure, to picture him as a fat, sweaty, red-faced, moustachioed beer-swiller who fancied he knew the answer to everything.

Once a small boy asked me, 'Did Rembrandt mix his colours with blood to make his portraits more life-like?'

I laughed at the idea.

'But he did, you know, sir. My Uncle George says so.' And the small boy dismissed me as an ignoramus.

One boy's father ran an art gallery that specialised in furniture pictures for suburban villas. When I was lecturing on Van Dyck, 'Please sir,' the son announced, 'my father says Van Dyck wasn't nearly as good as Bennett.'

'Who on earth was Bennett?' I demanded.

'Don't you know Bennett, sir?' He looked astonished at my ignorance. 'Why, he is one of the greatest artists who ever lived. Nobody has ever painted red-robed cardinals as well as Bennett can!' We are all artistically and culturally brain-washed, but this was a new line to me.

One evening, as I was returning to Bisham Gardens from the Heath, a large pink man crossed the road in a manner that suggested he had some urgent message for me. 'I'll have you know,' he said, 'that my wife is the biggest bloody bitch with whom it has ever been my misfortune to cohabit.' His voice and face were unmistakably Irish. His head was huge, shiny and topped by a haze of sandy fur. His eyes were pale blue beads, his nose a red button, while the broad mouth that produced the remarkable information was wide below the hairless waste of upper lip. I sympathised with his marital misfortune. He asked me if I was married. When I said that I was not, he replied that surely St Patrick must have been caring for me. He told me his name was Tony Padden; that he taught English at St Aloysius School and that the priests there were a lot of bastards. Having got a load off his mind he disappeared in the direction of the Spaniards Inn.

I came across Tony Padden from time to time, learned that he had parted from his fearsome spouse, and was fascinated by his stories of pursuit and passion. During the holidays I would receive postcards from as far afield as Athens and Beirut. Invariably they told of Padden enamoured of some proud Latin or sultry Levantine, and one day a card came from Monte Carlo with the message, 'Am following a red-haired Jewess to Istanbul'. For three years the postcards, tragic with abortive romance, poured through my letter box, until one day I heard that he was in Devon, that he had caught a 2½lb sea trout and hoped to land a salmon.

If Padden's romantic pursuits were over, his battles with the priests of St Aloysius were not, for occasionally, when we met in the village, he would grasp me by the lapels of my coat muttering, 'The bastards, the bastards! All will come to light, and when it does, wait!' Again and again some remark raised my hopes of some immense confrontation, but nothing ever happened and Tony Padden's lantern face grew brighter and brighter.

He was a fanatic for fresh air, and his pupils must have suffered as blasts of arctic wind invaded his classroom. One evening he walked down to the heath to correct some work on a bench near Highgate Ponds, and was found by a park-keeper frozen stiff as a board and quite unable to move. After a brief spell in hospital he was back again, his belief in fresh air undiminished.

Teaching art at St Aloysius was Leo Davy. He had been at the Slade with me and had amazed everyone by his talent and unconventional behaviour. Leo was a brilliant draughtsman and designer, but seemed to go out of his way to antagonise both the staff and the students. His clothes were extraordinary, and I imagined that he tore holes in them in order to project some weird image of himself. It was only when we met later in Highgate that I got to know Leo as well as anybody could, for he called on me regularly in Bisham Gardens. He was for some reason frightened of Alice, and drew my attention to his presence by heaving a handful of dirt at the window. Snoozing after a day at the school, I would leap out of my chair at the rattle on the glass and open the front door. Leo would sidle in, seat himself on the floor, gaze at my pictures and say 'Bloody artist, ugh!' He had infinitely greater talent than I had but invariably seemed jealous at the number of my pictures.

Slight and stooped, with a pale face marked in a disorganised fashion by bits of hair that could never have qualified as side-whiskers, moustache or a beard, Leo always looked hungry. I seldom saw him in the company of women, but he told me that he often wrote to the winners of beauty competitions. One day he was overjoyed for Miss Scotland

Paintings

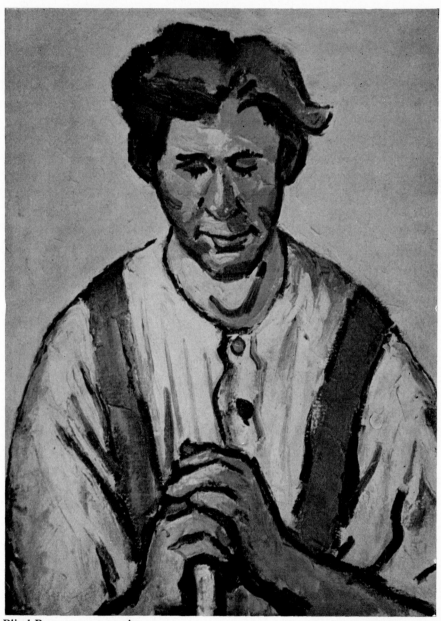

Blind Boy 1947 27×20 in
Collection Leonard Schlesinger Esq

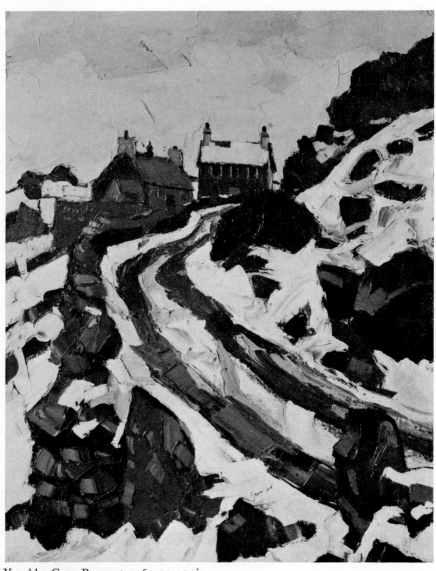

Ysgoldy, Cwm Pennant 1962 30× 24 in
Collection J. W. Blows Esq

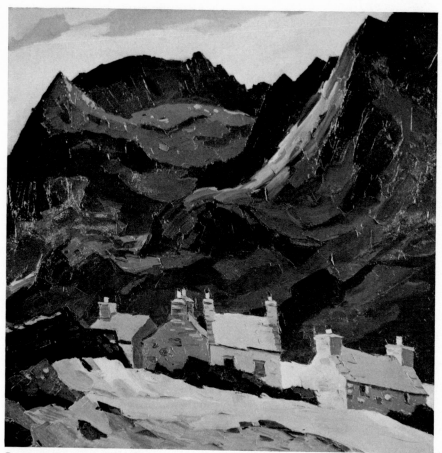

Gwastadnant 1971 48×48in
Collection Lt Commander and Mrs Baillie-Grohman

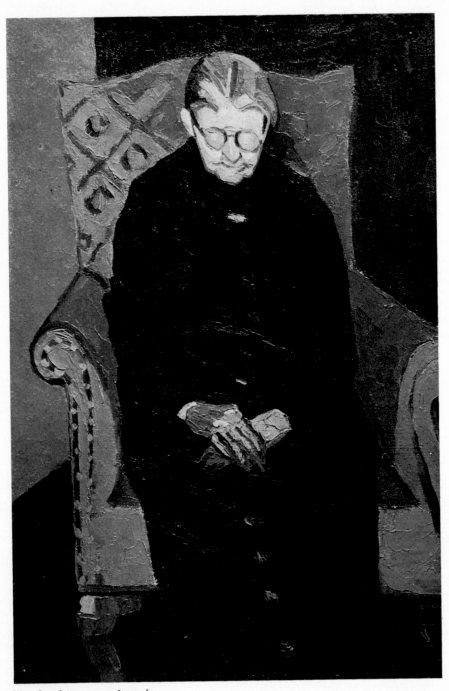

Mrs Stanley 1953 36 × 24 in

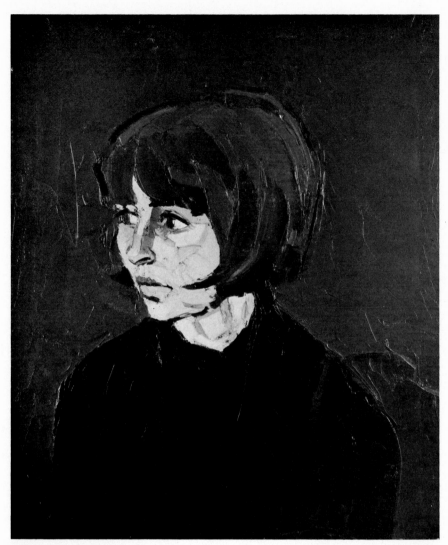

Anna 1962 24×20in
Collection Lord Grantchester

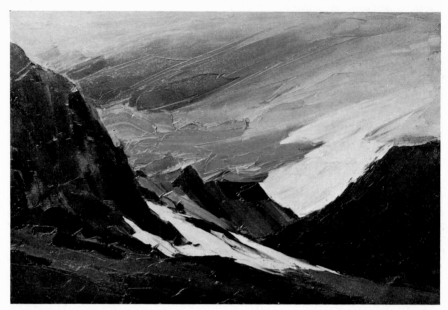

Ogwen 1966 30×46 in
Collection His Honour Judge Bertrand Richards

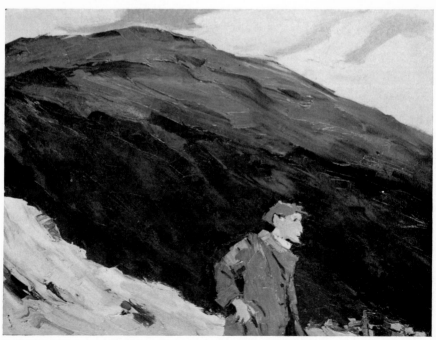

Dafydd Williams on the Mountain 1970 36×48 in
Collection Royal Academy of Arts

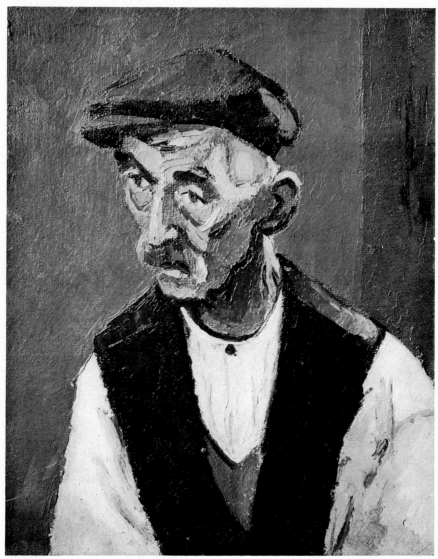

Hugh Thomas 1954 24×20in
Collection University College of North Wales, Bangor

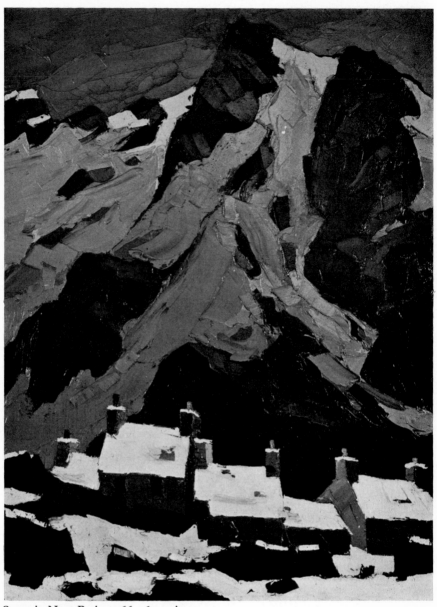

Snow in Nant Peris 1966 36× 24 in
Collection Mr and Mrs M. Wynn Williams Esq

had replied and asked him to get in touch with her at an address in Kensington. Leo telephoned; an angry colonel replied. Once again Leo retreated into his habitual melancholy.

I used to meet him in a coffee house in the village, and there he showed me a letter from the Bristol Aviation Company thanking him for his interesting suggestion of a braking system for supersonic aircraft. They added that such a device had been used by the Germans at their aircraft research station in Peenemunde, but that nevertheless it was most ingenious and that if they wished to use it they would notify him. I was astounded. Leo casually folded up the letter and returned it to his pocket.

I found it difficult to exist on my small salary, so I wanted to get a one-man show in a London Gallery. My work was not stylish or mature but I didn't expect the rudeness I was to receive from the dealers. At the Redfern Gallery a dark middle-European woman kept me waiting while she varnished her nails. When she thought the psychological effect of her bad manners had reduced me to size, she slowly climbed the stairs to where I had arrayed my pictures. 'Too dark and too academic,' was her brief criticism. Without stopping for a second look, 'Close the door behind you,' she ordered as she disappeared into another room.

In one gallery, I was told my work was too much like Pissarro, in another, too like Cézanne. Only in the sumptuous saloon of Wildenstein's was I treated with kindness. Colonel Beddington took me up in a lift to his room, placed my efforts on a plush easel and announced that he was going to pay me a compliment. Ringing a bell he ordered a lackey to bring in some pictures.

'Now I am going to compare you with Daumier,' he said; then explained that I wasn't yet ready for a show. He wished me luck and saw me to the door. I had been turned down again, but in a very different way.

One day Ralph Edwards, in his house in Chiswick Mall, announced that it was high time I had an exhibition. I agreed, and related my sorry experiences. He seemed surprised and with his usual generosity said he thought he could arrange one for me at Colnaghi's. Sure enough, two partners in that most human of firms came to see me in Highgate. Jim Byam Shaw and Tom Baskett were very different characters, but they both seemed to like my work and a show was arranged.

On the opening day I got there early. The gallery was deserted as I wandered round it, eyeing my pictures with a certain amount of parental pride. After what seemed an age, I heard steps in the passage and a pair of old ladies dressed in black appeared at the entrance to the

Gallery. There they stood, gazing in silence. Eventually the larger of the two turned to her companion. 'Oh no, Agnes,' she said softly, 'far too Chekov.' They turned round and disappeared.

In spite of this inauspicious start the show was a success, and when it ended the Gallery gave me a delightful drawing of stags by Landseer to celebrate the event.

By the end of 1948 my attacks were getting so frequent that I found it very difficult to go on teaching. One Christmas holidays I was met at Pwllheli station by Hugh Roberts the Shop, Abererch. He drove me home and when my mother opened the door, 'Here he is,' said Hugh, 'looking horrible!'

Indeed I was feeling so, and I got worse and worse until after Christmas I persuaded our doctor to send me to any hospital where I might possibly receive help.

In a large institution in the Midlands, under the influence of even more drugs than I usually took, I gradually came back to normal. We were a strange selection of inmates. There was a Cambridge golf blue, a Scotland Yard inspector, a Roman Catholic priest, a Harley Street specialist and an ex-Postmaster General. The knowledge that we were all fellow-sufferers broke down the barriers between us.

As far as I can remember, only two people held themselves aloof and they were a continually expectorating Chinese Jew and a neat, distinguished-looking man we knew as 'the Honourable Archie'. One day, when I was to go up to London, I went over to the barber's shop to have a shave. The chair was occupied by Archie, who sat hunched and silent while the genial barber lathered and shaved him. The operation over, Archie got up and stole silently away.

'Not very talkative,' I remarked.

'Blimey, no,' replied the barber; 'I cut him twenty years ago and he hasn't spoken to me since.'

I played golf with the Cambridge blue on nearby courses. I played football for the hospital in a local league. I painted some portraits of the nurses and patients. There was a fascinating variety of people in that hospital, so time went by amazingly fast. I stayed there for about two months, and benefited enormously from the attention of the doctors and nurses. I was allowed considerable freedom and even went up to London occasionally to submit pictures to exhibitions. I missed a term at Highgate, but returned at the end of April, and remained to teach until the end of the year, when I was allowed a year off by the Governors.

I went to Rome at the beginning of 1950. I suppose this was rather a stupid thing to do since the doctors had prescribed a drug which

made everything look vividly white whenever the sun was shining. Dark glasses were a help, but I was unable to do much painting. It was only when I returned and went to St David's that I managed to get to work again.

St David's must be one of the most romantic places in Britain. The cathedral that nestles in the narrow valley of the river Alan has a degree of spirituality I have never met anywhere else in these islands. I stayed with a friend in a small cottage at Rhosson, near the ruins of St Justinian's Chapel and opposite the rocky hump of Ramsay Island.

It was spring, and the cliffs were coated with an even greater assortment of wild flowers than were to be found at Port Swtan. Cowslips and campion, sea pinks and dog violets, they and many more were turning the lovely coastline into a wild exciting garden. The land is very like Anglesey, but the grass is greener, and the sea lunging out into the Atlantic seems to be more turbulent. The ragged coastline is broken by delightful bays with firm pink sand and the rocks have a purple tint. Over the land of St David's Garn Llidi crouches comfortably.

The farmers I met were for the most part a strong aristocratic breed, and when the maroons went off from the coastguard hut above the cottage it was they who manned the lifeboat. There was humour and hospitality there and no shortage of characters. 'Dduw,' said Edwyn Phillips, 'Idwal and I, we are like brothers. Damn he's a nice chap! But I don't like him.' Such a statement can be readily understood by a Welshman but it is not so easy for an Englishman to unravel its subtleties.

One day I had borrowed a pair of long white waders so that I could wander into a small marsh to look for the nests of snipe and duck. It was a lovely evening, and having failed to find what I was after, I left the marsh and walked up to a rocky outcrop so that I could watch the sun going down over Ireland.

As I climbed up a path among the rocks, I saw lying on its face a notice board on the end of a white post. Alongside it was a gaping hole into which the post had been driven. I turned it over and read, 'National Trust Property'. Thinking that it had been knocked over by a cow or blown down by the wind, I replaced it. A few days later as I was sitting on that rocky hillock again, I saw the farmer leave his farm buildings accompanied by his dog and come towards me. Casually he slung his long legs up the slope until 'breasting the ridge' he stopped short as if in surprise.

'A lovely evening,' he said.

'Lovely,' I replied.

'A beautiful time of the year.'

'Yes, isn't it?'

'A good place to come and stay.'

'Indeed.'

'Staying here for long, are you?'

'Oh, I'll be off in a day or two I expect.'

'Pity you have to go, isn't it?'

The civilities dispensed with, his voice reached a higher pitch. 'D'you know, sir, a strange thing happened the other day. I was down by the farm when I looked up at the old rock. And dduw, I saw a tall gentleman, about your height he must have been and wearing white waders. Yes, I was see him climbing up to where the National Trust put up an old notice. Now, I don't like that National Trust, letting people go all over my land, over my fences, over my walls. Damn I don't like them. So I take the old notice out of its hole and put it face down on the ground. Now, what did this gentleman do? He was pick up this notice and put it back in the hole.' He spoke softly again. 'Now I say to myself that is a very strange thing for a gentleman to do, isn't it, I say.' He was getting into his stride now as he sat beside me and gazed away across Ramsay Island to the distant Grasholm. 'Tall he was, and fair like you, sir, and don't you think it was a very strange thing for a gentleman to do?'

'Yes,' I said, 'very strange indeed.'

'Well, yes, I was go back to the old farm and say to myself, now why should a gentleman do that I wonder.'

His voice wailed on and he knew that I knew that he knew that it was I who was the white-wadered one. And I, being Welsh, knew that he knew that I knew that I was not going to admit anything.

Together we sat in that distant part of Wales as the sun went down. Together we got up and walked back to the farm. Having made his point he was satisfied. I saw his point and was not hurt by his rebuke. We were friends when I said good night and returned to the cottage.

Back in Abererch I began to paint many of the local people. Ellis Evans Gegin, John Jones Bont, Tom Owen, the Broomhall cowman and old John Cawrdaf Jones the church sexton, all came and sat for me. They seldom seemed to be interested in the result and smilingly departed as soon as I had finished.

I also painted pretty little Jane Williams Tynllan with her fair hair and dark eyes. As she sat in a pale blue dress and white collar I asked her what she had been doing that morning.

'We all went to Pwllheli to buy presents,' she replied shyly.

'What did you get?' I asked.

'Gwilym got a cap.'

'And Elwyn?'

'Oh, Elwyn got a toy train.'

'What about you Jane?'

'Two pairs of knickers.'

'And Hughie?'

'Oh, Hughie is in Bangor Infirmary. So Hughie got the Holy Bible.'

Over at Boduan I painted Ellis Jones, whom my father had known sixty years before when Taid was the rector there. When the rectory children, supervised by the ferocious governess, wearied over their schoolwork, young Ellis would stand on the garden wall making faces and trying to lure them outside to chase through the woods to birds-nest or to leap on to the backs of the local ponies. The wild unschooled Ellis became a hero to the children and my father always kept in touch with him. So it was easy to arrange a sitting, and Ellis, white stubble-bearded, with a long sad face, sat with the full weight of his ninety years on a settle by his kitchen fire.

I put my palette on the table and set my easel up in the doorway, its legs digging into the cracks between the slate flags. As I put my canvas up I heard Ellis saying, 'What's that?' in Welsh, and turned to see a large finger dive into a rich lump of alizarin crimson. He withdrew it and gazed fascinated as he rested his head on his hand, staining his beard deep red as if a careless barber had been at work.

A white kitten jumped on to the table. 'Damn you, get out!' shouted the old man. A great ruddy hand was transferred from beard to kitten, which bolted fearful and bloody into the garden and leaped into the large basket that contained Mrs Ellis's pure white washing.

I said nothing. I was frightened of losing my sitting. Mrs Ellis had gone to the village, so I painted like lightning to finish before she returned to view the damage. After I had done, I realised that the old man thought I was painting the picture as a present for him. When he plied me with marrows, peas and flowers, I felt guilty and had to do a drawing for him before I slipped away with the painting.

I had always wanted to paint Ellis Evans who lived in the village in a small neat cottage called Gegin. He was dark and Gallic with a face like a kindly Laval. He wore a similar drooping black moustache, while at the back of his head there rose a gigantic knob of flesh. This, Ellis told me, was the result of an explosion that occurred when a schooner with a cargo of slates from Portmadoc blew up in the London docks. Ellis was one of the crew. A piece of slate gashed his neck and the subsequent swelling never subsided.

He came to sit for me after attending a funeral, so it was an un-usually trim figure that sat solidly on a chair in front of me. I found him very difficult to paint. Frustration grew as the quality of paint

became more and more turgid. In desperation I lunged at the canvas. The easel swayed and instead of falling backwards fell forward towards me. My hands were full and there was a valuable carpet under my feet. Drastic measures were necessary, so I pushed my head forward and stayed the collapse of the easel. I was wearing a new tweed hat and this was forced into the thick wet paint. I felt sure that the picture was ruined; but when I re-organised things and looked again I realised with joy that it was finished. The hat had done everything my mind, brush and knife had failed to achieve.

As I wasn't allowed to drive, Hugh Roberts took me out to all the places I wanted to paint, and there he waited while I wrestled with the difficulties of painting and weather. He was great company and I think he enjoyed our outings together.

I threw myself with renewed vigour into the painting of Welsh landscape. Eagerly I sought out the distant places in Caernarvonshire and Merioneth that I had discovered while hunting with the Ynysfor Hounds. Furiously I painted in wind and rain, on scree or ridge, working as quickly as I could so that I could satisfy my creativity with the contentment of a finished picture.

I was lucky in having friends with whom I could stay. Sandy Livingstone-Learmouth always made me at home in his house above Tremadoc, where Shelley had had a brief unhappy residence. Everyone was welcomed at Tanyrallt, and one morning, as we had our breakfast, his faithful Miss Parry dispensed coffee to the policeman, the postman and the Johnny onions man.

Glasfryn, the home of the Williams-Ellis family, was another house I often visited. I have done more shooting round their wild and lovely estate than anywhere else. Roger, the eldest son, and I were almost of an age. With Wufi in attendance we scoured the woodlands for pheasants and woodcock and beat the lakes and streams for duck.

I led a strange existence of creation and destruction. When I was painting I wondered how I could ever endure to shoot; yet when I was out shooting the flashing birds became abstract objects at which I eagerly fired. Only when a poor crumpled body lay at my feet did I feel ill-at-ease. In bed at night my feelings became exaggerated, and I hated myself for what I had done. None the less, I regularly returned to Glasfryn.

My mother's health began to deteriorate because of her lonely life. Finding it difficult, as always, to communicate with other people, she grew more than ever isolated in Lleyn, and no doubt craved to be back in Anglesey, the land of the father she had loved so much. The melancholia from which he had suffered now became apparent in his

daughter and at times it was hard to get her to speak at all. Her eyes became pools of sadness. She lost confidence in everything she did. Dick and I agreed that she must move, so we set about trying to find a house for her in Anglesey. We found a perfect home for her—part of a large house in her father's old parish of Llansadwrn. At first she seemed to like it, but doubts began to creep into her mind and she made continual excuses for not moving there.

One Christmas holidays I returned to find the local policeman in the house with my mother. She looked strangely upset, and the constable muttered to me that she believed a large part of the family silver had been stolen. Time and again we counted, always with the same result: nothing was missing. My mother, I now realised, was very ill and living in another world. All night she moaned, and turned on me whenever I tried to comfort her. Our doctor, knowing that Dick was her favourite son, told me he ought to stay away, in case she turned against him as well. It was only after a week, during which I hardly dared let her out of my sight, that we managed to get her away to hospital.

Dick came home and we decided to move at once. The house had already been bought, and so it was not long before we had moved in. When, a few months later, my mother returned fit and well, she seemed delighted to be home again in the parish where she had been born.

Dick and I felt we had won an important battle. We didn't bargain for the inhospitableness, the insensitivity, of her old friends and relations. With very few exceptions they ignored her existence. Although they continually passed our gate in their cars, it was a rare thing for any of them to call. This upset her considerably and contributed to the gradual breakdown of her health.

An exception was Sisli Vivian, who lived half a mile away across the fields in Treffos, our old family home. Sisli and my mother shared a common great-grandmother, and although Sisli was much stronger physically they were somewhat similar to look at. They were very different in temperament, for Sisli was courageous and uncomplicated. Not that my mother lacked courage of another order. The problems she had to cope with later showed how brave she could be.

Sisli's father was Colonel Hampton Lewis of Henllys, an old warrior who had charged with the Heavy Brigade at Balaclava. Her mother was a Pritchard of Trescawen. From the Pritchards she had inherited her love of sport, particularly hunting. She had spent much of her youth and middle age with various packs in Ireland. She pursued hounds with such vigour and enthusiasm that she broke her bones with the utmost consistency, and, by the time she

was fifty, one of many cracks on her skull had destroyed her sense of taste. Undaunted, she continued to hunt until the Second World War, and when that was over started a pack of beagles on the wire-fence island.

Sisli was an individualist and often came out with surprising remarks. She once asked me how my brother was and when I told her he was feeling very low after having all his teeth out, 'Good Lord,' she said; 'that's nothing to feel low about. I left all my teeth in a tree in County Kildare in 1904.' Behind this seemingly insensitive exterior was a very warm heart, and she took my mother under her wing as soon as we settled across the fields in Gadlys. We were always made welcome in our old family home, in spite of the fact that she had been almost cut out of her aunt's will in favour of my mother. Our house was full of Pritchard furniture, but Sisli never seemed to care.

Cyril, her husband, came of an old Cornish family that had at one time been connected with the copper trade. They had flourished in Cornwall and South Wales, and their most distinguished son had been General Sir Hussey Vivian, one of the heroes of Waterloo. Cyril was a frustrated man of action. Bald with a fierce moustache, he roared around the house, complaining, laughing and talking incessantly. Rabidly loyal to King and Country, he embraced lost causes with fanatical enthusiasm, sometimes lapsing into periods of fantasy as his imagination ran riot in dreams of heroism and military glory.

One day, as I was waiting on the roadside for a bus to take me to Bangor, Cyril came round the corner driving his ancient little car. He stopped and asked me if I wanted a lift. I thanked him and was getting in when I glanced at a stranger who had been waiting beside me. I asked if he could come too and Cyril ordered him to get into the back of the car.

Seated next to Cyril, I felt all was well until at the end of our lane we joined the main road. It then became apparent that in his own mind he had become Ensign Vivian of the Dragoons in the Charge at Balaclava. A sheep was grazing peacefully on the broad grass verge along the other side of the road. 'Guns to the right of them!' roared Cyril. The small car lurched across the highway and mounted the verge. The sheep tried in vain to bolt through a stone wall, and then dashed madly towards Pentraeth. A horrified gasp came from the stranger behind me. The gasp became an anguished cry as Cyril, full of fight, spied another sheep on the opposite side of the road.

'Guns to the left of them!' Again we charged, and again the enemy was routed.

The presence of a totally unnerved man in the back seat could be felt as we drove up the hill to Wern, and I can't say that I was feeling

overconfident myself. Worse was to come. As we breasted the rise, I saw, in the dip beyond, the back of a Crosville bus on its way to Menai Bridge. Cyril seemed to swell as he sensed yet another adversary. 'Into the Valley of Death!' he yelled. The car shot forward. Two arms encircled me from behind. Terrified, the stranger slowly sank out of sight behind the front seat. The gap was closing fast. I shut my eyes. Cyril gave a violent twist to the wheel. I saw the bus loom over us as we swept past. Everything had been under control. We entered Menai Bridge at a slow and dignified pace. There Cyril stopped for petrol. I thought it wiser to change to public transport; so I got out and released the stranger. What stories, I wondered, would he tell of his travels in wild Wales?

Cyril was very good to my mother and often came to see her. She was fond of him and appreciated his visits. When he had gone she always said the same thing: 'We have never known a Vivian who wasn't kind.' After Cyril's death Sisli led a lonely life in Treffos and always welcomed me there if ever I wanted a meal. Realising that she would be alone one New Year's Eve, I suggested I should see the New Year in with her. She asked me to supper, and when I arrived I found that the cook, an alcoholic, had overcooked the pheasant to such an extent that on the first incision it disintegrated into powder. Sisli washed it down with sherry, I with Ribena. Afterwards we sat in the panelled hall in front of a large fire, where the old lady, surrounded by black labradors, fell fast asleep. There were three hours before the turn of the year. Piled-up copies of *The Field* and *Horse and Hound* were on a table beside me, and I read these as Sisli's snores harmonised with the crackling logs and the roaring of the wind outside. At eleven o'clock she woke. 'Has the ghost been in yet?' she asked. I replied that I hadn't seen him. Inebriated howls came from the back of the house. 'He's late. Probably celebrating with cook,' she suggested; but a few minutes later, 'Here he comes,' she said, as, leaving her chair and pulling a shawl round her shoulders, she sat hunched on a stool in the fireplace, eyes fixed on something or somebody coming down the stairs. Her eyes never left whatever she saw as they followed it round the room until it had returned to the landing above. At which she left the fireplace, removed her shawl, and returned to her chair, her head once more falling in sleep on to her chest.

I had heard in the village that there were ghosts in Treffos and one tough old lady who sometimes stayed there assured me that whenever the ghost came in she became as if paralysed and felt she was at the bottom of a deep well. No member of my family has ever seen a ghost in Treffos and no story of haunting has been passed down. That New Year's Eve I saw nothing, heard nothing and felt nothing. If

there really was a ghost it must have been the materialisation of one of my family who did not wish to disturb me.

I resumed my study of the hunts of Britain and the fees demanded for stallions at stud. Just before midnight I woke the old lady and we saw in the New Year together. On my return to Gadlys I realised I had not asked her what she had seen. I was never to know, since she died the following month when I was in London.

I was glad to be back in Anglesey, and found the landscape of my homeland most exciting. The light was more pearly than that of the mainland, the cottages whiter and more welcoming. I started to paint with an added exuberance, covered miles by bus, by car or on my feet, painting, drawing and absorbing the unique atmosphere of Anglesey.

I also painted many portraits.

A doctor friend from Conway used me as an occupational therapist, and often asked me to go to some farm or cottage in the Conway valley to paint a patient who was going through a bad period of loneliness or depression.

One of these was Hugh Thomas. I found him standing with a sickle in his hand trimming a hedge. His wife had just died and I could see from his eyes how sad he was. He was a typical Celt, tall and spare with a drooping moustache that accented the melancholy of his face.

I painted him in the rickyard of his small farm, while he sat on a stool against the stable door. The sunlight poured over the hills to streak between barn and stable, picking out his neck and cheekbones, the back of his cap and the edge of his big moustache. He didn't question me and showed little interest in what I was doing. When the light failed and I had to stop work, a slow smile was all I got as he wandered away into his fields. His daughter wept when she saw what I had done. Great wails echoed round the old kitchen, and nothing would console her. I returned home feeling that I had failed as a therapist; but I was pleased with the picture.

William Williams of Hafotty, Llansadwrn, was quite a different character. A large, happy Anglesey man, he sat by the fire with his cheeks dancing to the flames. This made it very difficult for me, so that after an hour and a half I was disgusted with my failure and decided to finish the picture at home. William Williams heaved himself off the settle and came to see what I had done. Clearly disappointed, he complained in a slow, high-pitched voice, 'Well, well, well, everything is go wrong! My motor's broke down, my tractor's big end is gone, my milking machine won't work and now you can't paint my face!' Tragedy was piled upon tragedy; but over our hearty tea all was

forgotten. He waved me a cheerful goodbye; and when I got home I beat the picture into shape.

Everybody who sat for me presented an individual problem. Mrs Stanley of Beaumaris gave me a difficult time. She was ninety-two when I painted her, and her pale transparent skin made her look as if she had been shut away from the world for many years. Her hair was thin. Like mist it crept over her tiny head, so that in places it was difficult to see what was hair and what was skin. Dressed in a long ultramarine dress, she sat in a huge green armchair. Her claw-like hands never stopped moving, and as they moved she sang a strange song that was more of a humming, for there were no words to it. Occasionally she would stop and fix me with two wet eyes.

'You know not the day nor the hour,' she announced. And later, 'God will take you in his good time.'

This made it hard for me to concentrate, and I felt like pointing out the probability that He would take her first.

'God has taken Bessie and Jinny . . .' There came a long list of her nearest and dearest. 'And he will take you too.' I was getting frantic when the small head dropped on to her chest and snores replaced the singing. I finished the picture to the sound of snores, seagulls and the motor cars in the street below.

13

My mother's illness, although at the time it had made her dislike me, had the effect afterwards of drawing us closer together than we had ever been before.

Back in Anglesey, she started to look after me even more solicitously than she had hitherto. She conveyed her affection, not by any show of emotion, since for her this was impossible, but by becoming what was practically my slave. This embarrassed me very much; yet because I knew she enjoyed cooking for me, and caring for my comforts, and anticipating my every need, I had to allow her to do as much as she could without wearing herself out.

Each time I came home for my holidays I could see she was getting weaker, and I heard stories of her behaviour that caused me considerable worry. I would hear from neighbours that, failing to get any reply to their knocks, they had broken in to find her speechless and frightened. Sisli Vivian told me that one morning my mother had arrived at Treffos covered in mud and leaves after spending a night curled up under a hedge. Her amazing vitality enabled her to survive, but the real trouble was her complete inability to communicate with anyone. I tried to draw her out, talked of my father, asked questions about hers. Nothing would serve to open the doors that closed in her thoughts from the world.

She wouldn't go to a convalescent home, and refused to have anyone to live with her, so I had to find somebody local who would come at least twice a week. I went round the farms and villages, searching for a help, but without success. At one small-holding, the farmer and I talked of local people and he described a wealthy couple in a magni-

ficently Biblical way. He spoke like a prophet with a strong staccato Welsh accent.

'And the blood was full in the woman and the money was full in the man, so they made champion together.'

During my search I heard many stories of my family from the older members of the parish. I learned with surprise that my grandmother insisted on the children dropping her a curtsey as she rode through the village and how she became very angry if they failed to do so. Colourful tales were told of the Craig-y-don family, tales that were elaborated when it was realised that I was of the Treffos branch. Gradually I became acquainted with the parish of my ancestors and on one ivy-covered wall near Treffos I found a stone carved with the simple inscription 'John Williams, 1824', and wondered why my great-great grandfather, in his old age, should have found it necessary to claim his land in such a way.

I wandered the lanes and footpaths of the parish, calling at farms and cottages. I listened to many stories but nowhere could I find someone to help my mother.

Finally somebody found for me Miss Williams of the Almshouses at Penmynydd. She was tall, strong and humorous and became very fond of my mother, and my mother grew to look forward to her visits. I noticed that they spoke Welsh together, something my mother would never have done in the past. Thus I began to realise that as her vitality ebbed away so the strain of living was dwindling as well. She became easier, more gentle with people, and obviously found it less important to do the right thing. Uncertain of what life was about, and of how she ought to behave with others, she seemed now to find her conscience eased by her increasing weakness. Amazingly courageous, she never complained at home. Only in hospital, where her character changed alarmingly, did she become difficult; and then she became very difficult indeed. Hospital must have irked her unbearably, and she kept on demanding to be taken home. But she had become too weak to be left alone. Every time I went to see her, I saw that I meant more to her than ever before, and when she died I was happy to know that our relationship had never been better.

I continued to teach in London, and came back home to Anglesey in the holidays. This arrangement of my life had enabled me to plan the number of pictures I had to paint in any given period. I tried to paint two pictures a week in London and three a week in Wales. Sometimes I failed to carry out this programme; but for twenty years I must have painted a hundred pictures a year. Such self-discipline was essential, for I knew too well my natural lethargy, but the very immensity of my output had its obvious dangers, for as

canvases piled up against the walls of my rooms I realised that it was essential to be ruthless. Consequently whenever I was forced to move, I destroyed about fifty oils and two hundred drawings which I considered to be of little merit. Contrary to the opinion of critics and connoisseurs I believe that a painter always knows his best work.

My greatest fortune was that I was ordered to take up art for the good of my health. This presumed that I was not a born artist, and therefore was able to paint naturally in an uncomplicated manner, free from the conscious pressure of the man who knows he is an artist and has to live up to it. I now know that I am a painter, but it needs a brief mental switch for me to acknowledge the fact. Therefore I live in a world of people as one of them and not as an artist with a cultural millstone round his neck. Unlike so many of my contemporaries, I have never considered it necessary to change my style. Painting to me has always been a long-term project, and my only hope has been that, as the years went by, I would become better, not different. I know that I am not a colourist, for this is a gift with which a man is born. I don't think I go wrong with colour, but I am equally conscious that I don't go right. I know my limitations and work within them.

Wales is a land of ochres and umbers, only occasionally going mad in a riot of colour. In my London studio it is the average day, with the sun behind the cloud and dampness on the rock, that comes to my mind. I work facing the light so that my canvas is in shadow and not bathed in a brilliance that would hurt my eyes, unduly sensitive as they are to startling light. Sun in the distance I can absorb; sun on my canvas I cannot. I naturally crave excitement, so the light behind a jagged ridge or the sheen on a wet rock-face stimulate me as alcohol or drugs may do others.

The pictures I have painted in Wales have always been topographical, done of the landscape in all weathers. I found, after a bit, that I was able to stand in the snow for hours, with the temperature below freezing point, and yet my hands were warmer at the end of a painting than when I had started on it. My left hand that held the palette, even though motionless in the frosty air, was comfortably warm. Only when I began to pack up my paints did I feel cold. So I imagine that unconsciously I practised some form of yoga.

I tried to be as exact as possible in my outdoor paintings, to master the tone and colour; but I never attempted to interpret. This I did in my rooms in London. Away from Wales, from the wind and the rain, the cows and the children, I could more easily condense my thoughts and paint better pictures.

The beginning was always a struggle. For the first hour I felt as it

I were bicycling up a very steep hill. Straining and pressing on the pedals, I would eventually get to the top. Then it seemed as if the whole landscape opened up in front of me, and with no effort I free-wheeled down to the end of the picture. For at some time something took over and I became the mere vehicle that produced the painting.

I have found from experience that the more I have allowed myself to be swept away into a fever of exuberance or even anger, the better the final result has been; while conscious thought has invariably brought disaster. Since I became a painter by chance, it took me many years to realise that people actually wanted to buy my work, and by this time I had become what might be called a selfish painter, indulging myself in the luxury of pigment for my own personal benefit. I continue to paint selfishly yet know I have to sell pictures in order to live. Sometimes it hurts when a picture that means something special to me is bought by an unknown purchaser, to be carried away to an unknown dwelling, possibly to be lost to me for ever. Nevertheless I know that it is important to dispose of pictures, for an empty studio is a great incentive to creative work. It is unfortunate that I am unable to give my pictures away to people of my own choice.

One of the strangest emotions that plagues me is that of a sense of duty, and it is possible that this stems from my clerical background, for my forebears were people with a strong social conscience. Duty to what or to whom is a difficult problem to solve, but I feel it might be something to do with Wales and the importance of recording its landscape and people; but emotions are often hard to unravel and maybe it is a streak of Puritanism that forces me to work, or even the latent epilepsy that stimulates my nervous system. Perhaps they all play their part.

My Welsh inheritance must always remain a strong force in my work, for it is in Wales that I can paint with the greatest freedom. I have worked in Holland, France and Austria, in Italy and in Greece, but in none of these lovely countries have I found the mood that touches the seam of melancholy that is within most Welshmen, a melancholy that derives from the dark hills, the heavy clouds and the enveloping sea mists.

Most landscape painters react to their own country more strongly than to any other, and I am happy to remain in Wales and paint my own particular part of it. In Anglesey the white farms and cottages welcome me, while across the straits I can see those wonderful mountains and am able to take advantage of them whenever I wish to do so.

I have been constantly amazed at the good fortune that has

159

followed me throughout my life. Moments that have seemed at the time to have been disasters have in due course proved to have been beneficial, as if my path had been plotted for me. The luck that gave Humphrey Williams the pot of gold has followed me, his great-great-great-great-grandson. I was lucky in that I was born into a landscape so beautiful I had no need to go elsewhere. There was never any question about what I should paint. I was lucky to escape the war. I was lucky in failing to get any jobs at Art Schools, thereby being allowed to stay at Highgate and develop my own work in peace. Finally I was lucky to be ignored by the world of art and the critics, who by singing their praises, often bring about the extinction of young artists.

'John is a very good little boy,' stated my report from Moreton Hall.

'Never have I met a boy with less ability,' was the verdict of Shrewsbury.

'This officer is immature,' roared the Army.

'I am sorry, but you are abnormal,' diagnosed the doctor.

'Ponderous, unimaginative and insensitive,' bleated Mr Eric Newton the art critic.

My father used to sigh, 'Why do you always go bang at things?'

'Stuff and nonsense,' said my mother.

SOUTH CAERNARVONSHIRE

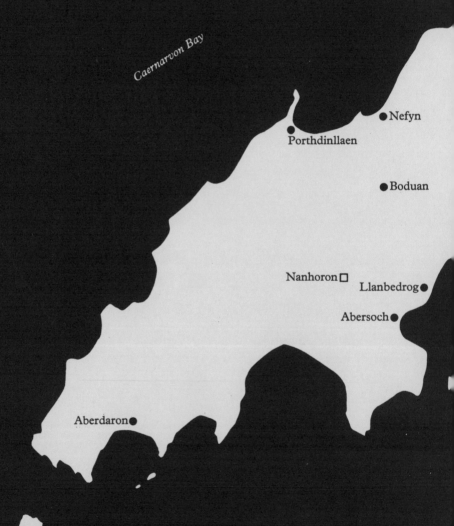

0 miles — 5

0 kms — 8

Caernarvon Bay

● Nefyn

● Porthdinllaen

● Boduan

Nanhoron ☐

Llanbedrog ●

Abersoch ●

Aberdaron ●

Cardigan Bay

Bardsey Island
(Ynys Enlli)